OR

SPIRITUALISTIC MYSTERIES EXPOS[ED]

BY

A MEDIUM.

ART ENG. CO. ST PAUL

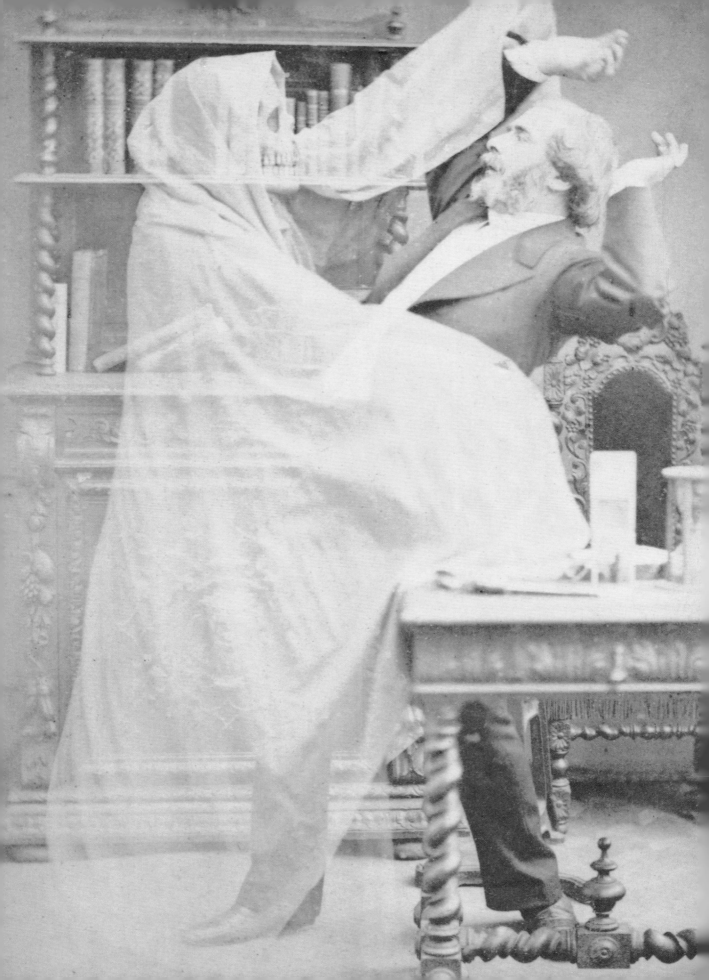

CONJURING THE *SPIRIT* WORLD

ART, MAGIC, AND MEDIUMS

edited by
GEORGE H. SCHWARTZ

with contributions by
TEDI E. ASHER
CHRISTOPHER JONES
LAN MORGAN
TONY OURSLER
JENNIFER LEMMER POSEY
GEORGE H. SCHWARTZ
MARK SCHWARTZ

*Rizzoli/***Electa**
Peabody Essex Museum

New York, New York | Salem, Massachusetts

(opposite) see p. 29

(detail, on the front cover) The Otis Lithograph Company, Cleveland, *Thurston the Great Magician — The Wonder Show of the Earth — Do the Spirits Come Back?*, 1929, lithograph, 79 1/2 × 39 1/2 in. (201.9 × 100.3 cm), Peabody Essex Museum, museum purchase, by exchange, 2023.14.1

(detail, on the title page) Eugène Thiébault (1826–1880), *Spectres Robin*, about 1863, albumen silver print, 3 7/8 × 2 5/8 in. (9.8 × 6.7 cm), Collection of Tony Oursler

(detal, on the back cover) Forbes Company Lithographers, Boston and New York, *European Wonders — Horticultural Hall*, about 1885, lithograph, 23 13/16 × 20 1/8 in. (60.8 × 51.1 cm), McCord Stewart Museum, purchase, funds graciously donated by La Fondation Emmanuelle Gattuso, M2014.128.295

This book is published on the occasion of the exhibition *Conjuring the Spirit World: Art, Magic, and Mediums*, organized by the Peabody Essex Museum, Salem, Massachusetts.

Peabody Essex Museum
September 14, 2024 – February 2, 2025

The John and Mable Ringling Museum of Art, Sarasota, Florida
March 15 – July 13, 2025

Conjuring the Spirit World: Art, Magic, and Mediums is made possible by Carolyn and Peter S. Lynch and The Lynch Foundation. We thank James B. and Mary Lou Hawkes, Chip and Susan Robie, and Timothy T. Hilton as supporters of the Exhibition Innovation Fund. We also recognize the generosity of the East India Marine Associates of the Peabody Essex Museum.

Support for this publication is provided by Furthermore: a program of the J.M. Kaplan Fund

Furthermore:
a program of the J.M. Kaplan Fund

First published in the United States of America in 2024 by

Rizzoli Electa
A Division of Rizzoli International Publications, Inc.
300 Park Avenue South
New York, NY 10010
www.rizzoliusa.com

in association with

Peabody Essex Museum
East India Square
Salem, Massachusetts 01970
www.pem.org

On Behalf of Rizzoli Electa
Publisher: Charles Miers
Associate Publisher: Margaret Chace
Senior Editor: Loren Olson
Copy Editor: Richard Slovak
Production Manager: Kaija Markoe

On Behalf of the Peabody Essex Museum
Director of Curatorial Affairs:
 Petra Slinkard
Curator-at-Large: George H. Schwartz
Editor: Michelle Piranio

Design by 60/40 Projects
Cara Buzzell and Lucinda Hitchcock
Typeset in GT Sectra Book,
MAD Serif, ITC Century Condensed

2024 2025 2026 2027 / 10 9 8 7 6 5 4 3 2 1

Printed in China
Paperback ISBN: 978-0-8478-4045-8
Hardcover ISBN: 978-0-8478-2824-1
Library of Congress Control Number: 2024933953

MIX
Paper | Supporting responsible forestry
FSC
www.fsc.org FSC® C104723

GHOSTS WERE IN THE AIR AND

IN THE SÉANCE ROOM,

WAITING IN THE PARLOR, HIDDEN IN THE CLOSET…

TRAPPED IN PHOTOGRAPHS,

FLOATING FREELY ON THE STAGE.

Ricky Jay

CONTENTS

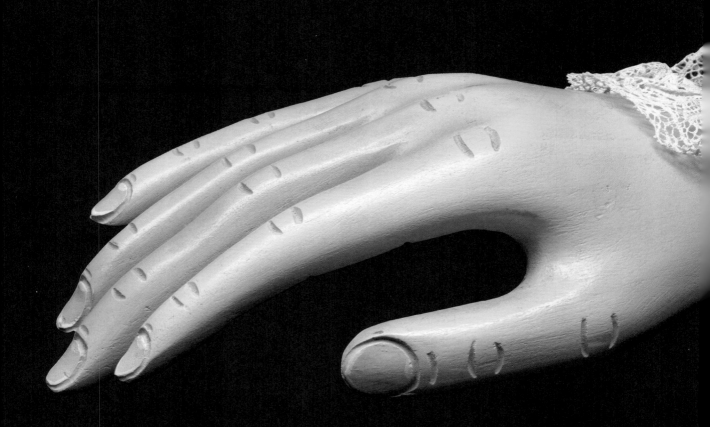

ACKNOWLEDGMENTS

CURATOR-AT-LARGE
PEABODY ESSEX MUSEUM

by GEORGE H. SCHWARTZ

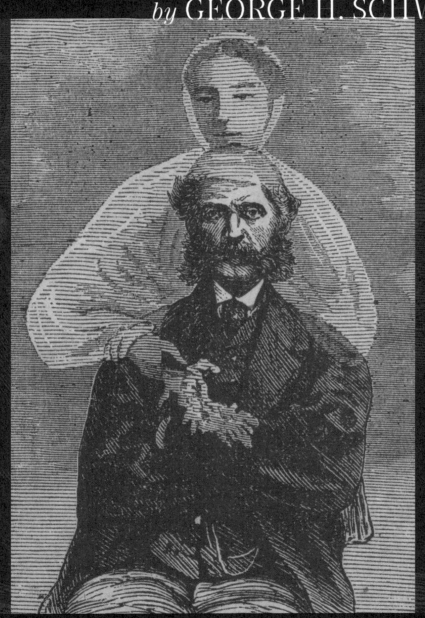

BELIEF IS AT THE CORE OF THIS BOOK AND ITS COMPANION exhibition. Whether one believes in communication with the spirit world or not, belief in the project's concept was foremost in turning an idea into a reality.

I am grateful to Jason Alexander for getting the ball rolling on this project, connecting me with John Lovick and Rob Zabrecky at the Magic Castle in Los Angeles, which helped start the engines of this endeavor. Gabe Fajuri was most generous with his time and willingness to introduce me to many collectors of both magic and Spiritualist objects and to lend to the exhibition, among other things. I am indebted to Tony Oursler for his great enthusiasm and support of this project in so many ways, from object loans to contributions to this book, and to John Gaughan for his generosity, knowledge, and dedicated interest in supporting this venture by lending works from his collection. Many other individuals graciously opened the doors to their collections, either in person or virtually, to enrich the scope of the project. I thank Bruce Averbook; Anna Thurlow Crankshaw; Brandon Hodge; Elwin, Marguerite E., and Paula B. Richter; and Doneeca Thurston at the Lynn Museum & Historical Society Collection. I am also beholden to the other institutions and individuals who generously lent works to the exhibition: Jose Alvarez; the Chrysler Museum of Art; David and Rhonda Denholtz; the Elmer L. Andersen Library at the University of Minnesota; the ESP Guitar Company; the Harry Ransom Center at the University of Texas at Austin; the Henry Sheldon Museum of Vermont History; the Houghton Library, Harvard University; the Library of Congress; the McCord Stewart Museum; the Minneapolis Institute of Art; the Missouri Historical Society; the Museum of African American History, Boston | Nantucket; the Smithsonian American Art Museum; and Shannon Taggart. I also extend my deep appreciation and sincere thanks to Steven High, Christopher Jones, Jennifer Lemmer Posey, Amanda Robinson, and their colleagues at the John and Mable Ringling Museum of Art, the second venue for the exhibition, for their many contributions to the project.

The design, production, and publication of this book have been capably directed by Loren Olson, senior editor, and her team at Rizzoli Electa, including Richard Slovak, copy editor, who ensured

consistency and clarity, and graphic designers Cara Buzzell and Lucinda Hitchcock, who provided harmony to the book's varied materials. Michelle Piranio, the book's editor, beautifully wove together and strengthened the manuscript. Thanks to Kathy Tarantola for her magical photography of Peabody Essex Museum (PEM) works and other objects, and to Laurel Mitchell, photo and permissions editor, for her efforts on image rights and reproductions. I am grateful to the authors who contributed to this volume. Additional thanks are due to Furthermore, a program of the J.M. Kaplan Fund, for its support of this book.

Exhibitions are collaborative projects that depend on the work of many dedicated staff members. I extend my gratitude to Lynda Roscoe Hartigan, The Rose-Marie and Eijk van Otterloo Director and CEO, PEM; Petra Slinkard, director of curatorial affairs and The Nancy B. Putnam Curator of Fashion and Textiles; and Daniel Finamore, associate director–exhibitions and The Russell W. Knight Curator of Maritime Art and History, for their wholehearted support.

Each member of the exhibition team contributed unique talents and skills to make this project a reality. I thank Rebecca Bednarz, editor for curatorial initiatives; Mary Butler, director of security; John D. Childs, The James B. and Mary Lou Hawkes Director of Collections; Mollie V. Denhard, head preparator; Marta Fodor, rights and reproductions coordinator; Dana Gee, technical services librarian; Betsy Hopkins, senior exhibit graphic designer; Elena Incardona, associate registrar for exhibitions; Sue Kim, chief philanthropy officer; Dan Lipcan, The Ann C. Pingree Director of the Phillips Library; Kelsey Mallet, exhibition project coordinator; Don McPhee, senior collection manager; Karen Moreau-Ceballos, associate director of exhibition design; Lan Morgan, assistant curator; Derek O'Brien, chief marketing officer; Victor Oliveira, director of merchandising; Angela Segalla, director of the collection center and collection stewardship; Hannah Silbert, director of exhibition planning; David Snider, director of learning and civic engagement; Kurt Steinberg, chief operating officer; Chip Van Dyke, associate director of media production; Whitney Van Dyke, director of marketing and communications; and Brandy Wolfe, director of institutional giving.

Many other colleagues at PEM contributed to the success of this endeavor. Thank you to Mia Alcover, Tedi E. Asher, Bethany Beatrice, Meg Boeni, Dinah Cardin, Sarah N. Chasse, Jennifer Close, Matthew

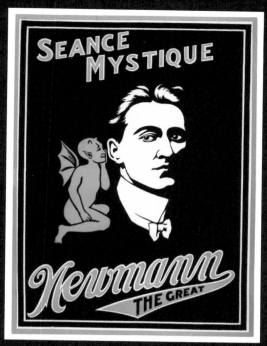

fig. 1 The Standard Printing Company, *Newmann The Great–Seance Mystique*, 1920, lithograph, 27 ¹⁵⁄₁₆ × 20 ⅜ in. (71 × 51.7 cm), McCord Stewart Museum, purchase, funds graciously donated by La Fondation Emmanuelle Gattuso, M2014.128.364

fig. 2 F. Adler, Printer, Boston, *Investigate! Do the Dead Return?*, about 1881, ink on paper, 9 ³⁄₁₆ × 3 ⁹⁄₁₆ in. (23.3 × 9.1 cm), Peabody Essex Museum, Phillips Library, BF1371 .I58

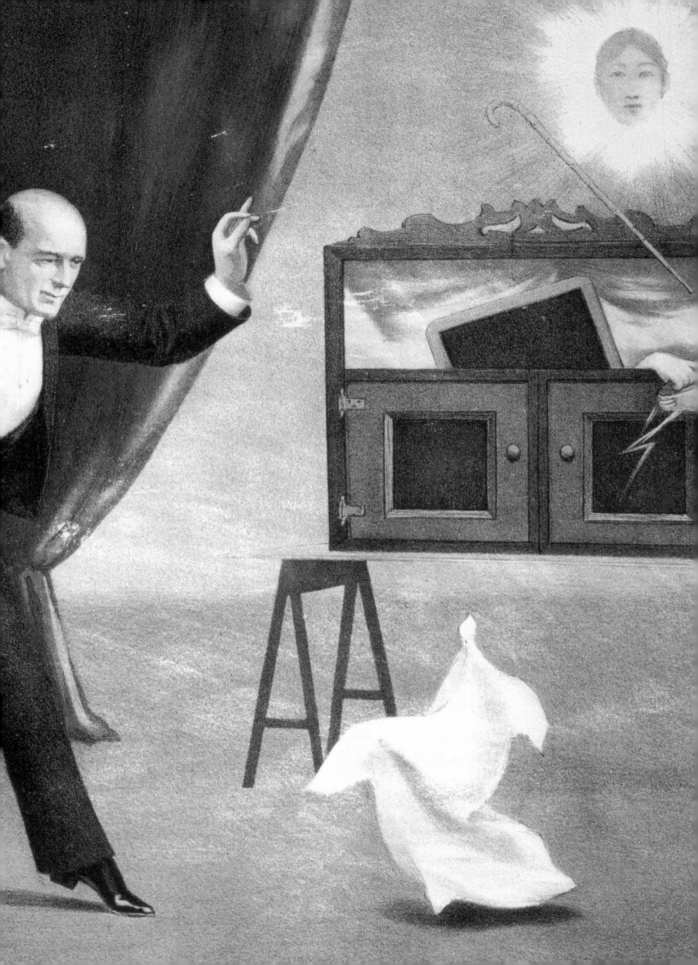

Delgrosso, Alyse Diamantides, Julie Diewald, Ellie Dolan, Lora Doughty, Patrick Doyle, Ani Geragosian, Christine Granat, Michael Hart, Caroline Herr, Jennifer Hornsby, Karen Kramer, Renata Leighton, Bronwyn McCarthy, Danielle Olsen, Sean Pyburn, Henry Rutkowski, Kathryn Smith, Trevor Smith, Chris Stepler, Stephanie Tung, Jessica Van Dam, and Meaghan Wright. Thank you also to Carmichael Art Conservation LLC and Northeast Document Conservation Center for conservation of PEM and other works, and magician Anton Andresen for developing interactive elements within the exhibition.

I also extend my appreciation to the consultants and the many individuals at public and private institutions who provided insights and research, and loan support: Peter X. Accardo, Emma Bowling, Jeff Brodrick, Cristine Burgin, Melissa Buron, Jason Busch, Beth Carter, Mike Caveney and Tina Lenhert, Jeff Chang, Jennifer Souers Chevraux, Amanda Claunch, Eric Colleary, Bevil Conway, David Copperfield, Robert Cozzolino, Simonette dela Torre, Sara W. Duke, Anne Eschapasse, Fionna Flaherty, Eva Garcelon-Hart, Emelie Gevalt, Jan Grenci, Randy Griffey, Kirk Hammett, Evelyn Hankins, George Hansen, Eleanor Harvey, Rick Heath, Melissa Ho, Margi Hofer, Anne Hyland, Tim Johnson, Andy Kolovos, Cara Liasson, Matt Masciandaro, Jessica S. McDonald, Carie McGinnis, Virginia Mecklenburg, Cristina Meisner, William D. Moore, Jennifer Mora, Leslie Morris, Nathalie Morris, Evan Northup, Elizabeth Seward Padjen, Cristian Panaite, Jane Panetta, Corey Piper, Andrew Rapoza, Thomas Rassieur, Rev. William V. Rauscher, Jill V. Rothschild, Karine Rousseau, Lauren Sallwasser, Sara Schultz, Jason Smiley, Sylvia Stevens-Edouard, Noelle Trent, Ken Turino, Christian Vachon, Shelley Venemann, Rachel Waldron, Zachary S. Wirsum, Matthew Wittmann, Gene and Jennifer Yee, Amanda Zimmerman, and Lauren Zimmerman.

Finally, thanks to my family. My father, Joel, instilled in me a love of Sherlock Holmes at an early age, and this project grew out of my curiosity in Sir Arthur Conan Doyle and his interest in the supernatural. My brother Mark, who allowed me to be his assistant when performing magic for our parents when we were kids, passed along his passion for the magical arts. To my wife, Janna, and our daughters, Hannah and Vivian, I am so grateful for your enthusiasm and support as I plunged into this fascinating world.

FOREWORD

*THE ROSE-MARIE AND
EIJK VAN OTTERLOO
EXECUTIVE DIRECTOR AND CEO
PEABODY ESSEX MUSEUM*

by LYNDA ROSCOE HARTIGAN

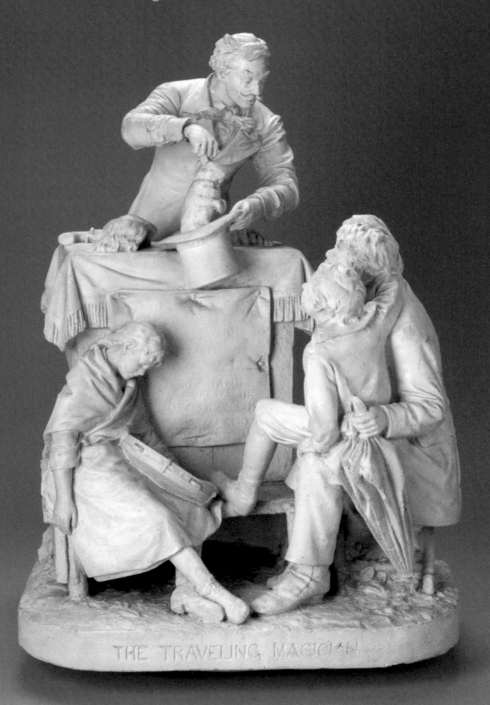

THE TRAVELING MAGICIAN

VISIBLE THINGS ALWAYS HIDE OTHER VISIBLE THINGS.
— René Magritte[1]

Spirits were in the air and the dead weighed heavily on the minds of Americans and Europeans from the mid-nineteenth to the early twentieth century.[2] Mediums and magicians delved into the supernatural and offered "communication" with the departed at séances and magic shows, two interrelated forms of popular culture that relied on works of art. *Conjuring the Spirit World* illuminates the art and objects that distinguished performances by mediums and magicians during the height of the Spiritualism movement and beyond. This international selection of paintings, photographs, posters, stage apparatuses, publications, and other objects reveals how these experiential performances entranced and mystified audiences, who, whether as believers or skeptics, navigated the intersecting realms of science and spirituality.

At the core of the appeal that Spiritualism held for Western society are the connections among belief, perception, and identity. While the age of Spiritualism and its associated performances have dwindled since the Great Depression and World War II, its central tenets continued through the twentieth century. And given the questions that still swirl around what is real or what is true, the battle between anti-Spiritualist magicians and psychic performers mirrors many of the cultural, political, and social tensions we are experiencing today.

Living as we are in a predominantly secular and rational age, understanding why so many were preoccupied with ideas of the spirit and the supernatural can be perplexing or cause for derision. Yet the capacity and need to believe is a fundamental feature of human behavior. The act of believing affords us one means of shaping and communicating our sense of self as well as our understanding of and connection to a larger context, from affinity groups to society and, yes, to the concept of an afterlife. Undeniably, the combination of neurological processes and circumstantial factors that create how and what we believe are complex and yield results ranging from truths to prejudices, and from hope to uncertainty.

fig. 3 John Rogers (1829–1904), *The Traveling Magician*, 1877, plaster and paint, 22 ⅜ × 16 ½ × 14 ¾ in. (56.8 × 41.9 × 37.5 cm), Peabody Essex Museum, museum purchase, 1924, 117654

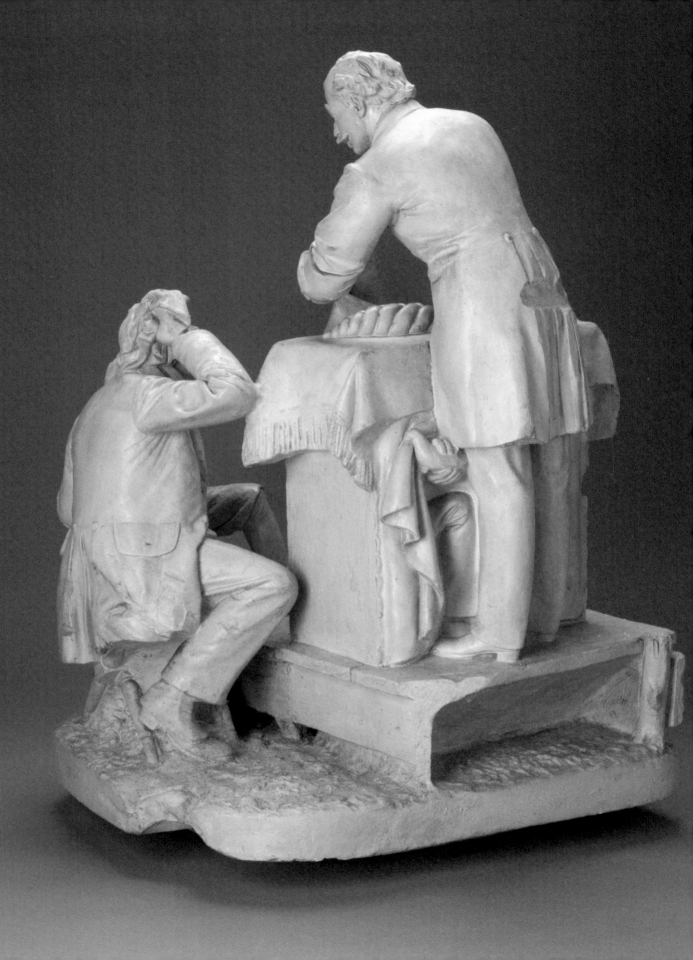

In 1931—a year representative of challenging, disconcerting times in the world—Albert Einstein observed that "the most beautiful experience we can have is the mysterious. It is the fundamental emotion which stands at the cradle of true art and true science. Whoever does not know it and can no longer wonder, no longer marvel, is as good as dead, and his eyes are dimmed."[3] From the questioning stance of "I wonder if . . ." (or why, or how) to the emotional experience of awe, wonder is a state of being human that must also be factored into how people across time, cultures, and place have navigated their curiosity and concerns about life and death and what could lie beyond.

We invite you to spend time with a specific work, *The Traveling Magician* (1877), by the Salem-born sculptor John Rogers (fig. 3). After the Civil War, Rogers created cast-plaster statues depicting aspects of American life, which were advertised in popular publications like *Harper's Weekly* and the *Atlantic Monthly*. Available by mail order at affordable prices, these "Rogers Group" statues decorated many American middle-class homes, earning the artist the honorific of "the people's sculptor." In this specific work, a devilish-looking conjurer, "Mons. Cheatum," performs for a man and a boy. According to Rogers, the magician "has the old man's hat, out of which he has taken several things, and is just now lifting out a rabbit, much to the astonishment and amusement of both."[4] A keen-eyed observer, unlike the characters in the sculpture, can spot under the table a pair of small hands holding a dove (fig. 4). This hidden assistant, seen only when one views the back of the sculpture, suggests the many layers that went into creating an illusion of objects appearing out of nowhere, one that links to the world of mediums and magicians conjuring spirits for the public.

The Peabody Essex Museum (PEM) is the ideal institution to organize this exhibition and this companion publication. Salem has historic connections to Spiritualism, magic, and witchcraft, and many of the best-known mediums and magicians—among them Harry Houdini—performed in the city in the late nineteenth and early twentieth centuries. And a project that at its heart asks us to consider the complexities of belief and wonder is

fig. 4 John Rogers,
The Traveling Magician
(*rear view*)

very much in keeping with PEM as a museum that celebrates creativity through the arts, humanities, and sciences to broaden perspectives, attitudes, and knowledge of ourselves and the wider world.

We extend deep appreciation to George H. Schwartz, curator-at-large, the organizing mind behind this mesmerizing project, and all PEM staff, whose individual talents and collaborative teamwork have brought it to lively fruition. We are delighted to share the exhibition with the John and Mable Ringling Museum of Art in Sarasota, Florida, and thank Steven High, executive director, for our partnership. We also thank Furthermore, a program of the J.M. Kaplan Fund, for its kind support of this publication. And finally, we wish to acknowledge the generous support for this project provided by Carolyn and Peter S. Lynch and The Lynch Foundation; Exhibition Innovation Fund supporters James B. and Mary Lou Hawkes, Chip and Susan Robie, and Timothy T. Hilton; and PEM's East India Marine Associates.

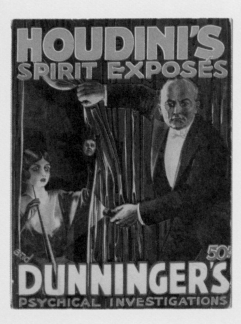

fig. 5 *Houdini's Spirit Exposés from Houdini's Own Manuscripts, Records and Photographs,* by Joseph Dunninger, *and Dunninger's Psychical Investigations,* edited by Joseph H. Kraus, 1928, 11 ¾ × 8 ⅝ in. (29.9 × 21.9 cm), Peabody Essex Museum, Phillips Library, purchase, 2023, GV1547 .D75 1928

INTRODUCTION

by GEORGE H. SCHWARTZ

"DO THE SPIRITS COME BACK?" THAT QUESTION FEATURES on a 1929 poster of magician Howard Thurston as he holds a skull in a position reminiscent of the famous scene in Shakespeare's *Hamlet* (fig. 6). Ethereal green smoke emanates from the skull's eye sockets, and the upper torso of a woman emerges from the mist. Disembodied limbs, holding a tambourine and bells, and another female head blowing a trumpet encircle Thurston's head. Imps abound, two near the magician's left shoulder, adding another layer of supernatural iconography to the scene.[1] This visual and textual ensemble would have been familiar to Americans and Europeans by the end of the 1920s, when Spiritualism was at its apex. Such bold proclamations, materializations of ghostly entities, and objects activated by mediums and magicians during performances reflected the belief system, dating to the mid-nineteenth century, that the living could communicate with the dead.

Thurston had been performing spirit-themed routines for decades when the Otis Lithograph Company of Cleveland produced this vibrant poster, the latest variation of a design created by the Strobridge Lithographing Company of Cincinnati in 1915. Apart from Thurston now looking his age, the one main addition to this version of the poster was his catchphrase "I Wouldn't Deceive You for the World." Reading that together with "Do the Spirits Come Back?," the viewer might wonder whether to believe and trust the magician or to think that this work and the performance it advertised were filled with far-fetched claims. Still, the poster enticed even the skeptical observer to buy a ticket and see the show. Thurston could certainly boast at the time that he was the greatest magician in the world, rivaling and sometimes besting his contemporary the famed escapologist Harry Houdini. Like many magicians, though, Thurston created a persona in his adult life that masked a past he did not want to reveal (just like his performance secrets): the suave, well-spoken master illusionist gave no impression of having experienced a childhood filled with abuse and crime.[2] In addition, during his stage career he was ambiguous about his belief in communicating with the dead. The poster, then,

encapsulates the visual and textual iconography of Spiritualism in the popular consciousness, and the truths and falsehoods that it unearths mirror the complex world of those who performed spirit-related acts.

Spirit mediums and stage magicians have been inextricably linked since the mid-nineteenth century. In 1848, Maggie and Kate Fox of Hydesville, New York, reported strange rapping noises emanating from the floorboards and walls in their house (fig. 7). The adolescent girls claimed that these jarring sounds, which were also heard by their parents and the throngs of curious neighbors who came to the Fox family's dwelling, were produced by the ghost of a murdered peddler buried in the cellar. Hailed for their abilities to communicate with the spirit world, the Fox sisters soon gave public demonstrations in nearby Rochester and beyond and attained celebrity status. They lit a spark in a region of western New York State labeled the "Burned-Over District," home to several new religious awakenings or revivals during the nineteenth century.[3] "The Rochester rappings," as they were dubbed, spawned the international Spiritualist movement. This socioreligious belief system's central tenet is that there is no death; spirits exist in the natural world and can be contacted through mediums like the Fox sisters, who were seen as possessing special gifts for communication with the departed. By the end of the century, this movement reportedly had millions of followers drawn to any number of Spiritualism's facets: its anti-hierarchical access to divine forces, its support of progressive causes like abolition, its alignment with scientific thought, the sense of closure it provided for those who were unable to physically mourn the dead during the Civil War (which would be repeated during World War I), and the room it opened up for women to have roles of power and agency in a male-dominated society.[4]

Six years after the Rochester rappings and one hundred miles to the west, teenage brothers Ira Erastus and William Henry Davenport from Buffalo performed a traveling ghost-communication act called the "Public Cabinet Séance," which Mark Schwartz explores in his essay on the history of the spirit

fig. 6 The Otis Lithograph Company, Cleveland, *Thurston the Great Magician—The Wonder Show of the Earth—Do the Spirits Come Back?*, 1929, lithograph, 79 ½ × 39 ½ in. (201.9 × 100.3 cm), Peabody Essex Museum, museum purchase, by exchange, 2023.14.1

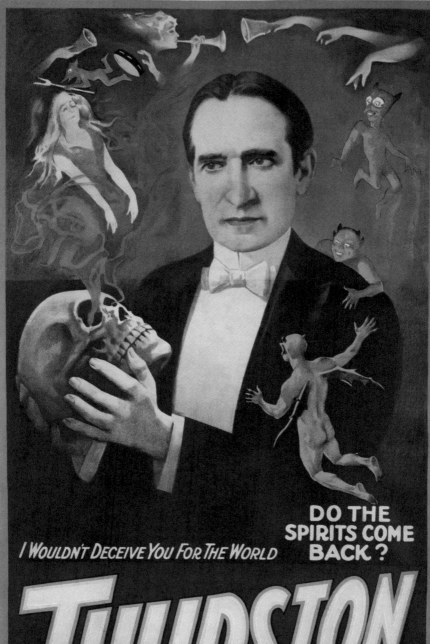

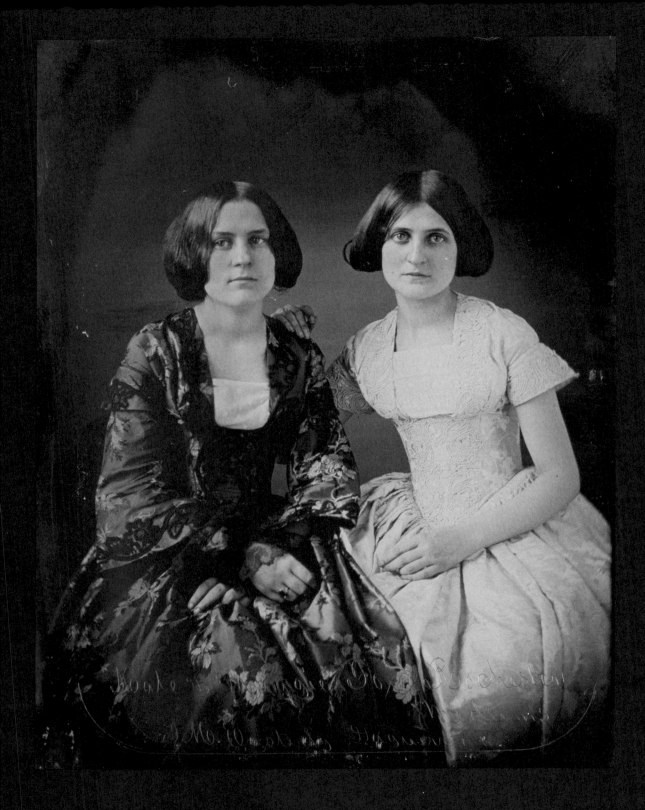

fig. 7 Thomas M. Easterly
(1809–1882), *Kate and Maggie
Fox, Rochester Mediums*, 1852,
daguerreotype, 3 ½ × 2 ½ in.
(8.9 × 6.4 cm), Courtesy of the
Missouri Historical Society,
St. Louis, N17196

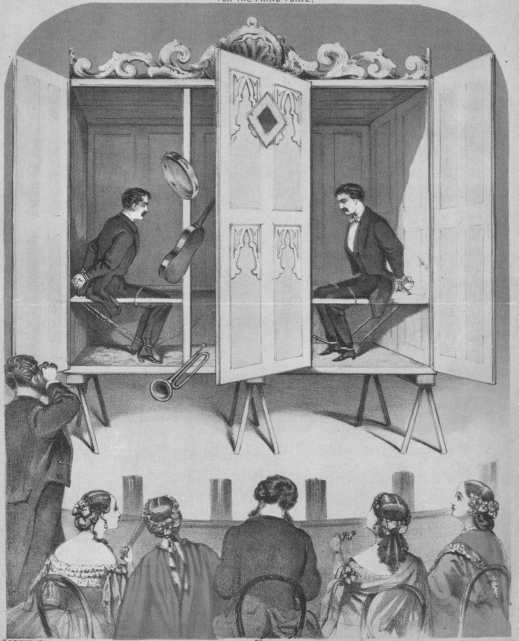

Packer (active
Davenport
ut 1865,
× 11 ¾ in.
n), Theatre and
ts Collection,

cabinet. After someone delivered a brief sermon about Spiritualism, the brothers were bound by their hands and feet and seated inside an oversize armoire with three doors filled with musical instruments (fig. 8). When the doors were closed, the audience heard the instruments sound and saw objects flying out from the box and hands emerging. When the cabinet was opened, the brothers were still tied up. The Davenport Brothers were seen as mediums by the Spiritualist community and as magicians by those who thought they were conjuring ghosts using explainable methods or simple legerdemain (sleight of hand), but the brothers never claimed to be either. They toured their spirit cabinet act in the United States, Canada, Europe, and beyond, influencing many future mediums and magicians such as Harry Kellar, "the Dean of American Magic," who began his career working for the Davenport Brothers.

Starting in the mid-nineteenth century, Americans and Europeans were entranced and mystified by two interrelated forms of popular culture that delved into the supernatural: séances (from the French for sitting or session) and magic shows. In both types of experiential performances, objects were integral to communicating with the other side. The Fox sisters, by asking a spirit to answer yes or no questions with a single or double rap, transformed house floorboards and tables into active agents in the experience.[5] The Davenport Brothers built a cabinet that mimicked a decorative piece of furniture, filled it with musical instruments, and activated the ensemble into a supernatural experience. As time went on, the demonstrations of spirit contact by mediums and magicians became more elaborate and visual. Objects that materialized the dead evolved from painted and photographic posthumous portraits into those that showed the departed or unnamed spirits hovering, comforting, or floating above a sitter, as Christopher Jones delves into in his essay on spirit photography; disembodied wooden hands tapped out answers to questions; blank canvases brought forth images of the deceased; and, in some cases, ghosts appeared before spectators' very eyes in full form or as a spectral essence, ectoplasm, oozing from the medium's mouth and other orifices.

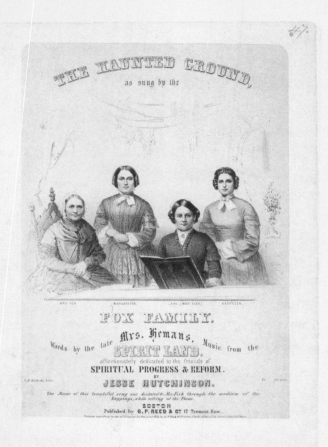

Works of visual and material culture were central to capturing the imagination of willing and skeptical audiences. Advertising broadsides and posters, books, newspapers, magazines, and other forms of print media not only promoted but also augmented and shaped these public and private demonstrations of spirit communication. The Fox sisters and the Davenport Brothers were even subjects in both song and image for sheet music created and sold at the outset of their emergence on the public stage (figs. 8, 9).[6]

As this book explores, art and objects played an instrumental role for mediums and magicians "conjuring" spirits for the public and "proving" the existence of spirits in the natural world. Mediums and magicians borrowed from and influenced each other, or railed against each other as non-believers or frauds. They were also in an ongoing competition for the same corner of the entertainment market. As Simone Natale, who specializes in media theory and history, observes, the Spiritualist movement "was closely connected to the contemporary evolution of the media entertainment industry" since mediums and Spiritualist leaders "employed some of the same advertising strategies, performance practices, and spectacular techniques that were being developed within the field of spectacular entertainments."[7] Jennifer Lemmer Posey, in her essay, looks at some of the early forms of ghostly public presentations using magic lanterns and other optical illusions.

In examining from an interdisciplinary perspective the importance that objects played in Spiritualism, belief, and illusion, this book also touches on the factors that help shape our contemporary understanding of belief systems, including the neuroscientific

fig. 10 Adelaide Herrmann
with ghosts, about 1900

underpinnings of belief and associated identities, which Tedi E.
Asher explains in her essay. Spiritualism's blurring of truth and
falsehood and the polarization that can arise from differing belief
systems are still very much a part of today's cultural landscape.

For those who study and see the world through a material
culture lens, it is not surprising that objects played a central role
in humanity's age-old desire to understand if there is life after
death. Before the inception of the Spiritualist movement, Ameri-
cans and Europeans kept loved ones "alive" and around them in
the form of death masks, portraits made from casts of the
departed, and, later, postmortem photographs, as Lan Morgan
illustrates in her essay on mourning objects. In relation to magic
performances, while a successful act is determined by the skill
of the conjurer, the focal point for the illusion is often centered
on an object that the audience expects to appear or disappear.[8]

Objects also hold a unique place in our understanding
of the past. As art historian and material culture theorist Jules
David Prown has succinctly stated, "Objects created in the past
are the only historical occurrences that continue to exist in
the present."[9] They can tell us as much, or even more, about a
culture than the written record, especially for those people who
are not represented in or who were not recording their past in
textual form. In recent decades, material culture scholars have
argued that objects have agency. Literature scholar Bill Brown
believes that objects transform into *things* when they can no
longer be taken for granted as part of the natural environment;
if the glass breaks, it asserts itself as a thing and can no longer
be ignored. "The story of objects asserting themselves as things,"
according to Brown, "is the story of a changed relation to the
human subject." Although "we look *through* objects . . . we only
catch a glimpse of things."[10] Many objects used to communicate
with the spirit world, such as furniture, went from passive
objects to active things as part of the human desire to communi-
cate with those long gone.

The objects and stories that follow highlight Spiritualism's
influence on religious, scientific, and social thought in the late
nineteenth and early twentieth centuries. Spiritualism arose

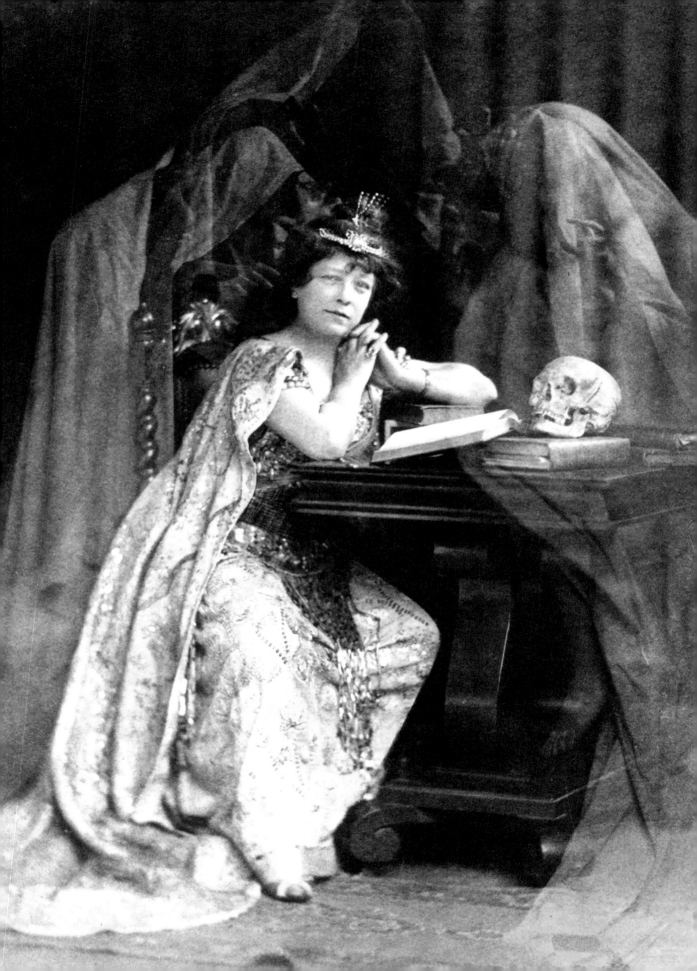

during a time when the empirical and the supernatural were thought by some people to coexist. Unlike other socioreligious movements, Spiritualists believed in science as a means for testing and proving that spirits were part of the natural world, and various branches of science and pseudoscience were established at this time. Many well-known and respected scientists of the day rallied to the cause, creating devices to test and prove theories; among these advocates was Alfred Russel Wallace, cocreator of the theory of evolution. The man most commonly associated with that theory, Charles Darwin, was in the anti-Spiritualist camp of the scientific community that led or supported the many exposés of intentionally deceptive mediums.[11]

Mediumship and magic served as a source of agency and reinvention for a diverse group of people. The Spiritualist movement started the same year, and in the same state, as the first women's rights convention in the United States, held in Seneca Falls, New York, in 1848. As Tony Oursler describes in his essay on Ethel Le Rossignol, being a medium provided women the opportunity to speak in public and to take leadership roles.[12] Although men dominated the world of magic, some women, such as Adelaide Herrmann, were as successful as, or more successful than, their male counterparts (fig. 10). Many magicians were immigrants who used their profession to forge a new identity in the United States and elsewhere, including Houdini, who was born Erik Weisz (later changed to Ehrich Weiss) to Hungarian Jewish parents in Budapest. Others, like Henry "Box" Brown, who mailed himself to freedom in 1849 in a packing crate, used magic and spirit performance exposés as a way to tell his story of an amazing escape and resurrection from enslavement in the southern United States (fig. 11).[13]

We invite the reader to keep an open mind when reading and absorbing the essays and images that follow, which, it is hoped, show that there are multiple ways of looking at humanity's desire to know the answer to the question "Do the Spirits Come Back?"

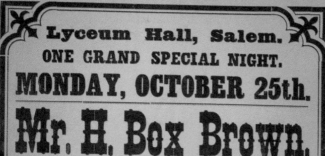

Lyceum Hall, Salem.
ONE GRAND SPECIAL NIGHT.
MONDAY, OCTOBER 25th.

Mr. H. Box Brown,

THE RESURRECTION OF

HENRY BOX BROWN.

Whose escape from slavery in 1849, in a box 3 feet 1 in. long, 2 feet wide, 2 feet 6 inches high, caused such a sensation in all the New England States, he having travelled from Richmond, Va. to Philadelphia, a journey of 350 miles, packed as luggage in a box. He has very recently returned to this country, after a lengthened tour of 25 years in England, where he has travelled extensively with various entertainments. Among these are The Panorama of American Slavery, The Holy Land, The Great Indian Meeting, the Great War between the North and South, Mesmeric Entertainments, and lastly the African Prince's Drawing Room Entertainment with which he will appear in the above Hall on Monday next.

AFRICAN PRINCE'S
DRAWING-ROOM

Entertainment

As performed in all the principal cities and towns in England.

PROGRAMME:

DESTROYING & RESTORING A HANDK'CHEF.
Astounding Feat with the Sword and Cards.
THE WONDERFUL FLYING CARD AND BOX FEAT.
BURNING CARDS AND RESTORING THEM AGAIN.
The Mysterious Cards Answering to their Names when Called.
THE MOST WONDERFUL AND MYSTERIOUS DOLL.

The Inexhaustible Hats.

The Wonderful Experiment of Passing a Watch through a Number of Boxes.

The Extraordinary Feat of the Flying Money.
THE INEXHAUSTIBLE PAN.
THE INSTANTANEOUS GROWTH OF FLOWERS,
THE ENCHANTED GLASS, &c.

This Entertainment has been highly patronised by all the nobility, gentry, Military, Clergymen, &c. of Great Britain, all of whom have spoken in the highest praise of it, as MR. H. BOX BROWN has many hundreds of testimonials from all the leading people in the Country. At the close of each Entertainment

THE IDENTICAL BOX
IN WHICH MR. BROWN ESCAPED,

Will be shown to the audience, at the same time he will give a short description of his labors and success in England with the

GREAT
...AMA

*fig. 11 Lyceum Hall, Salem…
The Resurrection of Henry Box
Brown*, 1875, ink on paper,
35 13/16 × 13 ½ in. (91 × 34.3
cm), Peabody Essex Museum,
Phillips Library, GV1547 .B76 +

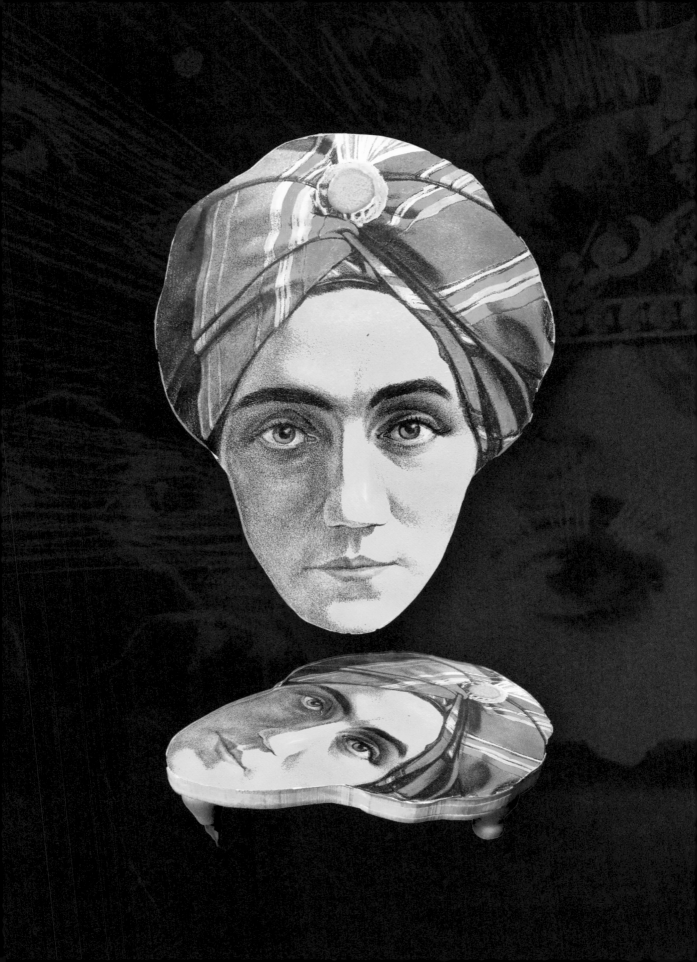

MEDIUMS, MAGICIANS, MAKERS, *AND THE* OBJECTS *USED TO* CONJURE SPIRITS

by GEORGE H. SCHWARTZ

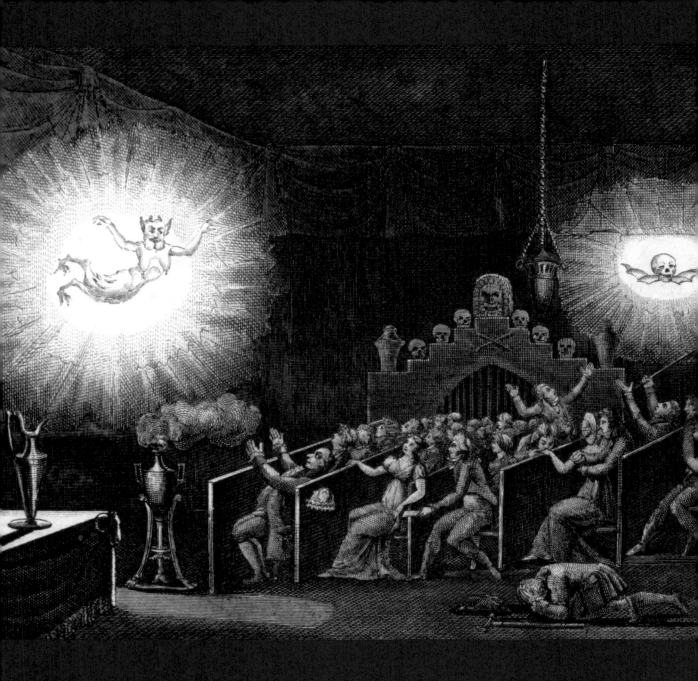

fig. 12 (*see p. 32*)
C. Alexander Publishing
Company, Los Angeles,
*Alexander's Original
Luminous Ouiji Divining
Board*, about 1920,
lithograph, wood,
11 × 6 ¼ in. (27.9 ×
15.9 cm), Collection of
Brandon Hodge

fig. 13 (*detail*)
Louis-François Lejeune
(1775–1848), after
Étienne Gaspard Robert
(1763–1837), called
Robertson, "Fantasmagorie
de Robertson dans la
Cour des Capucines
en 1797" (Robertson's
Phantasmagoria in the
Court of the Capucines
in 1797), in *Mémoires
récréatifs, scientifiques et
anecdotiques du physicien-
aéronaute E.G. Robertson*,
1831, engraving, 12 × 19 in.
(30.5 × 48.3 cm)

DECADES BEFORE THE BIRTH OF THE SPIRITUALIST

movement in the mid-nineteenth century, supernatural beings were being materialized for public entertainment. The Belgian physicist turned stage magician Robertson (Étienne-Gaspard Robert) created an immersive multi-sensory experience called Phantasmagoria, which became popular in continental Europe, Britain, and the United States by the early 1800s (fig. 13). In darkened rooms, early projectors known as magic lanterns illuminated ghostly and otherworldly figures painted on static and movable glass slides (see pp. 80, 82, fig. 69). Combined with sound, smoke, and other elements, this early "spook show" had spectators "shivering and shuddering," and caused them to "raise their hands or cover their eyes out of fear of ghosts and devils dashing towards them."[1] By mid-century, ghostly figures reached the theatrical stage as an illusionary effect commonly referred to as Pepper's Ghost. Created by English engineer Henry Dircks and perfected by fellow countryman and scientist-inventor "Professor" John Henry Pepper, the optical technique had its theatrical debut in a London performance of Charles Dickens's *The Haunted Man* in 1862. With the use of a powerful lantern and a sheet of glass positioned at a forty-five-degree angle to the audience, an image of an actor below the footlights appeared as a ghost onstage. Popular periodicals such as *Harper's Weekly* illustrated the effect, which was all the rage in Europe and America (fig. 14), and thirty years later Pepper himself published a book explaining the mechanics of this illusion, augmented with a ghostly skeleton emerging from a shroud on the cover (see pp. 84, 85, fig. 72).[2]

Away from the stage, methods existed for specters to materialize in the home, seen through stereoscopes (pp. 98–100, fig. 81) or with the aid of interactive publications. J. H. Brown argued in his anti-Spiritualist book *Spectropia* (1864) that people's perception of ghosts was caused by physiological afterimages on the eye's retina (see p. 116, fig. 99). Readers could see a variety of supernatural figures in the sixteen color plates engraved by John Filmer by staring at a dot in the image for about a quarter of a minute under strong light. When turning to a blank surface, according to Brown, "the spectre will soon begin to make its appearance, increasing in intensity, and then gradually vanishing, to re-appear and again vanish." While Brown wrote this book, he said, to extinguish "the superstitious belief that apparitions are actual spirits," newspapers advertised it as "A Novel and Unique Parlor Amusement" and "Capital Entertainment for a Dull Evening."[3]

Some performers could "reanimate" the dead. Automata, or self-propelled machines, were popular for centuries, and magicians such as the French watchmaker turned illusionist Jean-Eugène Robert-Houdin, the father of modern magic, incorporated them into performances in the 1800s. While automata were often human in form, a more ghostly version appeared at the turn of the century: a talking skull. Around 1900, the Hungarian Jewish magician Joseffy (Josef P. Freud, a distant relative of the famed psychologist Sigmund Freud) created a fully mechanical talking skull that operated like an automaton (fig. 15). He named it "Balsamo, the Living Skull" after the

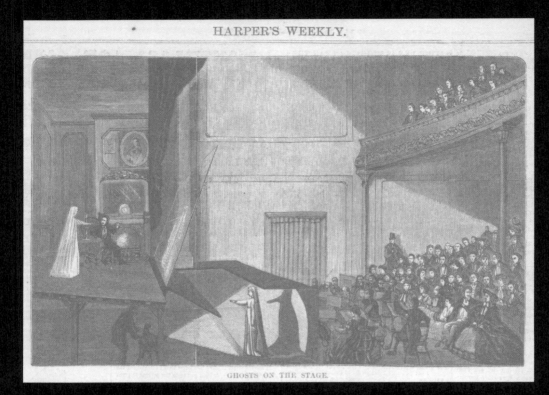

HARPER'S WEEKLY.

GHOSTS ON THE STAGE.

fig. 14 "Ghosts on the Stage," *Harper's Weekly*, April 2, 1864

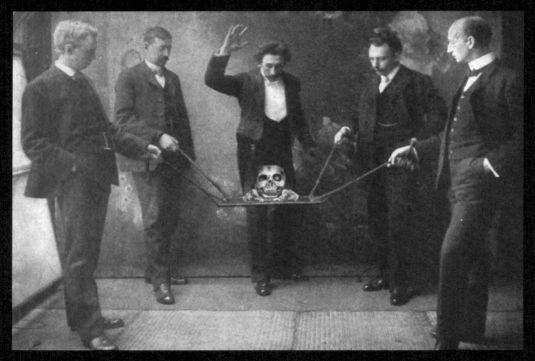

fig. 15 Balsamo, the Living Skull, with Joseffy standing behind, in *The Marvelous Creations of Joseffy*, by David P. Abbott, 1908

eighteenth-century Italian adventurer, occultist, and magician Joseph Balsamo (Count Alessandro di Cagliostro). Joseffy's mechanical marvel gave the appearance of a real skull but actually had an exterior made of copper concealing a complex motorized mechanism preset to perform a carefully orchestrated "conversation" between the magician and a suddenly animate skull. It sat upon a suspended sheet of glass and would move side to side and snap its jaw in response to questions.[4] Another version made by the German magical apparatus maker John Willmann in homage to Balsamo featured a replica skull that the magician passed around to the audience for inspection. Once returned, the magician mounted it on top of a large book. The magician would claim that the book contained all the magic secrets for his performance—which it did, housing wind-up spring motors. Since many people in the audience had touched the skull and did not detect trickery, no one suspected that the large leather-bound book was anything more than a massive magical tome.[5]

When Spiritualism emerged on the scene, the stage was already set for mediums and magicians—whose practices were often conflated in the popular imagination—to build on public interest in supernatural spectacles and optical illusions. By the 1870s, both mediums and magicians were producing physical "proof" of the spirit world through artistic means.[6]

Mediums specialized in a few methods to commune with spirits. These included paintings produced during public and private séances, cabinet effects like those of the New York–based mother-son duo Mrs. R. K. Stoddard (Jane A. Wheeler Hough Stoddard Gray Snyder) and Master Hough (Dewitt Clinton Hough) (fig. 16), and devices used to harness clairvoyant and mind-reading abilities. Some spirit mediums invented effects that magicians studied and reproduced onstage. On the other side, magicians' visually arresting advertising posters drew people to performances. Even though magicians, unlike mediums, proclaimed that they created spiritual manifestations using nothing more than explainable deception, their posters were filled with supernatural iconography.[7] Inside the theater, magicians incorporated spirit conjuring into their acts using a variety of illusionary devices. Some relied on extensive machinery such as spirit cabinets or spirit painting devices, while others used simple legerdemain.[8] Owners of magic shops such as Martinka & Co. and the Hornmann Magic Company in New York City created and

fig. 16 Salem Gazette Steam Job Press, *Mrs. R. K. Stoddard and Master Hough, Physical Test Mediums, Will Hold a Séance at Lyceum Hall, on Monday and Tuesday Evenings, February 9th & 10th...*, about 1880, ink on paper, 9 1/8 × 6 5/16 in. (23.2 × 16 cm), Peabody Essex Museum, Phillips Library, F1286.S76

purveyed material to stage magicians, while others like Ralph E. Sylvestre & Company of Chicago offered "mediums and others with the peculiar effects in this line," as described in its 1901 chapbook/catalogue *Gambols with the Ghosts*, intended for private circulation. *Mahatma*, the first magic magazine in the United States and billed as the only paper "devoted to the interest of magicians, spiritualists and mesmerism" when it appeared in March 1895, advertised spirit clocks and spirit bells among other spirit-themed apparatuses (fig. 17).[9]

In the early days of the Spiritualist movement, while inanimate furniture was suddenly echoing the voices of the dead, portrait artists, trained or untrained, were vessels for spirit communication. The New York newspaper *Spiritual Telegraph*, one of the earliest Spiritualist publications in the country, reported in 1854 that the "Spirits have...manifested a disposition to ultimate their thoughts in various artistic forms, executed in this sphere, often through the mediumship of persons who know nothing of the rules of Art, and are wholly unpracticed in the use of its implements."[10] Charles L. Fenton of Boston was one such painter, offering posthumous portraits of a different sort in an 1848 broadside: "Would it not be a high and a holy gratification, when that being has passed out of your natural sight into the spirit land, to have an image of the earthly appearance of that dear one?"[11] Fenton created his most ambitious series of spirit paintings around 1857, connected to the legend of Dungeon Rock in Lynn, Massachusetts, one of two rocky locations in this city that was a Spiritualist hotbed in the early days of the movement. According to local lore, Dungeon Rock was the site of a seventeenth-century pirate's tomb and treasure.[12] In the nineteenth century, several people attempted to blast the rock in hopes of obtaining gold, including Spiritualist Hiram Marble, who purchased a five-acre area around the fabled spot in Lynn Woods.[13]

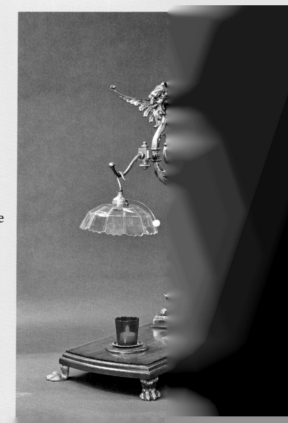

Seeking funds for what became a fool's mission (Marble never found what he was looking for), he created a museum within his cabin to attract devoted Spiritualists and the simply curious who visited Dungeon Rock from far and wide.[14] On display were artifacts from the excavation, including "an ancient broken sword, an old time dagger, and a pair of antique scissors" in addition to four paintings by Fenton depicting the spirits that local mediums said they were communicating with to guide Marble's excavation (fig. 18). These portraits depict the "amiable" pirate Thomas Veale "brandishing a formidable 'billy,'" who buried the treasure from his ship while escaping British authorities; "two ladies, the heroines of a very weak and trashy romance": Arabella, the wife of Veale, painted "in one day, under inspiration of 'spirits,'" and

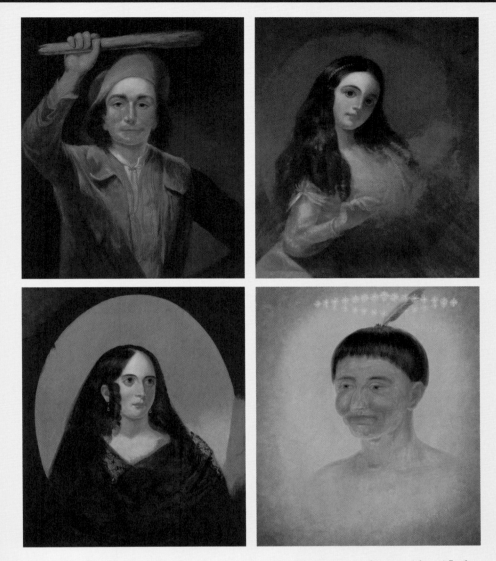

fig. 18 Charles L. Fenton (1808–1877), Spirit portraits of the pirate Thomas Veale (top left), Arabella (top right), Clorinda (bottom left), and an unidentified Native American man (bottom right), about 1857, oil on canvas, 32⅞ × 26⅛ in. (83.5 × 66.4 cm), 29¾ × 24¼ in. (75.6 × 61.6 cm), 29¾ × 24¼ in. (75.6 × 61.6 cm), 23¼ × 19⅜ in. (59.1 × 49.2 cm), Lynn Museum & Historical Society Collection, gift of Benjamin Johnson & Micajah Clough, 2362, 2369, 2363, and 2301

Clorinda, the wife of another member of Veale's crew; and an unidentified Native American spirit "who dwelt in the fabled cavern before the white men defiled it with their unholy greed for gold and jewels."[15] Of the ensemble, the portraits of Arabella and the Indigenous man exhibit visual cues pointing to "spiritual" origins: Arabella appears as if emanating from some ethereal or heavenly light, and the Indigenous man has a diamond-shaped halo above his head.[16]

Fenton's portrait of an Indigenous spirit with one feather emerging from his head and no clothing is an early example of American Spiritualists "conjuring" Native Americans in a stereotypical form, repeated by mediumistic artists into the twentieth century.[17] Sometimes, mediums materialized Indigenous people to counter the myth that they were a vanishing race and to advocate for Native sovereignty during a time of intense colonization.[18] In other instances, some mediums were exploitative when conjuring Native spirits. During cabinet stage performances in the 1870s and 1880s,

T. Warren (Lincoln) would claim to channel the spirit of Samoset, a seventeenth-century Wabanaki sagamore chief who was the first Native American to make diplomatic outreach with the Pilgrims in 1621 (fig. 19). In 1871, a Dr. Munn slipped backstage during a performance in Waterbury, Connecticut, and saw "Lincoln's arms out of the netting, probably helping the spirits."[19] Warren developed a reputation among believers and nonbelievers alike as one of the "vampires in Spiritualism" and was "frequently denounced as an imposter by spiritualistic journals." The early and influential Boston-based Spiritualist newspaper the *Banner of Light*, for example, exposed him and "his control (?)" Samoset and drove Warren out of New England to "the Southern States," where he was "palming himself off as a medium."[20]

Some spirit portraits or drawings were created with the aid of devices such as the planchette, French for "little plank," invented in Paris around 1853. Planchettes were first brought to the United States in about 1859–60 by the Spiritualist social reformer and politician Robert Dale Owen and Boston Spiritualist Dr. Henry F. Gardner. Originally a small upturned basket that could hold a pencil, planchettes developed in the United States into "a little board in shape like a heart, placed on wheels or castors, with a pencil in front," as described in period advertisements. When a person's fingers were placed on top of a planchette, it became "animated," moving "on its own accord," answering questions, talking "with you" among other "wonderful things."[21] Some mediums, including British mediumistic artist Georgiana Houghton, created artwork using a planchette, claiming that a spirit guided their hands. Most mediums used the device during automatic writing sessions—a sort of spirit dictation through a medium who was in a trance during a séance. Mediums at Spiritualist camps established in the second half of the nineteenth century in the northeastern United States and other regions of the country also used the devices.[22]

Planchettes became popular items for sale and use in the home starting in 1868, particularly those made by Kirby & Company of New York, which claimed to have sold more than two hundred thousand when they first hit the American market (fig. 20). The heart-shaped form was the most prevalent, but other styles existed, including one patented by Connecticut-born machinist and inventor Ralph S. Jennings: "Little Wonder." An 1868 advertisement in the *Montreal Daily Witness* for this "New and Popular Pastime" informed customers that they could "ask 'PLANCHETTE' any question and it will write the answer on paper in any language. It is one of the most interesting, amusing, and mysterious mediums of the present age."[23] The *Hawaiian Gazette* commented on the agency inherent in the planchette, which "by its performances has developed

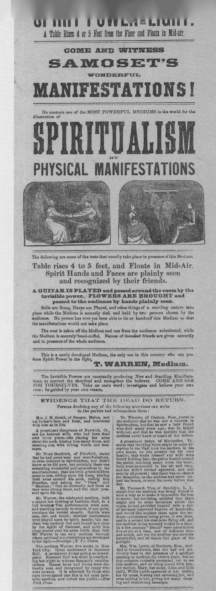

in many a belief in its supernatural powers," but for others, "it is merely a wonderful toy."[24]

Around the time that the planchette hit the American market, a new form of spirit portraiture emerged: spirit photographs (fig. 22). To our modern eyes, these images of floating, ghostly figures and entities around the living "look so fake that they must be real, and then so real that they must be fake," as journalist Dan Piepenbring describes.[25] The nascent medium of photography occupied a space between science and the supernatural in the 1860s, at a time when jarring images of bloated, dead bodies strewn across the American landscape during the Civil War inundated the nation. No longer able to mourn the dead physically at home, many looked to Spiritualism and spirit photographs as one source for comfort and closure. William H. Mumler, a Boston jewelry engraver turned amateur photographer, first introduced spirit photographs in 1861 (fig. 21). Those sitters anxious to view the dearly departed flocked to Mumler's studio and paid his exorbitant fee of ten dollars (the average price for a studio portrait was twenty-five cents). One of his photographs featured William Lloyd Garrison, publisher of the antislavery newspaper *The Liberator*, with the ghost of former United States senator Charles Sumner behind him. Sumner's spirit holds broken shackles over Garrison's right shoulder, denoting the work of both men as ardent abolitionists (fig. 23). Garrison was also a Spiritualist and would often publish articles related to the movement, while Spiritualist newspapers in turn ran antislavery essays. The practice of spirit photography and the market for such supernatural portraits spread throughout America, Europe, and beyond well into the twentieth century.[26]

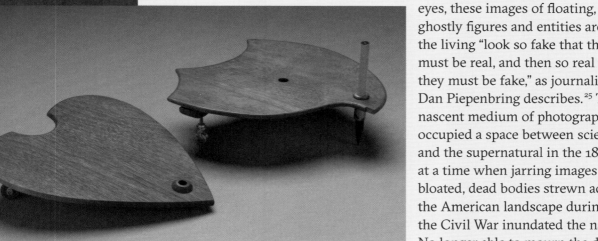

Around the turn of the twentieth century, spirit portraits turned into something even more surprising and otherworldly for believers—or, for skeptics and magicians, involving more intricate deceptions. Whereas previously some mediumistic artists painted what the spirits "instructed" them to, a portrait now would suddenly appear on a blank canvas during a séance or performance.[27]

fig. 20 (*left*) Kirby & Company, New York, *Kirby's Planchette*, 1868, wood and metal, 1¾ × 7½ × 6⅞ in. (4.5 × 19.1 × 17.5 cm), Peabody Essex Museum, gift of Margaret H. Jewell, 1925, 117946.1

(*right*) Ralph S. Jennings (1833–1886), *Little Wonder; or Planchette Improved*, 1868, wood and metal, 2½ × 8⅛ × 7 in. (6.4 × 20.6 × 17.8 cm), Peabody Essex Museum, gift of Margaret H. Jewell, 1925, 117946.2

fig. 21 F. A. Searle, Printer, Boston, *W. H. Mumler the Celebrated Spirit Photographer with His Wonderful Spirit Pictures and Lecture on Spirit Photography*, 1869, ink on paper, 8¼ × 6³⁄₁₆ in. (21 × 15.7 cm), Peabody Essex Museum, Phillips Library, BF1381.M86

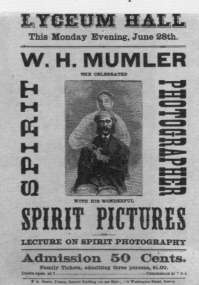

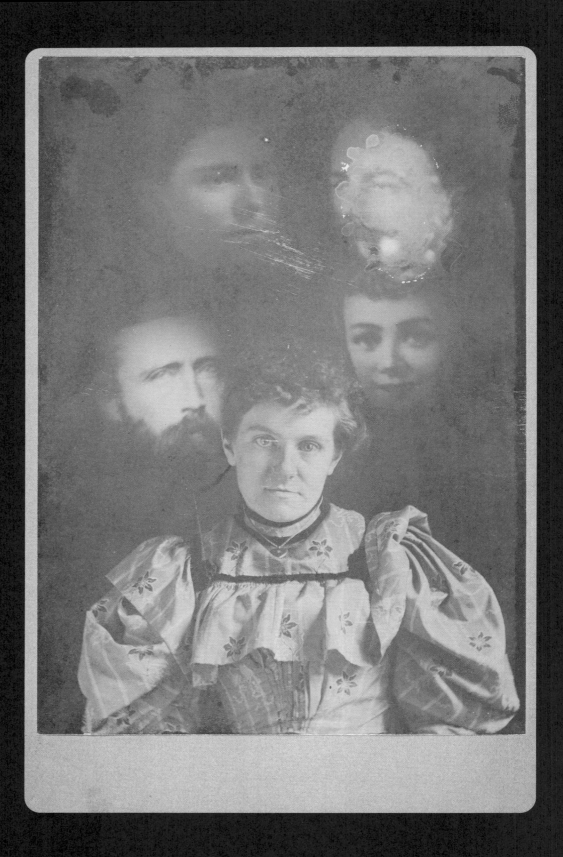

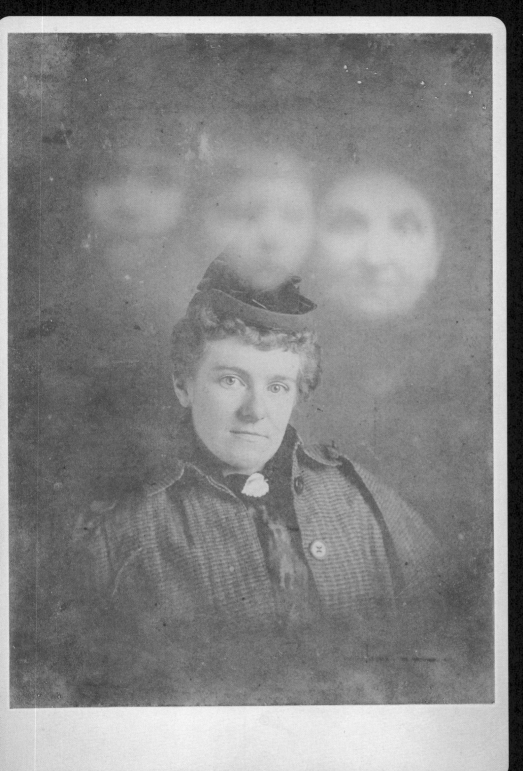

fig. 22 Spirit photographs of Lillie May Tittle Pepper of Beverly, Massachusetts, late 19th to early 20th century, gelatin silver prints, each 6 ½ × 4 ¼ in. (16.5 × 10.8 cm), Peabody Essex Museum, Phillips Library, gift of Daniel R. Fuller, 1991, MSS 1940, box 2, folder 4

Among the most well-known, and most scandalous, practitioners of this new type of spirit painting was Ann O'Delia Diss Debar. Born in Kentucky as Editha Salomen, she claimed she was the daughter of King Ludwig I of Bavaria and took on many aliases throughout her life. In 1888, *Frank Leslie's Illustrated Newspaper* discussed her methods when reporting on her trial for defrauding the widowed New York City lawyer Luther R. Marsh (fig. 24). Debar materialized seventy-five spirit paintings, including one of Marsh's late sister-in-law Catharine Stewart. Her technique was viewed either as complex, using chemicals to hide a pre-painted portrait, or as "quite ordinary," having a sitter, "her dupe, hold a blank canvas over his head, and gaze intently into a mirror" while "a picture previously prepared is substituted for the blank canvas—and so the spook-portrait 'comes.'"[28]

The businessman turned magician David P. Abbott from Omaha studied Debar's methods and those of Mary "May" Bangs and Elizabeth "Lizzie" Bangs of Chicago.[29] Abbott invented many successful spirit-themed illusions and authored exposés of dubious mediums. In his 1913 book *The Spirit Portrait Mystery*, he concluded that the Bangs sisters made a painting in advance that was "substituted or introduced in some way" before the end of a séance. The sisters would start their sessions with two blank canvases faced together "to have the front one conceal from the sitter what happened to the one behind it." Abbott concluded that the switch occurred at the outset, since "in magic, substitutions always take place early in the performance."[30] In turn, he created a spirit painting apparatus based on this principle. Howard Thurston performed this routine for audiences "under direct authority" from Abbott, as noted in an alluring advertising poster where spirits assist him in creating a likeness of Napoleon (fig. 25).[31] In reality, the apparatus used incandescent illumination to backlight a painted portrait behind a blank canvas, thus giving off the appearance of it materializing before an audience's very eyes (fig. 26).

One of the premier makers and dealers of spirit painting apparatuses and other spirit-themed illusions in the second quarter of the twentieth century was Floyd G. Thayer's magic company in Los Angeles. According to Gardner Bradford, writing about the shop at the time, it was "the source and fountainhead of much of the world's black arts, occultism, metaphysics, spirit messages and other supernatural manifestations that make humanity shiver and gape." Thayer's shop created an extensive line of spirit-related products ranging from spirit cabinets to slates "which materialize spirit messages," spirit paintings, "trumpet signals from the spirit world," and astral bodies "that whisper of things on the farther side of

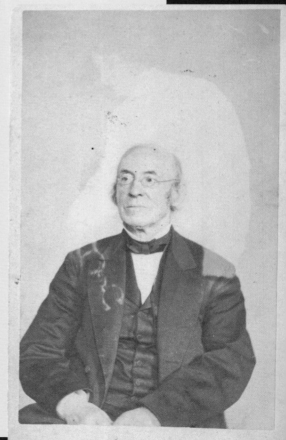

fig. 23 William H. Mumler (1832–1884), William Lloyd Garrison and the spirit of Charles Sumner, 1874, albumen silver print, 3¾ × 2¼ in. (9.5 × 5.7 cm), Museum of African American History, Boston | Nantucket, 2010.03.09

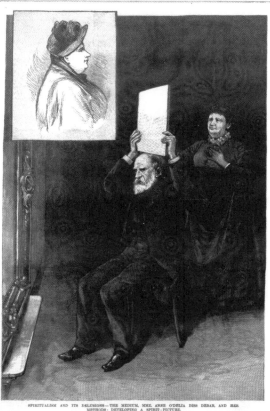

SPIRITUALISM AND ITS DELUSIONS—THE MEDIUM, MME. ANNE O'DELIA DISS DEBAR, AND HER METHODS: DEVELOPING A SPIRIT-PICTURE.
FROM SKETCHES BY A STAFF ARTIST.—SEE PAGE 156

fig. 24 "Spiritualism and Its Delusions—The Medium, Mme. Anne O'Delia Diss Debar, and Her Methods: Developing a Spirit-Picture," in *Frank Leslie's Illustrated Newspaper*, April 21, 1888, 16 × 11 in. (40.6 × 27.9 cm)

death," among other supernatural devices. It sold products to "magicians, mediums and masters of legerdemain" across the globe to "thrill and frighten the mystified millions." Thayer firmly believed that "there is not a single manifestation from the world beyond the grave that cannot and has not been duplicated by mechanical means," but when Bradford asked if he thought all séances and mediumistic activities were fake, Thayer clarified that "there are things that happen in our daily lives which seem to indicate a hereafter of some sort, though just what it is, I would not venture to guess."[32]

Thayer's shop made many of the apparatuses for one of the most successful twentieth-century magicians, Claude Alexander Conlin, known on the stage as "Alexander, the Man Who Knows." Born in South Dakota, Alexander spent the summer of 1897 at the Spiritualist camp Lily Dale in upstate New York (not far from the home of the famous Fox sisters), working as a boat boy taking care of the canoes during the day. At night, mediums who held meetings in the boathouse taught him the tricks of their trade plus the psychology around mediumship that would heavily influence Alexander's act.[33] Alexander hired artists to produce captivating advertising posters for his shows. Frederic Eugene "Kid" Jones, a miniaturist and aura portraitist, produced the simple yet captivating posters of Alexander's turbaned head with his eyes transfixed on the viewer (fig. 27). Jones, like many artists who created works for major lithographic companies in the late nineteenth and early twentieth centuries, was not credited on the posters. Instead, the words "AV Yaga Bombay" often appeared, meant to augment the faux South Asian origins of the magician's act and costume.[34] Alexander was one of the highest-paid magicians of his time, and he used mail order to his advantage, selling many devices for "conjuring" spirits (fig. 12; see p. 32), occult literature, and pseudo-psychology books. His keen business sense and suave demeanor onstage hid a dark past of criminal behavior, misogyny, and bigamy, making him one of the most infamous conjurers in the history of magic.

Alexander, like many magicians, began his performances with a clear disclaimer that "there is nothing supernatural" about him or his routines,

before commencing with several spiritualistic effects using Thayer-made devices. For his spirit painting routine, he would "print the pictures of anyone" the audience had written down on cards before the show started, "producing…quite credible portraits of persons not present upon blank canvases, without a stroke of the brush that any one can see." As a *Los Angeles Times* reviewer described, "Two such canvases are put face to face in a frame with an electric light behind them, left there for a few moments, and behold! When they are taken out again there is your portrait. But the most interesting part of it is watching the image grow, and the fact that at first the eyes of these faces are closed and only open when the image has reached completion."[35] The performance concluded with the Man Who Knows crystal-seeing mentalist act, which Alexander attributed not to supernatural powers but to "highly trained psycho-intelligence and intense concentration on each question submitted to him."[36] His "psycho-intelligence," however, was actually a mixture of techniques that are still used by mentalists, psychics, and mediums today: cold reading, or reading a person's body language, and hot reading, the gathering of background material on a person in advance. In Alexander's case, his assistants offstage relayed information to him through a wireless radio communication system planted in his turban (another Thayer creation).[37]

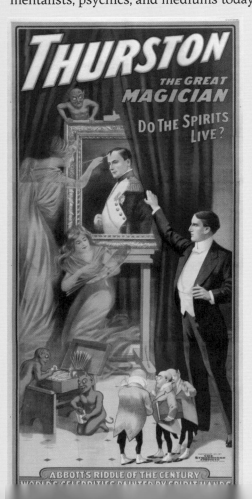

fig. 25 The Strobridge Lithographing Company, Cincinnati & New York, *Thurston the Great Magician— Do the Spirits Live?*, 1911, lithograph, 81⅛ × 38⅛ in. (206 × 96.8 cm), McCord Stewart Museum, purchase, funds graciously donated by La Fondation Emmanuelle Gattuso, M2014.128.908

fig. 26 Thayer Magic Manufacturing Company, Los Angeles, Spirit painting, about 1930, wood, gesso, oil on canvas, electrical cord, metal, and glass, H. 63 in. (160 cm), painting 19¼ × 15 in. (48.9 × 38.1 cm)

fig. 27 AV Yaga, Bo (attributed to Frede Eugene "Kid" Jones *Alexander: The Man Knows*, 1915, lithogr 42¹¹⁄₁₆ × 28³⁄₁₆ in. (71.6 cm), Peabody Museum, museum purchase, by excha 2023.23.1

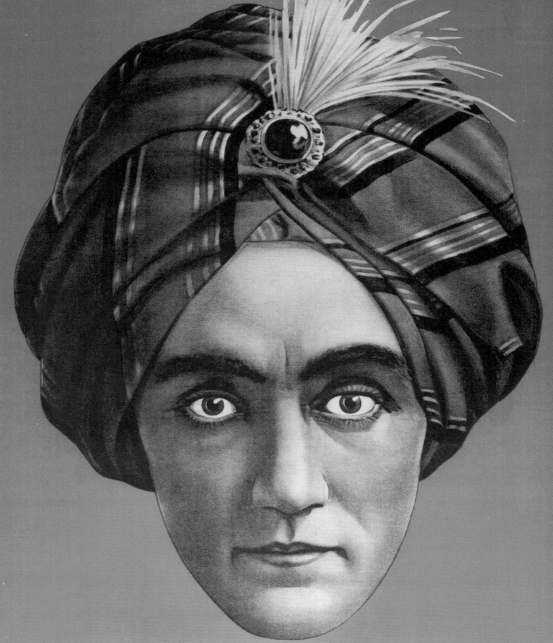

ALEXANDER

THE MAN WHO KNOWS

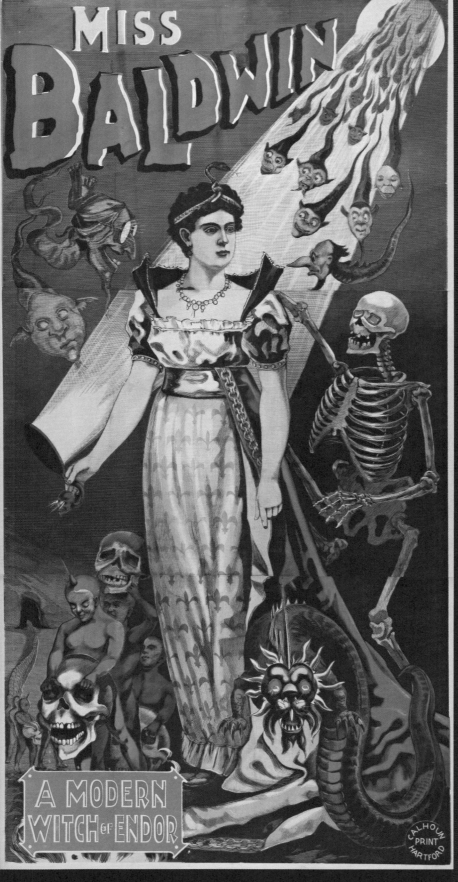

MISS BALDWIN

A MODERN
WITCH of ENDOR

fig. 28 Calhoun Print Company, Hartford, *Miss Baldwin, a Modern Witch of Endor*, about 1890, lithograph, 81 7/16 × 41 3/16 in. (206.8 × 104.6 cm), McCord Stewart Museum, purchase, funds graciously donated by La Fondation Emmanuelle Gattuso, M2014.128.29

CALHOUN PRINT HARTFORD

One of the first female clairvoyants was the British-born magician Kitty Baldwin (born Kate Russell). She traveled the world in the late nineteenth century with her husband, Samri Baldwin, an American magician who became one of the most outspoken early skeptics of Spiritualism.[38] Their performances included many exposés of spirit-related manifestations, usually with the disclaimer that no supernatural powers were involved. Reviews of her performances noted a lack of supernatural abilities, but one writer believed that "the marvellous impressions she receives and imparts prove that telepathy is a great deal more than a theory."[39] The poster advertising Kitty Baldwin's performances certainly supported a belief that there was something otherworldly involved in her act (fig. 28). Supernatural creatures abound, and her appellation by the press as "A Modern Witch of Endor" is rooted in the connections between spiritualistic practices and witchcraft dating to biblical times. In the first book of Samuel (1 Samuel 28:7–20), King Saul visits a medium—the witch of Endor—to conjure the spirit of the prophet Samuel, which was forbidden according to biblical law. Artists have depicted this scene for hundreds of years, among them the American painter William Sidney Mount. His 1828 rendition captures the same fervor he would later show for the Spiritualist movement, with the medium in the center as a powerful entity and the focal point of the scene (fig. 29).[40]

Some clairvoyant mind readers during this period did "claim" supernatural powers. American Ava Muntell (born Ivy Munn) performed cabinet séances and mind-reading acts during the early twentieth century.

fig. 29 William Sidney Mount (1807–1868), *Saul and the Witch of Endor*, 1828, oil on canvas, 36 × 48 in. (91.3 × 122 cm), Smithsonian American Art Museum, gift of International Business Machines Corporation, 1966.48.1

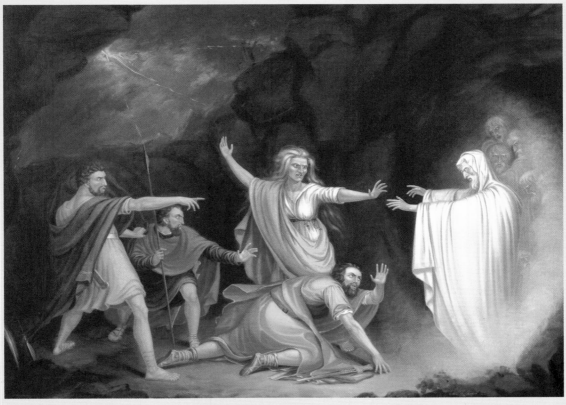

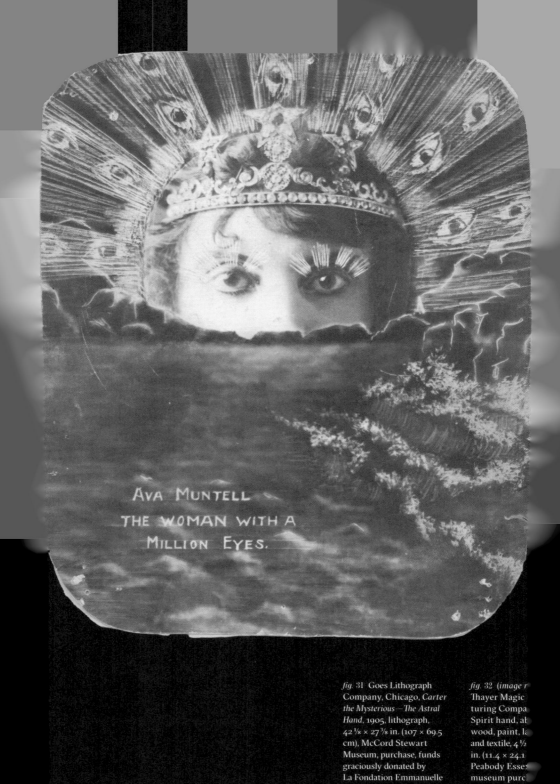

AVA MUNTELL
THE WOMAN WITH A
MILLION EYES.

fig. 31 Goes Lithograph
Company, Chicago, *Carter
the Mysterious —The Astral
Hand*, 1905, lithograph,
42 ⅛ × 27 ⅜ in. (107 × 69.5
cm), McCord Stewart
Museum, purchase, funds
graciously donated by
La Fondation Emmanuelle
Gattuso, M2014.128.87

fig. 32 (image r
Thayer Magic
turing Compa
Spirit hand, ab
wood, paint, la
and textile, 4 ½
in. (11.4 × 24.1
Peabody Esse
museum purc
exchange, 202

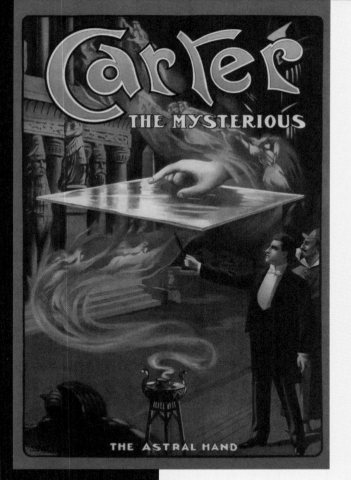

THE ASTRAL HAND

She was billed as "The Woman with a Million Eyes," "The Great Spiritualistic Phenomena," and "One of the Psychic Wonders of the Age," among many monikers, augmented by captivating visual advertising (fig. 30).[41] During a 1914 performance in Youngstown, Ohio, Muntell purportedly "predicted the sinking of the *Empress of Ireland*," warning a questioner not to take passage, "as not only would the ship be wrecked, but that the loss of life would be almost as great as that of the *Titanic*." During another evening, she predicted "the size of families, told inquiring lovers when they would marry, said the Mexican war would be settled peaceably by fall … and answered dozens of other queries." Her hands were then tied to a board when she was seated inside a spirit cabinet where "different articles placed inside were rattled and thrown out."[42] Like Alexander, Muntell advertised products for sale through mail order. One was a booklet for thirty cents aimed at Spiritualists, "written under control messages of the new era," where the reader could learn to get spirit messages in their homes and "build a wall of protection from evil influence."[43]

The American magician Charles Carter, known onstage as Carter the Great, was said to "out-clairvoyant the clairvoyants," sending "his audience away wondering if there be unseen spirits that travers the air … and thoughts that fly from person to person, unspoken, telepathic."[44] One of the featured routines during his career was "the Astral Hand," a version of the spirit-rapping hand that had been performed by mediums and magicians since the mid-nineteenth century.[45] One of many made by Thayer's magic shop, this disembodied woman's hand with a Victorian lace cuff was described as "a mysteriously endowed block of carved wood, which,

placed upon a sheet of glass, acts with an intelligence that is startling" (fig. 32).[46] Another reviewer noted that Carter would place the hand on a piece of glass held up by the back of two chairs, and it would rap "out answers to questions fired by the audience . . . in response to the magician, who stands yards away."[47] The poster for Carter's Astral Hand heightens the supernatural aspects of the illusion (fig. 31). In front of a Near Eastern–style temple, an oversize hand appears to emerge from a mist emanating out of an urn. It hovers just above an oversize sheet of glass with Carter below, who extends his wand upward to control either the hand or the spirits, or both. A devilish goateed figure in a red cloak and hat stands behind Carter, adding another layer to the supernatural scene.

Along with elaborate apparatuses and methods for materializing spirits, mediums and magicians continued to use seemingly ordinary objects such as schoolhouse slates. The British medium William Eglinton was one of many who specialized in slate writing. He would sandwich a piece of chalk between two blank writing slates at a séance table or on the stage, then hold it above while the sound of scratching was heard. When pulled apart, messages "appeared" in answer to a sitter's or audience member's question. Eglinton and the American medium Henry Slade were two of the most well-known mediums using this technique in the last quarter of the nineteenth century; they also were "caught cheating" and prosecuted for fraud.[48] Slate writing became a popular form of spirit communication, and magic shops sold slates designed to be performed in different ways as well as books that exposed several techniques for this "supernatural" illusion (fig. 33).

Eglinton also purportedly conjured full apparitions of spirits. The Dutch natural history illustrator John Gerrard Keulemans, an honorary associate of the Society for Psychical Research in London, created eight chromolithographs in 1885 of Eglinton from "original pencil sketches, water-colour, and crayon drawings, prepared immediately after the séances."[49] Keulemans's work was considered "exquisite . . . representing spirit lights, the appearance of materialized hands on the luminous slate, and the various stages of materialization."[50] Four of them show the medium in a trance conjuring an apparition: an otherworldly visual spectacle rendered in a sort of cinematic sequence (fig. 34). Keulemans wrote that his objective was "to illustrate the gradual formation of a 'substantial spirit,' as seen in a reduced light; . . . representing some of the various stages of the gradual development of a 'form.'"[51] The French artist James Tissot, who dabbled in mysticism and the occult, attended one of Eglinton's séances in London on

fig. 33 Spirit Slate Writing and Kindred Phenomena, by William Ellsworth Robinson, 1898, 7 3/4 × 5 3/8 in. (19.7 × 13.7 cm), Peabody Essex Museum, Phillips Library, purchase, Library Acquisition Fund, 2022, BF1290 .R63 1898

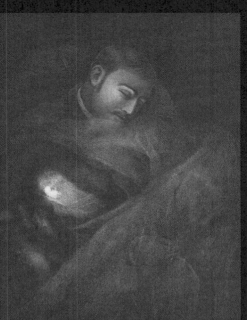

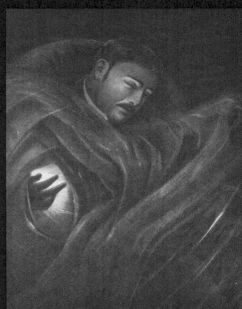

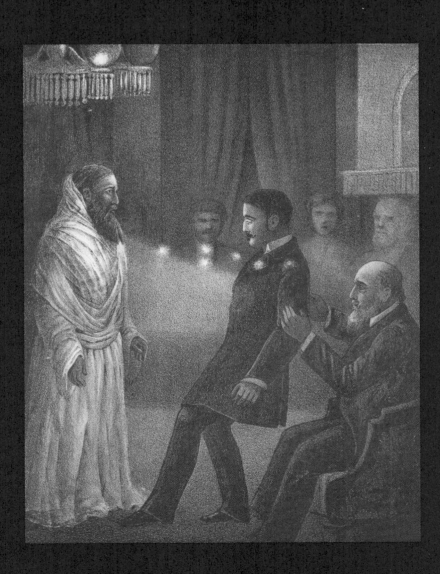

fig. 34 John Gerrard Keulemans (1842–1912), "Phases of Materialisation No. 1–3" and (*below*) "An Apparition Formed in Full View," from *'Twixt Two Worlds: A Narrative of the Life and Work of William Eglinton*, by John Stephen Farmer, 1886, lithographs, each 11 ⅝ × 9 ¼ in. (29.5 × 23.5 cm), Peabody Essex Museum, Phillips Library, purchase, 2023, BF1027.E4 F3 1886

May 20, 1885. During this sitting, Tissot claimed to see the spirit of Kathleen Newton, his late lover and muse, with Ernest, Eglinton's spirit guide. Tissot created a painting and a mezzotint documenting this profound experience; he exhibited the print in the offices of the London Spiritual Alliance along with works by Keulemans (fig. 35).[52]

The trance state shown in Keulemans's lithographs was used by many mediums at a séance to "communicate" with the spirit world. Once in that altered state, the medium might speak in a different voice; voices would seem to emanate through devices such as spirit trumpets, invented by the Ohio medium Nahum Koons in the early 1850s, which "amplified" the utterances of the dead (fig. 36); or physical proof of spirits would materialize, such as ectoplasm (often gauze covered with phosphorescent paint) (fig. 37).[53] Some, like the Italian medium Eusapia Palladino, would appear to move or levitate objects like tables through no apparent physical effort (fig. 38).

Palladino was one of several mediums who agreed to tests by scientists to prove that her abilities were supernatural. In the mid-nineteenth century, the rapid pace of scientific discovery and technological innovation affected Americans and Europeans in many ways. Spiritualism, with its progressive, anti-authoritative structure, was one of the few religious movements that embraced science and aligned itself with technological progress as a means of proving that spirits existed in the natural world. Samuel F. B. Morse's single-wire telegraph allowed communication between two distant points through unseen forces transmitted by wires, causing an inanimate telegraph key to click. Spiritualists argued that they had established a "spiritual telegraph" between the living and the dead, with the medium as the conduit and rapping noises as the communication code. The masthead of the *Spiritual Telegraph*,

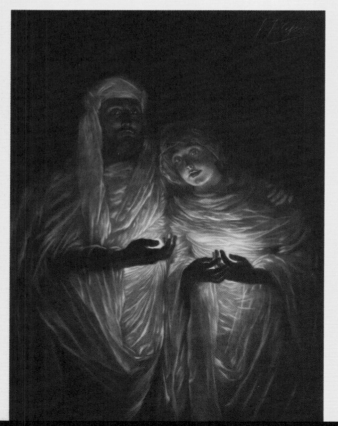

fig. 35 James Tissot (1836–1902), *L'apparition médiunimique* (The Mediumistic Apparition), 1885, mezzotint printed in black ink on Japon pelure paper, 25 5/16 × 19 3/8 in. (64.3 x 49.2 cm), Minneapolis Institute of Art, The Richard Lewis Hillstrom Fund, 2016.106.1

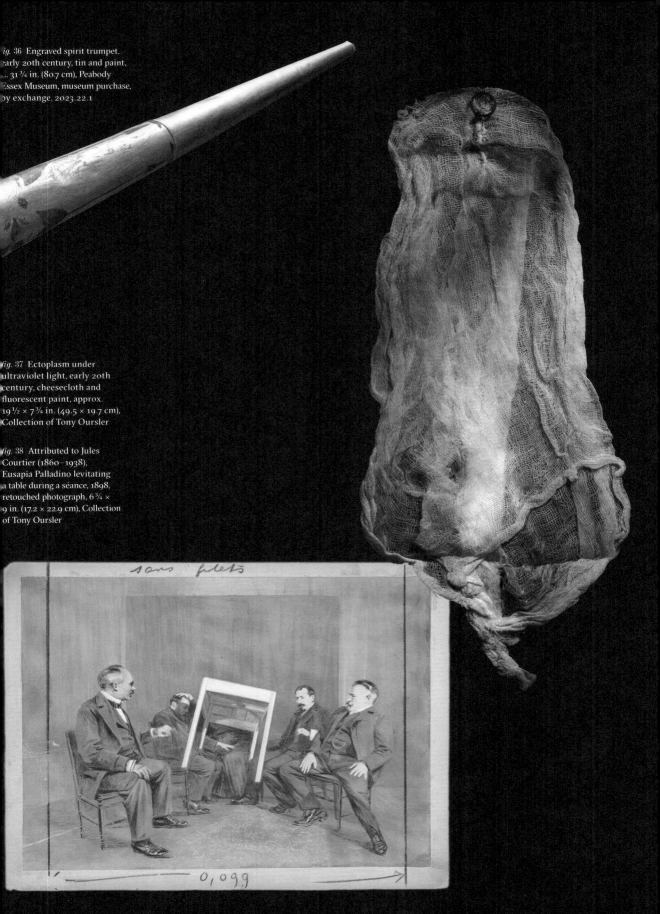

fig. 36 Engraved spirit trumpet,
early 20th century, tin and paint,
... 31¾ in. (80.7 cm), Peabody
Essex Museum, museum purchase,
by exchange, 2023.22.1

fig. 37 Ectoplasm under
ultraviolet light, early 20th
century, cheesecloth and
fluorescent paint, approx.
19½ × 7¾ in. (49.5 × 19.7 cm),
Collection of Tony Oursler

fig. 38 Attributed to Jules
Courtier (1860–1938),
Eusapia Palladino levitating
a table during a séance, 1898,
retouched photograph, 6¾ ×
9 in. (17.2 × 22.9 cm), Collection
of Tony Oursler

created by the New York artist and engraver John William Orr, cemented this link between science and the supernatural. Below a rendering of Earth and above the publication's name are leafy branches; the one above "Spiritual" looks withered, while the one over "Telegraph" appears healthy and strong, perhaps denoting the communication between the dead and the living (fig. 39).[54]

A number of scientists invented devices to test the paranormal abilities of mediums. In 1855, the celebrated American chemist Robert Hare created what he considered to be foolproof testing technology: Spiritoscopes. One featured a wood board holding a vertical cast-iron dial with the alphabet around the outer edge, the numbers 1 through 9 underneath, the words "Yes" and "No," and several phrases (figs. 40, 41). A medium would sit behind the device and roll it back and forth across a table, where a series of pulleys would rotate the pointer, spelling out messages "from the spirits." While many people thought the empirical and the supernatural coexisted, Hare came into his experiments as a skeptic. His devices, however, turned him into a firm believer in Spiritualism. Many colleagues shunned Hare, believing the elderly scientist had been duped, and Spiritualists distrusted him because of the original intentions of his experiments.[55] Decades later, magicians would play off the connections between science and the spirit world. Thayer's magic shop created Spirito in 1924, advertised as "the radio that tunes in on the 'mysterious unknown'" (fig. 42). Thayer claimed "nothing

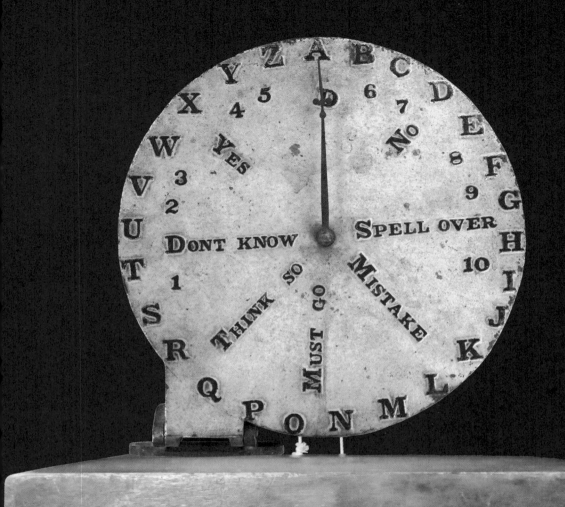

fig. 40 Robert Hare (1781–1858), Spiritoscope, about 1855, wood and metal, 10 × 11 × 12 in. (25.4 × 27.9 × 30.5 cm), Collection of Brandon Hodge

fig. 41 "Plate IV" in *Lecture on Spiritualism: Delivered at the Tabernacle, in the City of New York, in November, 1855, Comprising an Account of the Manifestations Which Induced the Author's Conversion to Spiritualism*, by Robert Hare, 1856, lithograph, 5 7/8 x 8 3/4 in. (14.9 x 22.2 cm), Peabody Essex Museum, Phillips Library, BF1272 .H37

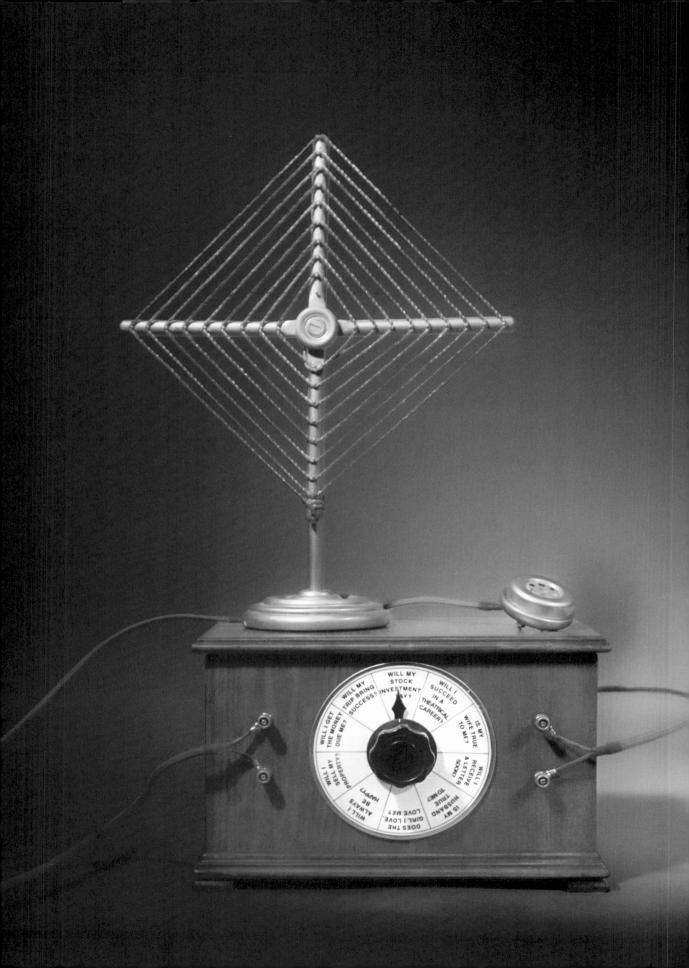

supernatural for Spirito" apart from being "the master scientific marvel of the age!"[56] Spirito's exterior exuded cutting-edge technology: a dial with questions that a volunteer could select and an earphone and antenna on top, both connected to the front with wires. The inside, though, was completely empty apart from a hidden coil that wirelessly transmitted the voice of an assistant offstage as "the spirit."[57]

On the other side of the Atlantic, the respected British chemist and physicist Sir William Crookes tested several mediums as part of high-profile cases. Known for his vacuum tube, called the Crookes tube (later utilized in the development of X-rays), Crookes took interest in Spiritualism in the 1860s and attended séances after losing his brother in 1867.[58] He performed experiments on two well-known mediums in the 1870s. One was the British medium Florence Cook, who apparently brought forth a spirit named Katie King, as documented by *Frank Leslie's Illustrated Newspaper* (but which turned out to be Cook or an accomplice) (fig. 43). The other was American Anna Eva Fay (born Ann Eliza Heathman), "the Indescribable Phenomenon," whose spirit cabinet act in which she materialized phenomena while being bound to a hitching post influenced many performers into the twentieth century. On a double-sided broadside for Fay's performance in Salem in 1881, the reverse contains a diagram of Crookes's galvanometer-centered device used to test Fay, followed by a long account of his findings, which he believed "proved" Fay could communicate with the dead (Fay purportedly admitted in confidence to deceiving Crookes) (fig. 44).[59] Crookes thought the results validated the legitimacy of spirit communication, while his colleagues considered his efforts humiliating.

August 22, 1874.] FRANK LESLIE'S ILLUSTRATED NEWSPAPER. 373

Mechanic's Hall, Salem.

Wednesday Night, OCT. 5.

First Appearance of the Indescribable Phenomenon

ANNIE EVA

FAY

OF LONDON, ENGLAND.

In a Scientific Seance on

SPIRITUALISM

Miss Fay will present a New Line of Manifestations never before seen in this city, in the broad gaslight, on the open stage, in full view of the audience, and will present a line of scientific experiments as given by her before PROF. WM. CROOKES and the Royal Society.

Beautiful Flowers Materialized in Full Gas Light

And Passed to the Ladies in the Audience by Hands Plainly Seen.

NOTICE.—MISS FAY is positively the only lady in the world who has the endorsement of members of the Royal Society of London; they having for three months tested her in every conceivable way that human ingenuity could conceive, and at the end of the investigation presented her with letters signed by such names as Wm. Crookes, F. R. S., Wallace, Sergeant Cox, Ionides, the Greek Philosopher, and others, to the effect the illustrations given in their presence were beyond human aid; some claimed Odic Force, some Electricity or Magnetism, and still others, supernatural power.

The many Spirit forms that appear around the Medium are truly wonderful, and seen by all present; they stand beside you, converse with you as in life, and shake hands with their friends.

A Table rises four or five feet in mid-air and faces are seen and recognized.

A Guitar is played and passed around the room by invisible power. Flowers are brought and passed to the audience by hands plainly seen. Bells are Rung. Harps are Played, and other tests of startling nature take place.

Twenty to thirty communications received every evening for persons in the audience.

Tables Float in Mid-Air ! The Spirit Hand Answers Questions !

The Spirit Carpenter ! The Self-Acting Knife ! Etc.

The following are a few of the many Press Notices which MISS FAY has received.

"Before a large and critical audience last evening, Miss Annie Eva Fay, the 'medium' now attracting so much attention, produced phenomena on an open stage, in plain sight of the whole audience, which staggered the most skeptical. Possibly there may be more things in heaven and earth than are dreamed of in our philosophies. At all events, this sort of thing is entitled to a fair hearing—the world wants the facts, regardless of what effects they may have on his or that 'ism.'"—*Editorial. BOSTON GLOBE.*

"A really marvelous exhibition was given by Miss Annie Eva Fay at the Providence Opera House last evening. It was the unanimous verdict that whatever the true explanation of the feats performed by Miss Fay, no such marvelous exhibition had ever before been seen here and that in many respects it surpassed the most wonderful tricks of the cleverest artists in Legerdemain. There is no turning down of lights, and everything is done with an appearance of the greatest fairness and the fullest opportunity to detect any trickery and aside from any question of supernormal phenomena, the entertainment is one of the most intensely interesting and marvelous that is now before the public."—*PROVIDENCE TELEGRAM.*

SCIENCE.—Mr. Wm. Crookes, F. R. S., prints an account of a seance at his house, in which Miss Fay exhibited some remarkable phenomena while under severe scientific conditions. The sitting took place on Friday evening, Feb. 19, in the presence of several well-known men of science, and on Mr. Cooke' suggestion, the medium was so placed as to form part of an electric current connected with a galvanometer, indicating on a graduated circle the exact deflection produced by the current. The sitting was held in a well-lighted drawing room, the medium thus "being tied by electricity," being screened by a curtain.—*The London Daily Telegraph, March 12.*

Miss Annie Eva Fay, who for some time has been a prominent figure, both in this country and America, made her first appearance in Edinburg last night, at the Albert Hall, before a large audience. A distinctive feature traced the manifestations is that they occurred in full gas light, and it is but little to say that Miss Fay caused a FUROAS. There is nothing supernatural about her any more than there is about any other medium. How it is done we cannot pretend to say, and look at it as one of the best conjuring seances of this kind we have ever seen. Not much over a century ago Miss Fay would have been burnt as a witch, now she will only puzzle and amuse the many who go to see her.—*Scotsman.*

Baron Carl du Prell, of Munich, Bavaria, has been enthusiasky Miss Fay, the medium, for the investigation of spiritual phenomena. In his report, this philosopher says he found the experiments quick intelligence, and independent of Miss Fay.

"She gives her seance in the broad gas-light, without resorting to the trickery of a darkened room."—*Courant, Amsterdam, Holland.*

By invitation a most influential assemblage of scientific men and other notabilities were gathered yesterday evening to witness a private seance given by Annie Eva Fay. Among the guests were Prof. Karl Ebing Zocker, Kandl, Buttelstein, Oser, Magel, Benedict, Winterslin, Beus, Frisch, Skancey, Mosol Erner, Stelem Nordungel, also Count Lamsam, the Marquis de Bonneville 'n Herbs, etc. The object of the seance was to subject Miss Fay to strict scientific scrutiny, and the results were in every way highly interesting.—Vienna, Austria, News.

Last night, King Oscar, the Crown Prince, and Prince Carl, accompanied by ministers of state, attended Annie Eva Fay's seance at the Fen Saloon. They seemed to enjoy the seance very much, joining in heartily with the audience in according Miss Fay a hearty welcome to Stockholm.—Stockholm, Sweden, Dagblatt.

The most marvelous, thrilling and exciting exhibition ever introduced to the German public.—German Hamburg Nachrichter.

Newen Vareyn, St. Petersburg, Russia, says: Miss Fay finished her evening the seventh seance given before Prof. A. Ackshoff and others. Epof. Ackshoff has promised to give the St. Petersburg public a full account of the wonderful experiments. The tests were of such a nature that they were compelled to look beyond Miss Fay for an explanation.

Simply wonderful.—Berlin Tagblatt.
Almost miraculous.—Paris Figaro.
Electricity.—Royal Scientific Society.
Static force of power.—Sergeant Cox.
The best exhibition of occult power or force we ever saw on any public stage.—El Imperial, Madrid, Spain.
Incomprehensible.—London Times.

ALL ARE INVITED.

DOORS OPEN AT 7:00. **COMMENCE AT 8:00.**

A Scientific Examination of Miss Fay's Mediumship.

By WILLIAM CROOKES, F. R. S., Editor of the "Quarterly Journal of Science"

About a year ago Miss Annie Eva Fay came to this country from the United States, with a good reputation as a medium for the production of physical phenomena.

On Friday evening, Feb. 19th, Miss Fay came to my house alone, to submit to tests in the presence of several well-known scientific men. She entered the drawing room, and conversed with us for about a quarter of an hour, after which my friends went down stairs to examine the electrical apparatus and my library, which was to be used as the dark room. They examined the cupboards and opened the desks. They put strips of paper over the fastenings of the window shutters, and sealed them with their signet rings. They also sealed up, in a similar manner, the second door of the library, which opens into a passage. The other door opens from the library into my laboratory, in which the experimentalists remain during the tests; a curtain, consequently, was suspended over the door, to place the library in comparative darkness and to admit a rapid and easy passage to and fro.

The accompanying cut shows the arrangement of the apparatus.

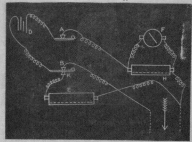

D, battery.
F, galvanometer.
H, shunt to cut off more or less of the current in order to regulate the deflection of the galvanometer.
E, box of resistance coils.
A and B, keys to make and break contact.
(A) is always closed, and used only to correct or check zero.
(B) pressed down to K, puts the resistance coils in place of the medium.
The two wires on each side of the arrow go to the medium.

The medium takes hold of two handles, attached to the wires below the arrow, and thus completes the circuit, and causes the light from the galvanometer to be deflected on the scale. The shunt is now adjusted, the object being to distribute the current between the galvanometer and the shunt, so as to cause a convenient deflection of the former. Any movement of the medium is now seen by a variation of the position of the spot of light. If the wires or handle are short circuited in any way the spot of light flies off the scale; if, on the other hand, contact is broken by the medium leaving go, the light immediately drops to zero.

To take the resistance of the medium, the key, B, is pressed down, which places the resistance coils in the circuit instead of the medium. Pegs are then taken out till the deflection on the galvanometer is equal to that produced by the medium; the resistances are then equal both of the medium and coils, and the figures are read off on the scale.

When she seized the terminals, the exact amount of deflection due to the resistance of her body was given by the galvanometer; if she caused the handles to touch each other the deflection was so great as to cause the light to fly wildly off the scale; if she ceased to hold the handles for an instant the ray of light came to zero; if she attempted to substitute anything besides her body to establish partial contact between the two handles, the great oscillations of the luminous index, which would have taken place while it was being done would at once have been infinite against its production of the right amount of deflection.

Miss Fay was now invited down into the library; she took her seat in a chair before the brass handles, and the gaslights in the library when reduced to one, which was turned low. We noted the distance from her of several prominent articles. A musical box was lying on my desk at a distance of about four feet from her; a violin lay upon the table at a distance of about eight feet; and my library ladder rested against the book shelves at a distance from her of about twelve feet. We then asked her to moisten her hands with salt solution, and to seize the terminals. This she did, and at once a deflection was produced upon the galvanometer scale due to the resistance of her body; we then left the library and entered the laboratory, which was illuminated by gas sufficiently for us to see everything distinctly.

We commenced the test at 8:55 p. m.; the deflection by the galvanometer was 211° and the resistance on Miss Fay's body, 6,600 British Association units. At 5:56 the deflection was 214°, and at this moment a hand-bell began to ring in the library. At 8:57 the deflection was 214°. A hand came out of the cabinet on the side of the door farthest from Miss Fay.

It should be clearly understood that I was on one side of the wall with the galvanometer, that Miss Fay was on the opposite side holding the handles, soldered to pieces of wire, so secure that she could not move her hands or the handles an inch to the right or left, and that under these conditions, a hand came out from the furthest side of the curtained door alongside of us at a distance of three feet from the brass handles, and all within three minutes after we had left the room.

At 8:58 the deflection was 201°; at 8:59 it was 215°, and at this moment a hand came out at the further side of the curtain, and handed a copy of THE SPIRITUALIST newspaper to Mr. Harrison.

At 9 o'clock the deflection was 209°; at this moment a hand was again seen to come out and hand Sergeant Cox a copy of his book, entitled, "WHAT AM I?" At 9:01 the deflection was 200°, the hand appeared again and gave a little book on SPECTRUM ANALYSIS to the author, who was one of the observers.

At 9:02 the deflection was 214°; a hand was again visible and gave a well known traveller who was present a book entitled AIR OF TRAVEL.

At 9:03 the hand threw a box of cigarettes at another gentleman who was present, and who was known to be partial to the fragrant weed. I could have been positive that that box of cigarettes was in a locked drawer in my desk when Miss Fay entered the room.

At 9:04 the deflection was 213°. I again measured the resistance of Miss Fay's body, and it was then 6,500 British Association units. At this moment a small ornamental clock, which had been standing on the mantle-piece, five feet from the medium, was handed out.

At 9:04½, the deflection was 210°; Sergeant Cox, and some of the other observers, said that they saw a full human form standing at the opening of the curtain.

At 9:08, the circuit was seen to be suddenly broken. I entered the library instantly, followed by the others, and found that Miss Fay had fainted, or was entranced. She was lying back in the chair senseless, but revived in the course of half an hour. This remarkable seance lasted for exactly ten minutes.

A piece of old china, in the shape of a plate, was found lying upon the top of my writing-desk in the library; it was not there before the experiments began. In my drawing-room up stairs there is a moulding all around the wall, near the ceiling, and about eight feet from the ground; resting upon this moulding are several pieces of old china, including some small plates. Miss Fay had been in the drawing-room for perhaps an hour before the seance began, but she was not there except in the presence of several witnesses; the room was well lighted, and had she mounted a chair to reach one of the plates near the ceiling, of course everyone must have seen it. The plates had been on those mouldings for weeks without being moved, for no member of my family had occasion to touch them; and one of the gentlemen present said he was sure that the plate was not on the desk when the experiments commenced, because he looked at the top of the desk with the intention of placing something on it, which he wished to put out of the way. Many similar cases of the carriage of solid objects from one place to another by abnormal means are on record in Spiritual literature.

We conclude this report with a synopsis of the manifestations witnessed, which no mortal could possibly take the slightest part therein.

The musical box was opened, wound up, stopped, and set agoing.

A bell was carried about ringing, and ultimately pushed through, by the side of the curtain, from the library in which the medium sat, into the laboratory occupied by the spectators.

The materialized hand which carried the hand was seen; it remained for an instant, moving the fingers to attract attention.

A violin was carried from the table in a distant part of the library into the laboratory. The library-ladder was carried in a similar manner.

WILLIAM CROOKES, F. R. S.

MISS FAY will give one Seance at Mechanic's Hall, Wednesday Night, Oct. 5th.

Some scientists were convinced they could accurately test spiritual or psychic phenomena.[60] Magicians, however, believed scientists were ill-equipped to do so since they were not trained in the art of deception. Magicians and other performers documented the methods of fraudulent mediums in published exposés. One of the earliest American examples was *Psychomancy: Spirit-Rappings and Table-Tippings Exposed*, written in 1853 by the American naturalist, inventor, and trained ventriloquist Charles Grafton Page, MD.[61] Page's book focused on revealing a physical source or device for the Fox sisters and other mediums' abilities.[62] Like magic posters, the covers for many published exposés highlighted perceived supernatural aspects involved in spirit-themed performances—floating instruments, spirit drawings, disembodied limbs, and more—while the interior text contained the opposite (fig. 45). *Revelations of a Spirit Medium* (1891) is one of a handful of volumes written by a former medium who went by "A. Medium" as a tell-all book aimed at exposition and repentance (fig. 46).[63]

Magicians also gave exposés on the stage. The first public demonstrations by the Fox sisters at Corinthian Hall in Rochester in November 1849 were followed almost immediately by demonstrations of how the sisters made rapping noises by cracking their knees or toe joints.[64] Over in England, John Nevil Maskelyne witnessed a performance of the Davenport Brothers and was able to "see behind the curtain" for a brief moment. Maskelyne, with the aid of his friend George Alfred Cooke, duplicated the brothers' feats onstage without supernatural claims. The two went on to design many successful stage illusions and for thirty years ran London's Egyptian Hall, one of the premier variety theaters that catered to magic, illusion, and anti-Spiritualist exposés (see p. 65, fig. 50). From 1874 to 1875, the London-born illusionist Professor Thomas William Tobin, who got his start mixing

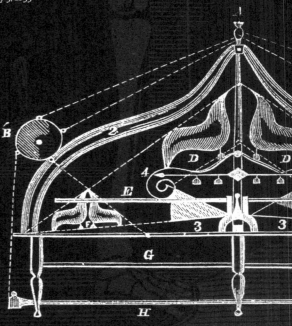

fig. 47 *Mr. A.S. Gear, of Boston…has the honor to announce that he has arranged with Professor Tobin…a strange exhibition of the illusions of science and the delusions of sense…Spiritualism's Humbugs—Spiritualistic Jugglery—Exposed*, 1875, ink on paper, 20 9/16 × 7 1/8 in. (52.2 × 18.1 cm), Peabody Essex Museum, Phillips Library, BF1371 .T63 1875

fig. 48 "Spiritual Machine," *Scientific American*, February 3, 1855

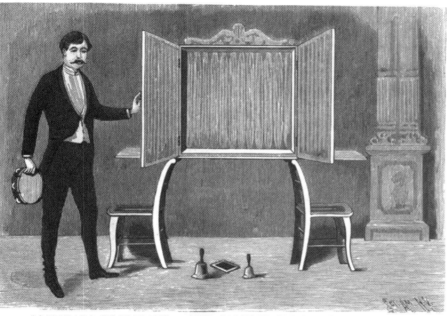

CASSADAGA PROPAGANDA—THE CABINET OPEN FOR INSPECTION.

fig. 49 "Cassadaga Propaganda—The Cabinet Open for Inspection," *Scientific American*, November 7, 1896

the oxygen and hydrogen for the spotlight used in John Henry Pepper's ghost illusion, demonstrated the mechanisms of spirit routines for audiences in the northeastern United States.[65] His performance at Salem's Mechanic Hall on August 16, 1875, was advertised with a striking broadside featuring a skeleton emerging from a safe flanked with the words "Spiritualism's Humbugs— Spiritualistic Jugglery— Exposed" (fig. 47). The *Salem Register* noted, "We do not suppose Prof. Tobin will destroy the faith of the genuine spiritualists, but he may aid in relieving them of the dead weight of bogus mediums and tricky humbugs that have done so much to disgust the public with everything under the name of spiritualism."[66] A decade later, in 1888, Maggie Fox herself recanted her supernatural abilities, heralded as "the Death Blow to Spiritualism."[67] It did nothing to that effect, and she retracted her statement a year later. Debunking exposés, in essence, gave more publicity to Spiritualism and hardened true believers who claimed these "unmasking" performances were utterly insignificant when compared with the spiritual phenomena they claimed to witness in their circles. For them, magicians, unlike mediums, were professed and intentional deceivers of the senses.[68]

The symbiotic but often antagonistic relationship between magicians and mediums, science and the supernatural, reached its apex in Boston in 1924. The internationally renowned American medium Margery (Mina Crandon) was the focus of a $2,500 prize offered by the magazine *Scientific American* in 1922 to any medium around the globe who could produce scientific proof of ghosts. This publication had explored the connections between science and the supernatural since the mid-nineteenth century. In 1855, it published an article about a "spiritual machine" in the rooms of Jonathan Koons in Athens County, Ohio (fig. 48). Koons created a twelve-by-fourteen-foot spirit house that included many of the effects later used by the Davenport Brothers in their traveling act. Koons believed his "battery" could charge the room to produce spirit manifestations. *Scientific American* saw Koons's efforts and other similar methods of spirit communication as "sublimely nonsensical," but while aiming to dismiss pseudoscientific claims as mechanically produced, covering these episodes actually reified them.[69] Years later, the magazine published features on the workings of some

magician-created spirit effects, including a version of the spirit cabinet routine called the Cassadaga Propaganda (fig. 49).[70]

In Margery's Lime Street home, she conducted séances for the *Scientific American* judges, filled with ringing bells in the dark; a Victrola playing of its own accord; the voice of the medium's dead brother, Walter, whom she frequently channeled; and the materialization of ectoplasm (fig. 51).[71] Some of the attendees were convinced of Margery's abilities, but one was not: Harry Houdini. In his personal quest for contact with his mother, who died in 1913, Houdini desperately wanted to believe in an afterlife. His unrequited journey, however, turned him into the most aggressive debunker of fraudulent mediums to date. Houdini remarked, "I do not say there is no such thing as spiritualism, but state that in the thirty years of my investigation nothing has caused me to change my mind."[72] He performed spirit-themed routines and mentalism using hot reading early in his career, until he realized that it was wrong to be deceitful (fig. 52).[73] Houdini's experiences hardened him against mediums who he believed took advantage of people's emotional vulnerability stemming from the loss of a loved one.

Houdini spent the last few years of his life touring the country giving lectures and demonstrations to show how mediums could appear to conjure the dead through methods he, too, employed. Striking graphic posters drew audiences to these performances, considered the most entertaining shows in Houdini's career.[74] Other magicians incorporated questions such as "Do Spirits Return?" in their advertising posters, often left unanswered in the text, but Houdini's poster is definitive: "Houdini Says No and Proves It" (fig. 53). Back on Lime Street, he showed the other judges how he thought Margery was performing some, but not all, of these unexplainable acts in her home. Integral to Houdini's examination were devices he created for testing or limiting Margery's abilities. His medieval-looking "Margery box," which restricted the medium's movements, was actually similar to a spiritual cabinet offered by the London magic shop of Millikin and Lawleys in 1878 (figs. 54, 55). Margery, who at first admired Houdini as a performer, grew to dislike him, as did many other Spiritualists who were not happy with Houdini's methods and what they characterized as a crusade against the movement. Some believed he gave the public "a false aspect of Spiritualism as a religion" and that his intentions were "seldom to arrive at the truth, but most often to get the better of his opponent, and when he fails to do this . . . he loses his temper." Others drew, and otherwise expressed, their criticism of Houdini employing antisemitic tropes.[75]

Margery did not get the *Scientific American* prize, but her supporters were unswayed, most notably Sir Arthur Conan Doyle, the creator of Sherlock Holmes, who defended her in the press.[76] Doyle was the most high-profile supporter of the growing Spiritualist community in the early twentieth century and embodied both sides of the relationship between science and the supernatural. A trained physician who created the world's most celebrated fictional detective, he entertained various fantastical beliefs

fig. 50 Forbes Company Lithographers, Boston and New York, *European Wonders—Horticultural Hall*, about 1885, lithograph, 23 ¹⁵/₁₆ × 20 ⅛ in. (60.8 × 51.1 cm), McCord Stewart Museum, purchase, funds graciously donated by La Fondation Emmanuelle Gattuso, M2014.128.295

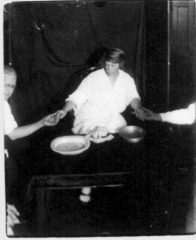
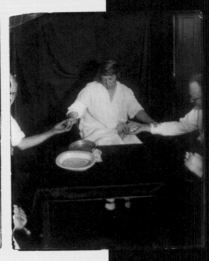

Spiritualistic
ENTERTAINMENT

...THE FASHIONABLE EVENT OF THE SEASON...

GIVEN BY

MYSTERIOUS
HARRY
Houdini

The Great Occult Demonstrator

ASSISTED BY

MLLE. BEATRICE
HOUDINI

PSYCROMETRIC ••••ARTIST

Greatest seance ever introduced in America.
Every manifestation given under test condi-
tions in full light. Independent Spirit Slate
Writing, between two SEALED SLATES.

$100 REWARD

TO ANY SHERIFF, OFFICER, DETECTIVE
OR PRIVATE INDIVIDUAL
Who will produce a handcuff or leg shackle that
PROF. HOUDINI cannot escape from. It's an
utter impossibility to tie rope, or secure the
Medium so as to prevent the manifestations
from occurring

SKEPTICS

Most Cordially Invited as a Committee

BRING YOUR OWN ROPE AND HANDCUFFS

that seeped into his work. His short story "Playing with Fire," about the experiences of a small group of friends who attend a séance in an art studio, was published in the *Strand Magazine* in 1900 and featured illustrations by the British artist Sidney Paget, who created some of the earliest visual likenesses of Sherlock Holmes (fig. 56). Doyle also wrote many books on Spiritualism and collected objects like spirit photographs; he displayed these in his Psychic Bookshop, Library & Museum, which he ran from 1925 to 1930, located behind Westminster Abbey in London (fig. 57).

To some, Doyle was both disciple and advocate, a fervent supporter of Spiritualism and a tireless defender of his faith when confronted with allegations of fraud. To others, he was "one of the most deceived men walking the earth," a sentiment the British illustrator Bernard Partridge captured in a cartoon featuring Doyle's fictional detective chaining the author to prevent him from navigating "the vast inane" (fig. 58).[77] His statements to the press embodied this binary. Doyle admitted, "You will find mediums do silly things which are quite unnecessary and clearly bogus," such as Eusapia Palladino, who confessed that she often resorted to trickery because the demands for physical evidence at every séance required her to use such means. He would then counter

fig. 51 Margery (Mina Crandon) excreting ectoplasm during a séance, 1925, gelatin silver prints, each 5 × 4 in. (12.7 × 10.2 cm), Collection of Tony Oursler

fig. 52 Combe Printing Company, St. Joseph, Missouri, *Spiritualistic Entertainment...Mysterious Harry Houdini assisted by Mlle. Beatrice Houdini*, about 1897, lithograph, 34 × 11 in. (86.4 × 27.9 cm), Theatre and Performing Arts Collection, Harry Ransom Center, University of Texas at Austin

fig. 53 *Do Spirits Return? Houdini Says No—and Proves It*, 1926, lithograph, 41 ¾ × 27 ¾ in. (106.1 × 70.5 cm), Library of Congress, Prints and Photographs Division POS–MAG–.H68, no. 4

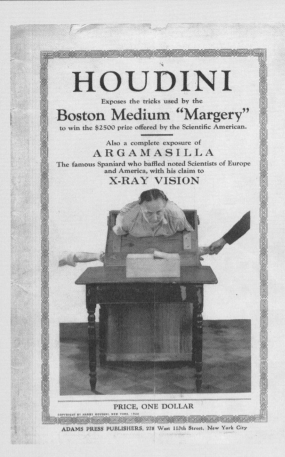

HOUDINI

Exposes the tricks used by the
Boston Medium "Margery"
to win the $2500 prize offered by the Scientific American.

Also a complete exposure of
ARGAMASILLA
The famous Spaniard who baffled noted Scientists of Europe and America, with his claim to
X-RAY VISION

PRICE, ONE DOLLAR

COPYRIGHT BY HARRY HOUDINI, NEW YORK, 1925.

ADAMS PRESS PUBLISHERS, 278 West 113th Street, New York City

fig. 54 *Houdini Exposes the Tricks Used by the Boston Medium "Margery" to win the $2500 prize offered by the "Scientific American,"* 1924, 9½ × 6 in. (24.1 × 15.2 cm), Collection of Tony Oursler

fig. 55 *"No. 360-Spiritual Cabinet," Catalogue of Conjuring Tricks, Puzzles, & Novelties, in the Magic Art, on Sale at Millikin and Lawleys,* about 1877, Courtesy Dartmouth College Library

his statement, noting that "the next moment you may see some really psychic manipulation, quite beyond all possibility of fraud." Doyle rationalized his mindset as part of "the pitfalls of psychic research" and emphasized, "So long as you get positive results which are certain, you can afford to regard the negative ones as of no consequence."[78]

Doyle and Houdini first met in 1920 when Houdini was performing in England. They had a mutual respect for each other and became friends, corresponding and respectfully debating their views on spirit communication. Doyle, like Houdini, toured America giving lectures on Spiritualism in 1922. While in Atlantic City, New Jersey, Doyle and his wife, Jean, a medium who specialized in automatic writing, spent time with Houdini and his wife, Bess. Lady Doyle performed a séance in which she claimed to communicate with Houdini's departed mother, writing pages of "genuine" spirit communication according to the Doyles. Houdini was not convinced. The text contained a cross on the first page and was in English, and Houdini's mother was Jewish and spoke only German during her life. The bond between the two men soured after this point, and they attacked each other in the press and in their books on Spiritualism: Houdini's *A Magician among the Spirits* (1924) and Doyle's *A History of Spiritualism* (1926). The relationship between Margery, Houdini, and Doyle has captivated the public's imagination through countless books and television and radio dramatizations produced over the last half century, and the battle between mediums and magicians persists to this day.

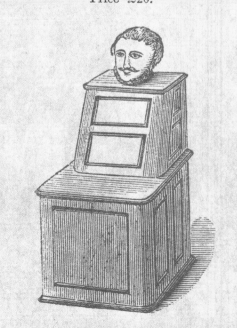

No. 360.--SPIRITUAL CABINET.
Price £20.

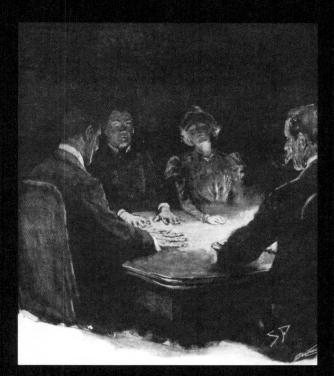

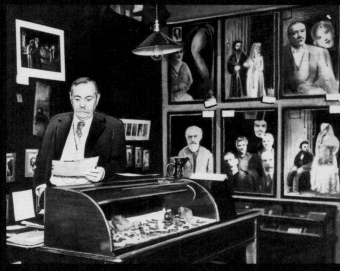

fig. 56 Sidney Paget, "'There is Much Power,' Said the Frenchman," from "Playing with Fire," *Strand Magazine*, March 1900, lithograph, 9 ½ × 7 in. (24.1 × 17.8 cm), Peabody Essex Museum, Phillips Library, purchase, 2023, AP4 .S75 XIX 1900

fig. 57 *Sir Arthur Conan Doyle in the Psychic Museum*, originally published in the *Strand Magazine*, May 1927, gelatin silver print, 9 ⅝ x 8 in. (24.5 x 20.3 cm), Collection of Tony Oursler

fig. 58 Sir John Bernard Partridge (1861–1945), "Mr. Punch's Personalities. XII. — Sir Arthur Conan Doyle," *Punch*, May 12, 1926, lithograph, 10 ⅝ × 8 ¼ in. (27 × 21 cm), Private collection

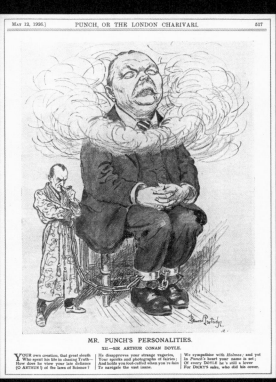

I SEE THEE STILL,

IN EVERY HALLOWED TOKEN ROUND;

THIS LITTLE RING THY FINGER BOUND,

THIS LOCK OF HAIR THY FOREHEAD SHADED,

THIS SILKEN CHAIN BY THEE WAS BRAIDED

...

THIS BOOK WAS THINE, HERE DIDST THOU READ;

THIS PICTURE AH! YES, HERE INDEED,

I SEE THEE STILL.

Charles Sprague, 1850[1]

I SEE THEE STILL:
MOURNING OBJECTS
IN AN AGE
BEFORE SPIRITUALISM

LONG BEFORE SPIRITUALISM TOOK HOLD OF POPULAR consciousness in the mid-nineteenth century, objects played a key role in aiding people to remember, mourn, and commune with the dead. Specially created mementos, small relics, commissioned likenesses, and exchanged gifts kept the departed close, providing a tangible link between the world of the living and the world of the dead. The range of material culture produced through the nineteenth century is evidence of rapidly shifting perceptions of death and the afterlife and a universal urge to replace emotional loss with material substance.

The earliest American objects associated with death are connected to funeral customs. Although seventeenth- and early eighteenth-century Christian doctrine generally restricted overt expressions of grief, material objects played an important social role among the small, tightly knit communities forming the early colonies.[2] Following the funerals of wealthy or prominent individuals, families distributed small, personalized gifts, such as scarves, gloves, or rings, to attendees according to their social rank. Often crafted from extravagant materials, these objects tangibly bound the bereaved together while projecting the memory and position of the deceased into the future. In 1798, the Salem diarist Reverend William Bentley observed this firsthand when he recorded: "Mr. Edw. Norris shewed me a Ring belonging to the first Edward Norris & now held by the sixth for the seventh, a minor. It is of gold, enameled with a death's Head, with a posy *LIVE TO DIE*."[3] If death occurred away from home, these objects could serve to memorialize the deceased in the absence of a body. When twenty-four-year-old merchant William Pickman of Salem died in Barbados in 1735, his body was interred on the island.[4] His family, grieving him from afar, commissioned a funeral ring in his memory featuring a gold and enamel band inscribed with his name, age, and death date, as well as a small paper skeleton beneath a crystal at its center (fig. 61). This ring may have served as a material site of mourning for his loved ones, who were unable to provide burial for Pickman.

Images such as skeletons, depleting hourglasses, coffins, and winged death's heads (skulls) dominated the visual culture of death and mourning in

fig. 59 Samuel A. Fuller (1825–1902), Posthumous
portrait of Sadie O. S. Mallard, 1884, oil on canvas,
30 × 25 in. (76.2 × 63.5 cm), Private collection

fig. 60 Miniature, about 1790s, watercolor, mother-of-pearl, hair, metal on ivory, 2 ¹¹⁄₁₆ × 2 ¼ in. (6.8 × 5.7 cm), Smithsonian American Art Museum, Bequest of Mary Elizabeth Spencer, 1999.27.79

the seventeenth and early eighteenth centuries. The iconography of memento mori, a Latin phrase meaning "remember that you must die," emphasized the impermanence of earthly existence and conveyed little more than a thin veil between the living and the dead.

This imagery persisted until the end of the eighteenth century, when sweeping cultural changes and the dawn of the new republic led to a more sentimental attitude toward bereavement. Romantic literature, in particular, induced a landslide of emotional meditations on death and encouraged individual expressions of grief. In response, mourners commissioned or created their own mementos. By combining the new vogue for classically inspired imagery and a lexicon of visual mourning symbols, these objects memorialized distinct individuals while asserting the personal values of the maker. In one such example, a painted miniature depicts a female mourner seated near a tomb adorned with seed pearls symbolizing tears (fig. 60). The figure lifts her gaze as a materializing spirit ascends to the heavens, breaking free of her earthly resting place with such force that a jagged piece of the structure falls to the ground and mingles with the grass. The dying grass, composed with macerated bits of the deceased's hair, compounds the corporeal connection to the earth, while the upward direction of the obelisk-shaped tomb, rising cypress trees in the background, and inscription "Rest in Hope" (a reference to Psalm 16:9) all reinforce the Christian belief in resurrection. Just as the miniature could be held closely in the palm and contemplated privately, a sense of tactile connection to the *body* of the deceased now formed a means of processing loss. Hair, which had long been used to symbolize the bonds of love and friendship, exploded in popularity as a material for its connection to a unique individual.

While the previous examples refer obliquely to the deceased, more explicit records of the dead served to conjure memory and provide a tool for personal communion. Posthumous portraiture supplied the living with a final visual record of loved ones, styled and composed as they wished to remember them. *Death of William*, a singular work from about 1807 by Italian-born artist Michele Felice Cornè, depicts a young deceased child of the Webb or Luscomb families of Salem, laid out on a finely wrought table in an interior scene (fig. 62). His weeping mother appears in the background, clutching a twisting blue curtain that dramatically delineates the realms of the living and the dead.[5] Posthumous and deathbed portraits were often displayed in the home, where they manifested a near physical presence. After American artist John Trumbull painted his wife, Sarah, in a moribund state in 1824, he hung the portrait above his bed behind green curtains that extended the drapery depicted on the canvas. When the curtains were drawn

fig. 61 Funeral ring for William Pickman, 1735, gold, enamel, rock crystal, and paper, ³⁄₁₆ × ⁷⁄₈ × ¹³⁄₁₆ in. (0.5 × 2.2 × 2.1 cm), Peabody Essex Museum, gift of Anna J. Haskell, 1885, 2208

for his own private contemplation, Sarah's portrait would have brought her lifelike presence into Trumbull's physical space.[6]

Many mourners alternatively preferred to remember their loved ones as they had been in life. In January 1847, Salem artist Charles Osgood rendered a portrait of the deceased Lucy Stickney for her husband, painted as though she were alive and in good health (fig. 64). Later that year, her husband wrote in a letter, "Mr. Osgood is I believe not exceeded in portrait painting by any artist in the United States.... He took a likeness of my wife after death which is considered by those who knew her a faithful likeness (from a cast)."[7] This final phrase indicates that Osgood rendered Mrs. Stickney's portrait with the aid of a death mask. Artists used these imprinted

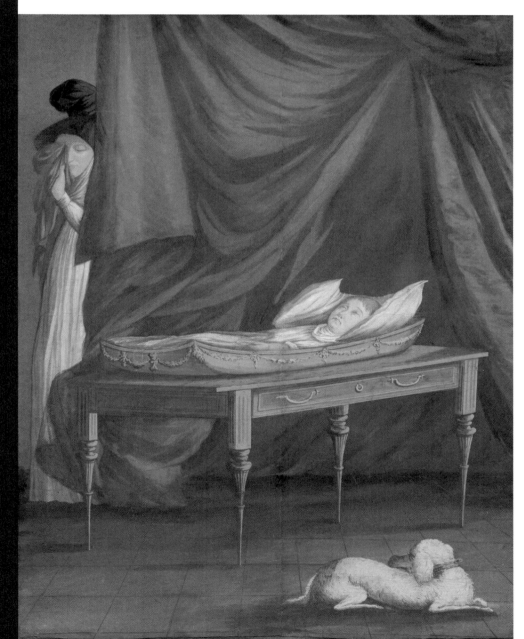

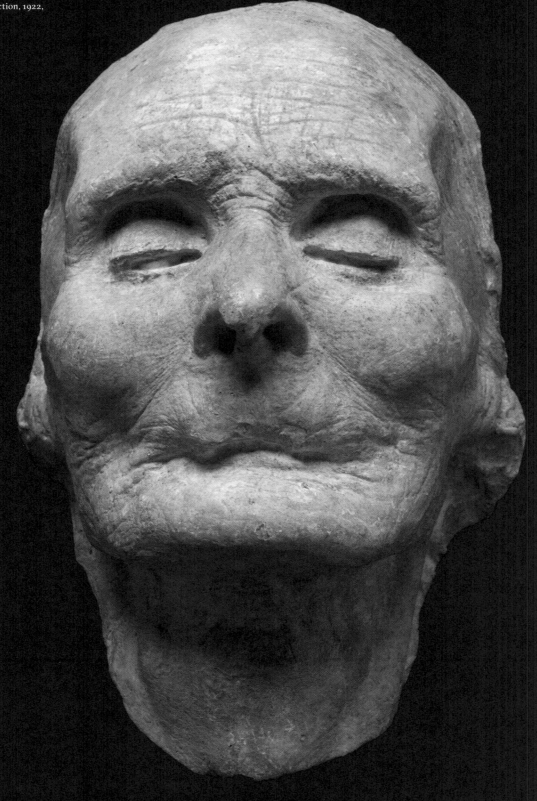

fig. 63 Death mask of
a woman, 19th century,
plaster, 8 × 4 ¾ × 5 ¾ in.
(20.3 × 12.1 × 14.6 cm),
Peabody Essex Museum,
museum collection, 1922,
115441

plaster casts to capture the particularities of a person's features before the rigors of death set in (fig. 63).

Following the introduction of the daguerreotype in 1839, photography offered a potent new tool for remembrance. While grounded in scientific principles, its seemingly supernatural abilities to freeze a person in time were at once frightening and unprecedented. American photographers relied on magical language to advertise their services, appealing to consumer anxieties by promising to "secure the shadow ere the substance perish."[8] The parents of sixteen-month-old Felis Vina Margolles quickly had his photograph |taken after his death, posing him as though sleeping in a clean white dress before a setting of ethereal clouds (fig. 66). Unlike a painted portrait, photography could not fully sanitize the visceral realities of death, evident in Felis's half-opened eyes and wooden stare.

fig. 64 Charles Osgood (1809–1890), Portrait of Lucy (Waters) Stickney done from a cast taken after her death, 1847, oil on canvas, 30 × 25 ¼ in. (76.2 × 64.1 cm), Peabody Essex Museum, estate of Lucy W. Stickney, 1929, 119841

During a time when advancing technologies and questions of vision were a part of popular discourse, photography had the alluring and uncanny ability to give the illusion of physical presence. To this end, clock- and watchmaker John Frederick Mascher harnessed the technology of the stereoscope, patenting a daguerreotype case embedded with magnifying lenses that gave the appearance of dimensionality to subjects both living and dead (fig. 65). *Scientific American* praised Mascher's invention in 1853, describing how it enabled viewers to "look upon the loved and respected . . . when they are in the tomb . . . to see them as they once were with us."[9]

As Spiritualism began to proliferate in the mid-nineteenth century, the languages of mourning objects and spirit paintings began to blend. William Matthew Prior was an established portrait painter when he created *Heavenly Children* in about 1850 (fig. 67). Prior was a passionate advocate for such fringe religious movements as Millerism (today known as Seventh-Day Adventism) and progressive causes like abolitionism, so it was natural that he would become an early proponent of Spiritualism. He had experienced great loss in his life; his father, siblings, six children, and first wife all died before 1850. His second wife, Hannah Frances Walworth, advertised as a clairvoyant. Prior was living in Boston, an early center for the Spiritualist movement, when he started to paint posthumous portraits of children using "spirit effect."[10] In addition to providing material closure, this painting, with children's heads floating in the clouds, promised spiritual reunion in the afterlife and hinted at a continued existence on another plane.[11]

A little over thirty years later, in 1884, the Reverend Samuel A. Fuller,

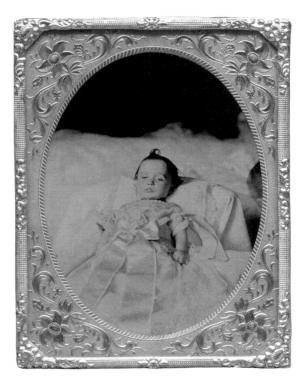

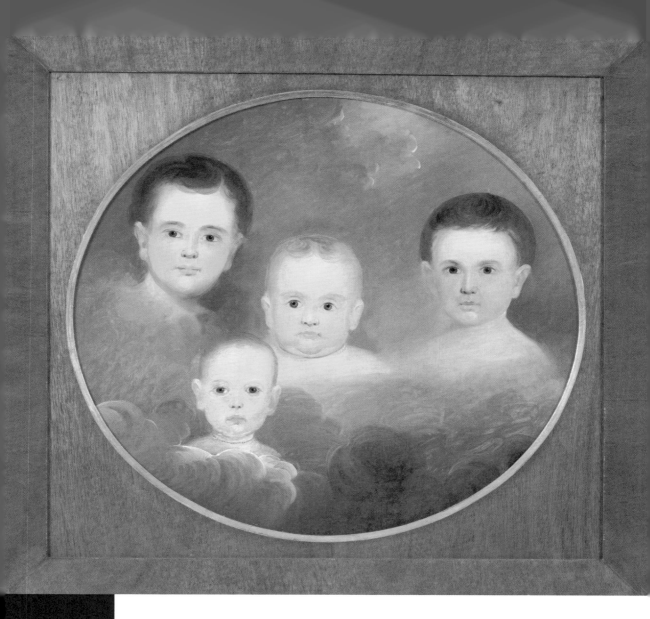

Fig. 67 William Matthew Prior (1806–1873), *Heavenly Children*, about 1850, oil on board, 20 × 22 ¼ in. (50.8 × 56.5 cm), American Folk Art Museum, gift of Valerie and Robert Goldfein, 2016.18.1

an ordained minister, painted a three-quarter-length posthumous portrait of Sadie O. S. Mallard of Manchester, New Hampshire (fig. 59; see p. 72). Fuller's depiction of Mallard floating in a daisy field holding wilting flowers is reminiscent of the spirit-like effects employed by Spiritualist mediums who "channeled" the dead. Just as Sadie inhabits two worlds within the frame of this painting, the portrait itself represents a style somewhere in between posthumous portraiture and those painted with "spirit effect." While both of these practices ebbed by the early twentieth century, the survival of mourning-related articles is evidence of the talismanic power people have given to objects to soothe loss and create connection with the departed.

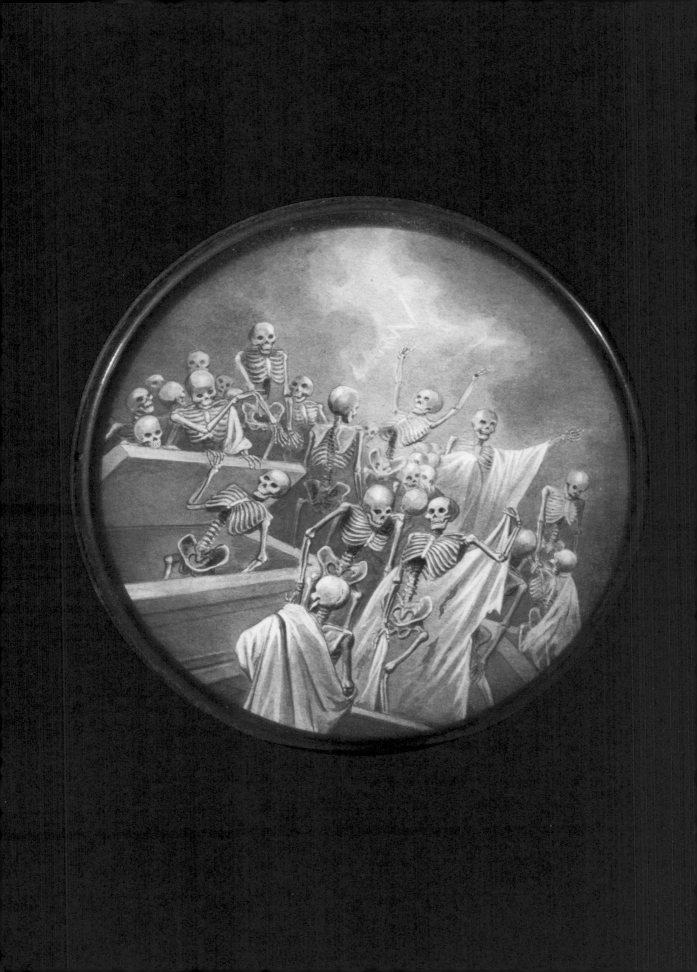

SPECTACLES OF SCIENCE AND SPIRIT:
OPTICAL ILLUSIONS AND ENTERTAINMENT IN THE NINETEENTH CENTURY

IN THE SAME POST-ENLIGHTENMENT ERA THAT SAW THE rise of the Spiritualist movement in the United States and abroad, a burgeoning market for popular entertainments capitalized on a public curiosity about the difference between seeing and knowing. Spectacles like magic lantern shows and the theatrical illusion known as Pepper's Ghost were ethereal visions, precursors to cinema that created such realistic and uncanny imagery that audiences could question what was science and what was spirit.

It is in that environment that Mr. N. Belcher and Company billed the "Dissolving Views!" of the 1876 Centennial Exposition (fig. 70) made possible by the technological wonder of the stereopticon, an evolution of the magic lantern that used two lenses to create smooth transitions between the projected images. Belcher's show visually transported the audience from Salem, Massachusetts, right to the grounds of the Philadelphia exposition. The language of the advertisement goes so far as to suggest that the experience might even be "more satisfactory . . . than when seen amidst the crowds, bustle and confusion of the Great Exposition." The stereopticon show allowed audiences far and wide to participate in the landmark anniversary of the nation's birth, an event that helped bridge national divisions in the wake of the Civil War.

The application of this optical device for an educational presentation would not have been new to the Salem audience. By that time, magic lantern projections were used routinely to illustrate lectures, presentations, and storytelling. The glass slides of the late nineteenth century were often commercially produced with hand-tinted photographic images, ensuring that each audience saw the same true and realistic view of the subject. Even in this didactic use, magic lantern shows altered perceptions of reality and

raised questions about belief and knowing.

The projection device known as the magic lantern originated around 1660, possibly invented by Dutch mathematician and scientist Christiaan Huygens, whose scientific contributions included the wave theory of light and the discovery of Saturn's largest moon. The device placed an artificial light source, initially a candle, between a reflective surface and an image painted on a glass slide (figs. 68, 69). The light, transmitted through a lens, resulted in an image that was spectral and dreamlike. In its earliest applications in Baroque theater, the magic lantern was used as a source of "bewilderment," evoking apprehension and even fear in viewers with imagery of demons, monsters, and otherworldly apparitions, while simultaneously countering those uncanny visions with the physical presence of the lantern itself.[1] In a time when the influence of the Catholic Church was coming up against the discoveries of science, magic lantern shows bridged the "monstrous and the marvelous" of the spiritual world with the spread of knowledge from the scientific community.[2]

By the end of the eighteenth century, Romantic fascination with Gothic narratives paired perfectly with the imagery created by magic lanterns. In 1799, Étienne-Gaspard Robert, who used the stage name Robertson, opened his "Phantasmagoria" show in an abandoned chapel at the Couvent des Capucines in Paris (see p. 34, fig. 13).[3] Assembled in a poorly lit room, the audience was greeted by Robertson, who purported himself to be "dedicated to destroying the old enchanted world of superstition" and "stressed that his phantoms were merely applications of the laws of optics and perspective."[4] The magic lanterns were hidden from view, projecting onto diaphanous fabric screens from the back. Accompanied by sounds of rumbling and thunder, the show even incorporated movement of the lanterns, creating actual motion in the images of skeletons, specters, mythological monsters, and witches.[5]

Phantasmagoria shows soon made their way to the United States. Precursors to today's haunted houses, these experiential sites were certainly advertised and understood as entertainments, and yet their optical illusions were so new that even the most rational audience members may have found it difficult to ascertain what was theater and what was reality. In this way, the Phantasmagoria were precursors to the séances popularized by the Spiritualist movement. The displays furthermore fulfilled a desire among "a nation of skeptics [to decide] for themselves the truth of matters put before them."[6]

fig. 68 (*top left*) Magic lantern, manufactured by Ernst Plank (German company) about 1880–90, brass, tin, wood, glass, and paint, 11 ⅝ × 4 ½ × 7 ½ in. (29.5 × 11.4 × 19.1 cm), Collection of Tony Oursler

fig. 69 (*previous page*) Magic lantern slide, mid- to late 19th century, metal, wood, glass, and paint, 4 × 7 in. (10.2 × 17.8 cm), Collection of Tony Oursler

(*above*) Attributed to Carpenter and Westley of London, mechanical lantern slides, mid- to late 19th century, metal, wood, glass, and paint, 3 ¾ × 7 in. (9.5 × 17.8 cm), Collection of Tony Oursler

MECHANIC HALL, - - SALEM.

Wednesday, Thursday, Saturday & Sunday Ev'gs,

DEC. 13, 14, 16 & 17.

ADMISSION, 25 CENTS. CHILDREN, 15 CENTS.

Reserved Seats, Adults, 35 Cts. Children, 25 Cts.

Doors open at 7 Commence at 7.45.

Tickets at the usual places and at the door.

MATINEE WEDNESDAY AFTERNOON, AT 2.30,

For Ladies and School Children.

Admission, P.M., Ladies, 25 cts. Children, 10. Four Evenings, with Reserved Seats, $1.

Voluntary on the Organ before each Exhibition.

BELCHER & CO.'S
MAMMOTH MIRROR
OF THE
CENTENNIAL!

Change of Programme Every Evening!

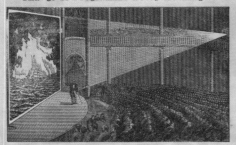

AMERICA'S
GREAT EXPOSITION

RE-PRODUCED AT YOUR VERY DOORS !

This Exhibition takes the audience over the entire grounds of the Centennial Exhibition, showing the form, manner, construction and location of many of the principal buildings, then goes completely through each one of them, showing their contents, and each particular national exhibition in a wonderfully vivid, and, possibly, more satisfactory manner than when seen amidst the crowds, bustle and confusion of the Great Exposition itself. The views, as they appear upon the screen, will be fully described by

Mr N BELCHER, of Boston,

Who has been well known during the past six years as Manager and Lecturer for

Black's Celebrated Boston Stereopticon !

And who has spent much time at the Centennial, obtaining full and explicit information concerning the most prominent and interesting portions, and objects of special importance connected with it. The subjects are illustrated by means of

DISSOLVING VIEWS !

16 to 20 feet square, interspersed with
Gorgeous Transformation Scenes !
Beautiful Colored Allegories !
AND
STARTLING OPTICAL ILLUSIONS !

Brilliantly illuminated by means of the New

Cylindrical Pressure Light,

(The most powerful form of the Calcium Light science has yet discovered,)

UNDER THE SKILFUL MANAGEMENT OF

Mr. A. L. SMITH, the well-known Boston Stereoptican.

This arrangement of the Light requires no gases to be made; no gas-bags are needed, as in old style Stereopticons, and is so powerful in its operations that a picture of gigantic proportions is produced, startling in its apparent reality, and so wonderfully stereoscopic, that it seems to the audience as though the end of the hall had been taken away, and that they were looking directly out of doors upon the scene itself. This illusion has never been so perfectly produced by any apparatus heretofore invented. The views do not slide on and off the screen, but are dissolved from one to another, in a manner pleasing to the eye, and with an effect mysterious and enchanting to the beholder, by means of mechanism peculiar to this instrument, and patented by Mr. Belcher.

During the Entertainment a number of

Philosophical and Scientific Experiments

Will be performed, illustrative of the wonders of CHEMISTRY and OPTICS, such as the combination and composition of the gases oxygen and hydrogen; the burning of steel; the illumination of the hall equal to the brightest noonday, &c.; and Pepper's great masterpiece, the wonderful and startling illusion of The

DANCING SKELETON !

An experiment upon which Prof. Pepper, of the Polytechnic Institute, of London, devoted nearly a year of constant study before bringing it into successful operation, and first performed in America by him in Tremont Temple, Boston, in 1872. The skeleton resolves itself into form and animation, apparently from empty space, goes through a number of comical evolutions, then gradually fades away again, and entirely disappears.

The Entertainment is decidedly scientific and educational in its nature, full of instruction and amusement, refining and elevating to the mind and feelings, intensely interesting to everybody, and no man, woman or child should fail to see it.

Fitchburg Mon. July 12

THE

TRUE HISTORY

OF

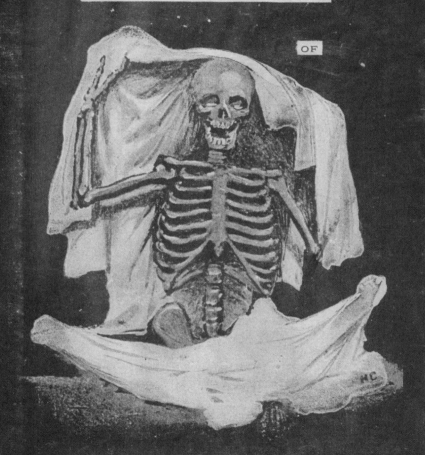

PEPPER'S GHOST

CASSELL & COMPANY, Limited:
LONDON, PARIS, NEW YORK & MELBOURNE.

The draw of the Phantasmagoria faded in advance of the Civil War, as entertainments like P. T. Barnum's American Museum in New York touted the display of wonders of the natural and the human world, promising truth instead of humbugs and deceit. At the same time, photography evolved into a commercial enterprise, and devices like the stereoscope entertained the public with the science of optics, making the fantasies of the ghostly world less interesting than the documentation of the tangible one. Magic lantern shows increasingly were used as illustrative accompaniment to lectures or, like Belcher's show, a way to learn about other people and other places. The technology was even adopted for advertising. The Great London Circus, for example, created a technological spectacle to promote its performances. A poster for the 1880 show, managed by James Bailey before his association with Barnum, celebrated the methods used to announce the show's arrival in a town (fig. 71). Along with the street parade, the circus was preceded by a "Free Exhibition" in which Professor Bernard used his magic lantern projector to share images of the circus to generate excitement and boost ticket sales.

New discoveries in optics created additional opportunities to entertain the public by challenging the notion that seeing is believing. In 1862, "Professor" John Henry Pepper debuted the theatrical illusion now known as Pepper's Ghost to an audience at the Royal Polytechnic Institution in London. Pepper, a Victorian scientist popular for his public lectures, refined an existing technique created by his fellow Englishman Henry Dircks.[7] Using a sheet of glass set at an appropriate angle and a carefully positioned light source, Pepper could create a refracted, seemingly spectral image of an actor that would appear and disappear on the stage as the lighting changed (fig. 72). It is a Pepper's Ghost illusion, presented by "Professor" Pepper himself, that is mentioned at the bottom of the bill for Belcher's show in Salem. Described among the "Philosophical and Scientific Experiments," the Dancing Skeleton's inclusion in the program suggests that even as they searched for truth in their entertainments, American audiences were still enchanted by experiences that left room for the spirit.

fig. 72 Cover (*left*) and frontispiece from *The True History of Pepper's Ghost*, by John Henry Pepper, 1890, 7 ⅜ × 5 in. (18.7 × 12.7 cm), Peabody Essex Museum, Phillips Library, purchase, Thomas Cole Library Fund, 2023, GV1561 .P46 1890

DIAGRAMS ILLUSTRATING THE "GHOST" MACHINERY. (*See p. 8.*)
(From a drawing by Mr. Barnard Chalon.)

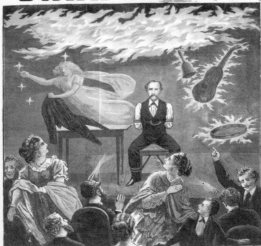

COLSTON (LESSER) HALL,
BRISTOL.

FOR A SHORT SEASON ONLY, Commencing

SATURDAY NEXT, November 10th, 1883

AND EVERY EVENING UNTIL FURTHER NOTICE.

The Great, Original, and World-Renowned Conjuror,

HERR

DOBLER

WILL APPEAR IN HIS GRAND ENTERTAINMENT OF

Chinese, Hindoo, and other Eastern Feats

Performed by no other ARTISTE IN EUROPE, together with his justly celebrated and Incomprehensible

✠ DARK SEANCE ✠

This marvellous performance, ORIGINALLY produced by HERR DOBLER to the Public, has been COPIED and ADVERTISED by every conjuror throughout the country, who have traded on it through the great sensation his séances have created everywhere. This wonderful performance has been investigated now for a number of years by some of the most scientific gentlemen of the day, and can be performed by no other conjuror but himself - all others being simply absurd imitations

JUST ADDED TO

Herr DOBLER'S ENTERTAINMENT,

A NEW AND STARTLING ILLUSION.

THOUGHT READING

OR, SPIRIT WRITING.

Extract from the "DUBLIN IRISH TIMES," Saturday, January 6th, 1883.

Speaking of HERR DOBLER'S Performance at the Antient Concert Rooms, Dublin, it says : One most astounding feat he performs is what he terms Spirit Writing. A packet of note paper is handed to one of the audience, who selects a piece from where he thinks proper, folds it up and places it in an envelope; seals it down and puts it in his pocket. When this is done a document is handed to another member of the audience, who selects a page anywhere he likes out of about 300 pages. He names the number of the page selected. Then a similar document is handed to another member of the audience, who after finding the page named by the first person, has the privilege of selecting any word he thinks proper on the page chosen. After that is done, and the same word the first person opens the envelope, and on looking at the paper the word selected (out of a dictionary containing about 30,000 words) is found distinctly written on the particular piece of paper which never once came in contact with Herr Dobler, but was in possession of one of the audience the whole time, and before the documents were introduced at all. We have seen him perform this feat three times, and must admit it is a mystery.

This Incomprehensible Feat will be performed at every Entertainment given by Herr DOBLER.

ENTIRELY NEW PROGRAMME!

All the Latest Wonders of the Wizard Art! Everything performed entirely without Apparatus!
The Greatest Exhibition of Conjuring in the World!
THERE IS ONLY ONE DOBLER!—*Vide London Times.*

ADMISSION—2s. and 1s. Children Half-price. Gallery, 6d.
Dark Seance, 1s. extra. To a limited number only.
D. & J. ALLEN, Printers, 18, Corporation Street, Belfast.

fig. 13 D&J Allen, Printers, Belfast, *Herr Dobler . . . Dark Seance*, 1883, lithograph, 40³⁄₁₆ × 15 in. (102 × 38.1 cm), McCord Stewart Museum, purchase, funds graciously donated by La Fondation Emmanuelle Gattuso, M2014.128.140

BOXING UP
THE MEDIUM:
THE STORY OF THE
SPIRIT CABINET

PERHAPS NO OBJECT DEMONSTRATES THE CONNECTION between Spiritualism and stage magic more than the spirit cabinet. The original armoire-like device was used to prove that spirits, not the medium, were producing the ghostly effects at a séance or public lecture. Magicians quickly adopted the object for demonstrations and illusion shows, expanded and improved upon it, and changed aspects of it to fit within the culture of the time. The results were spirit cabinets of various sizes, with performers employing very different methods to achieve seemingly supernatural effects.

The first spirit cabinet appeared a few years after the Spiritualism movement in the United States started in 1848, with the Fox sisters in upstate New York performing spirit rappings at séances and public demonstrations.[1] Many séances and demonstrations were said to require darkness, with various reasons given, such as preventing "auras" from being destroyed by light and reducing visual distractions for the medium.[2] The spirit cabinet's development was tied to debates about whether darkness or the isolation of the medium from observers allowed for the use of trickery. In addition to providing an extra layer of suggestibility, darkness distorted audience members' depth perception, making luminous objects even more impressive.[3] Spiritualists balked at the idea of deception taking place and compared the production of spirits to the development of a photograph in a darkroom.[4] The Fox sisters and other early mediums were therefore "tested" under conditions designed to prevent trickery and to determine if their claims were indeed true. Some of these methods included having participants hold hands around a séance table or restraining the medium with ropes.

The Davenport Brothers, Ira Erastus and William Henry, of Buffalo, New York, soon began their own Spiritualist demonstrations in the 1850s.[5] Their father conceived of a way in which they could perform in the light of a large audience hall: a wardrobe-like container that would enclose the brothers and allow them to work in darkness. The spirit cabinet was born. Wooden cabinets or curtained-off areas of rooms became standard for mediums in the séance room going forward. Once again, Spiritualists provided

by MARK SCHWARTZ

justification for the use of these devices, arguing that mediums needed to be sequestered, either to focus their psychic energy on materializing the spirits or as a way of ensuring that no assistants would aid the medium in the production of ghostly effects.[6]

The Davenport Brothers began their first tour of the United States in 1855. Their demonstrations consisted of a "light séance" followed by a "dark séance." In the light séance, the audience hall was lit up and the brothers performed their spiritualistic feats from inside a cabinet about six feet high, six feet long, and two and a half feet deep, with three outward-opening wooden doors and a curtained opening in the top portion of the middle door (see p. 25, fig. 8).[7] The brothers would have their hands bound behind their backs and be tied to benches inside the cabinet as they sat facing each other. The middle section would contain musical instruments such as banjos, bells, and tambourines. With the doors closed, a hand would appear at the middle window ringing a bell, the instruments would play, and banging would be heard from inside the cabinet, creating a sense of pandemonium. When the doors were quickly opened, the brothers would be

found still securely tied, looking as if nothing had occurred.[8] In the "dark séance" following this demonstration, the brothers would be bound in chairs onstage and surrounded by a ring of spectators, called committee members (a comparable presentation is shown in fig. 73). The lights would be put out, and similar phenomena would take place with the addition of phosphorescent hands, faces, and objects.[9]

The Davenport Brothers toured the United States until 1864, when the Civil War curtailed their plans. They embarked on a European tour, conducting public demonstrations in England. It was at one of these performances that John Nevil Maskelyne, a young amateur magician, learned the Davenports' secret quite by accident.[10] Called onto the stage to be a committee member in a lecture by the brothers, Maskelyne stood outside their cabinet, and a movement of the curtain behind the aperture of the middle door allowed him to see that the brothers were free of their bonds and manipulating the articles inside. He realized that they were able to slip in and out of their constraints at will.[11] Within a few months, Maskelyne and his friend George A. Cooke were performing and exposing the secrets of the spirit cabinet routine to enthusiastic audiences.[12]

Certain accounts suggest that the Davenport Brothers' father was influenced in his creation of the spirit cabinet and the associated rope ties by the feats of Indigenous shamans in North America, having learned how one could escape from bonds from "Indian jugglers of the West."[13] Some Indigenous peoples in North America, including the Ojibwe and Inuit, have a ceremony that is remarkably similar to the spirit cabinet routine. In this centuries-old sacred rite, a shaman would be bound with ropes and seated in a tent to commune with the spirits.[14] The arrival of different spirits would be signaled by the shaking of the tent and other manifestations such as the throwing about of objects.[15] At the end of the ceremony, the shaman would be found either still tied up or free of his bonds through the intervention of the spirits.[16] Some mediums using spirit cabinets would emerge free of their bonds. In the late nineteenth century, Harry Houdini would make this aspect the central part of his performance, removing such escapes from the realm of Spiritualism into that of stage magic.[17]

The Davenport Brothers returned to touring the states in 1868. A year later, a young magician, Harry Keller (later Kellar), became an assistant to the brothers and served as their business manager, learning their secrets unbeknownst to them. In 1873, Kellar and another assistant, William Fay, struck out on their own with the spirit cabinet routine forming a central piece of their act.[18] Kellar would sometimes present the spirit cabinet as an illusion not requiring supernatural means, and other times as an exposé of the Davenport Brothers' demonstrations.[19]

Around 1882, Kellar radically improved upon the Davenport Brothers' routine by having the cabinet in a disassembled state at the beginning of the demonstration. The cabinet would be put together onstage and shown on all sides, proving it was empty. Tambourines, bells, and the like were placed in

the empty cabinet, which immediately became animated once the doors were closed (fig. 74). The doors would then be reopened, and the audience would see the empty interior.

Kellar further enhanced the spiritualistic cabinet effects with the introduction of the Cassadaga Propaganda (fig. 77), named after the famous Spiritualist retreat in upstate New York (later renamed Lily Dale). In essence, it was a miniature version of the spirit cabinet routine and involved a small cabinet placed on a plate of glass held up by two chairs. The glass and initial placement of the folded cabinet seemed to make it impossible for an assistant to be aiding in the effect. In reality, a clever arrangement allowed for a child to be hidden behind the back of the cabinet. In addition to the usual manifestations, the "spirit" inside the cabinet would aid a spectator in a game of euchre onstage with another volunteer.[20]

The Cassadaga cabinet did not replace the Davenport-style spirit cabinet illusion, and Kellar performed both of them in many of his shows in the 1890s.[21] Magician Karl Germain wanted to perform a Cassadaga cabinet effect for his own show but with less of the apparatus needed to hide a child assistant behind it. What he developed was a much smaller box with two doors facing the audience (fig. 75) in which a bell, a tambourine, and a borrowed handkerchief would become animated once placed inside. Clearly there were no assistants inside the two-foot-long cabinet, but assistants from the wings of the stage could move the objects without being seen.[22] Magician Harry Blackstone eventually made this dancing handkerchief portion of the routine a mainstay in his own stage show (fig. 76).[23]

Around 1909, Germain again added a unique element to the spirit cabinet illusion. His new method required no hidden assistants backstage or within the cabinet, but instead used a lifelike painting depicting him in a chair in a trance. While the audience thought they saw Germain sitting motionless in the middle of the spirit cabinet, he was secretly moving about, hidden from view, producing spirit manifestations.[24]

Howard Thurston developed and patented his own unique design of the spirit cabinet in 1918 (fig. 78). This version combined principles behind several different stage illusions and allowed audience members to see into the dark, empty cabinet during the whole performance. The cabinet cleverly hid two assistants who could produce spirit manifestations such as ghostly faces while remaining invisible to the audience. Thurston would add comedy to the proceedings as well, with a member of the audience getting roughed up by the spirits inside the cabinet, an element also later used by his protégé Dante (fig. 80).[25]

Although it became less frequently performed, the spirit cabinet never really disappeared from the magician's repertoire. Stage magicians still included it in their shows into the 1950s.[26] The Willard family and their descendants have performed it on stages across the United States from the 1880s up to the present day (fig. 79).[27] David Copperfield's unique take on the spirit cabinet was part of his 1995 traveling show and TV special

fig. 75 Artist in the United States, Cassadaga Cabinet, about 1930, wood, brass, and fabric, 40 × 27⅞ × 14 in. (101.6 × 70.8 × 35.6 cm), Peabody Essex Museum, museum purchase, by exchange, 2022.29.1

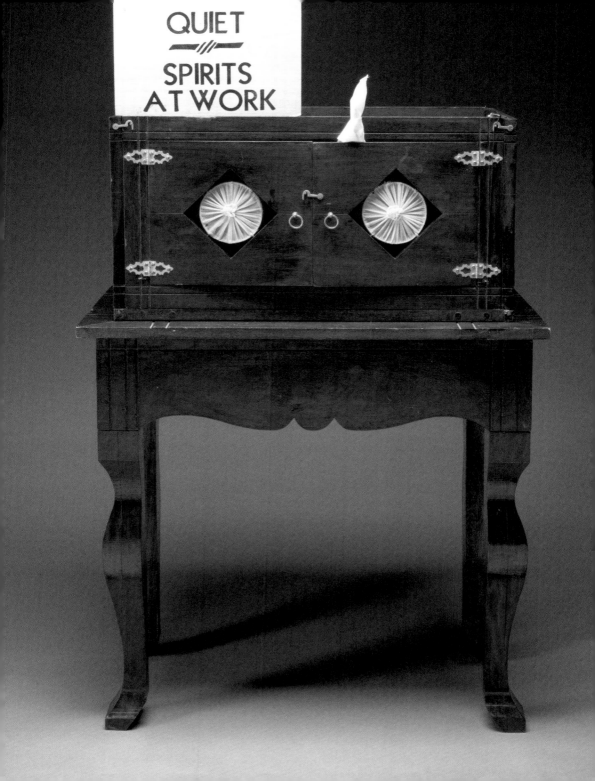

QUIET

SPIRITS
AT WORK

BLACKSTONE

The Man Who Controls

SPOOKS

IN THE LIGHT

4902N2 MADE IN U.S.A. NATIONAL PTG. & ENG. CO. L.I. CITY, N.Y.

fig. 76 National Printing and Engraving Company, Long Island City, New York, *Blackstone: The Man Who Controls Spooks in the Light*, 1920, lithograph, 41 ⅛ × 28 ³/₁₆ in. (104.4 × 71.6 cm), McCord Stewart Museum, purchase, funds graciously donated by La Fondation Emmanuelle Gattuso, M2014.128.51

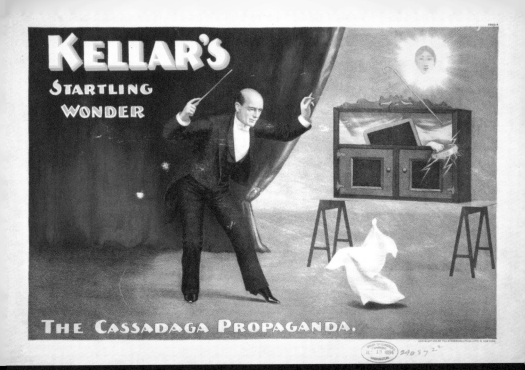

Unexplained Forces. The magician explained that he wanted to make the connection between the cabinet and the spirits more apparent to a modern audience and hit upon the idea of having the cabinet constructed from the remains of a "haunted house."[28] Copperfield created an elaborate story about a house of ill repute—the Barclay House—and a curse for dramatic effect.[29] As part of a larger sequence of stage illusions tied to the Barclay House, Copperfield would produce spirit manifestations while being tied to a chair inside the cabinet.

A staple in performances by both Spiritualist mediums and stage magicians from the mid-nineteenth century to today, the spirit cabinet in its many forms reveals the ties between these seemingly disparate yet overlapping professions.

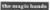

fig. 79 *Falkenstein & Willard*, 1993, 17 × 11 in. (43.2 x 27.9 cm), photographic poster, Private collection

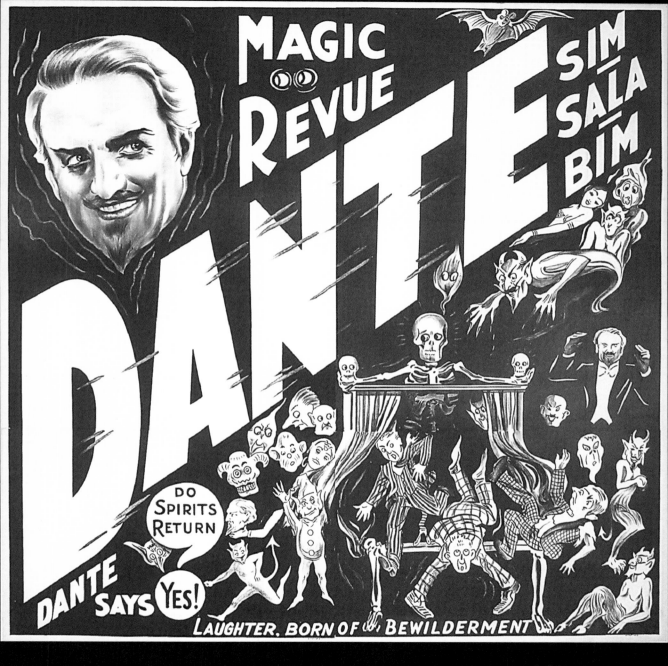

fig. 80 Magic Revue. Dante. Sim Sala Bim, about 1946, lithograph, 80 × 81 in. (203.2 × 205.7 cm)

ALL PHOTOGRAPHS ARE MEMENTO MORI.

TO TAKE A PHOTOGRAPH IS TO PARTICIPATE

IN ANOTHER PERSON'S (OR THING'S)

MORTALITY, VULNERABILITY, MUTABILITY.

Susan Sontag[1]

PHANTOM EVIDENCE:
SPIRIT PHOTOGRAPHY FROM THE *NINETEENTH CENTURY* TO THE PRESENT

WHEN SPIRIT PHOTOGRAPHY EMERGED IN 1862, PHOTOG-raphy as a workable technology was itself only twenty-three years old, and much of the discourse surrounding its nature and claims was ambiguous and contradictory. Early literature on photography frequently connected it to the supernatural, with one of its early inventors, William Henry Fox Talbot, even describing it as partaking of the "marvelous," a spell-like "natural magic" that could fix a fleeting shadow.[2] Edgar Allan Poe wondered at witnessing the "marvelous beauty" of an image slowly materializing on a developing daguerreotype.[3] French novelist Honoré de Balzac expressed to his friend the photographer Nadar that he believed the camera removed "spectral layers" from its subject and transferred them to the photograph to make an image, depleting the sitter in the process.[4] The connection of photography with death was well established in the United States in the 1840s and 1850s, with a thriving industry of postmortem photography, which captured a final likeness of a deceased loved one before they were interred and memory of them lost.[5] Photographic artists were also giving visual form to ghosts, if only as special-effect amusements. In 1856, the London Stereoscopic Company produced a series of novelty tableaux in which apparitions inter-loped into domestic life to humorous effect (fig. 81).[6] Yet at the same time, nineteenth-century discourse posed a counternarrative about photography as an exacting and objective recording apparatus for scientific applications due to its foundation within the principles of chemistry, optics, and geometry.[7] Beginning in the 1850s, photographs even took on an evidentiary role in the courtroom.[8]

It was within this unsettled photographic territory between science, the supernatural, and amusement that William H. Mumler, a Boston engraver, chemist, and recent dabbler in photography, claimed he had captured a spirit

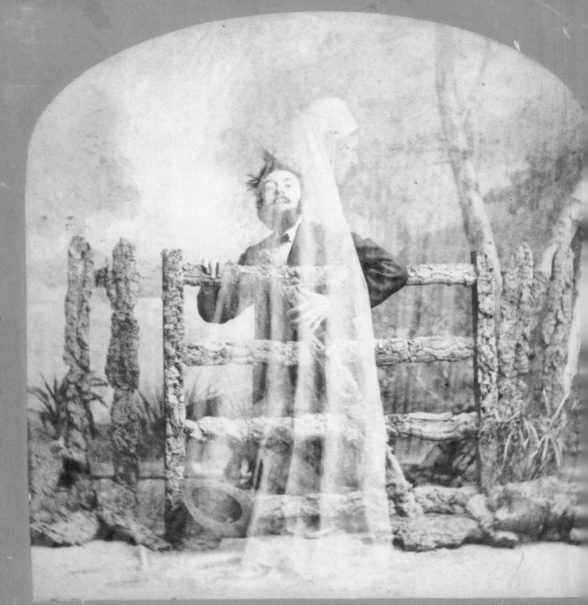

By The London Stereoscopic Company.
110 AND 108 REGENT STREET & 54, CHEAPSIDE

THE HORRIFIED ENGLISHMAN

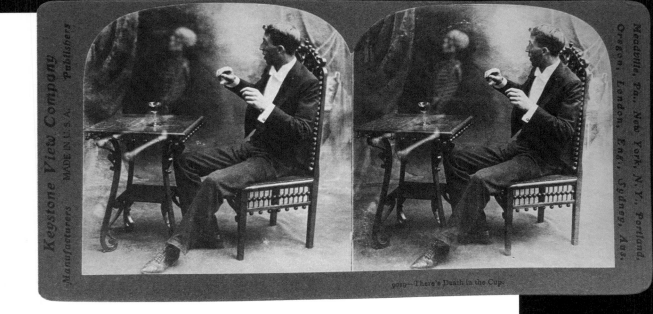

Keystone View Company

There's Death in the Cup.

while taking his self-portrait. "Ghosts" on photographs were not unheard-of. In this era, glass plates were coated with a wet light-sensitive emulsion of collodion to create a negative that was exposed in the camera. Operators often reused these plates, but if they were cleaned improperly, an ethereal face from a previous portrait sitter would reappear in the new exposure. Mumler, however, was the first to present such an image within the context of the burgeoning Spiritualist movement, and quickly his testimony that the "spirit extra" on his self-portrait resembled his dead cousin gained traction in the Spiritualist press. That Mumler professed to be only a photographic novice lent credibility to his claim.[9]

Despite skepticism, even among Spiritualists, Mumler became the spirit photographer archetype. His wife, Hannah, was a medium in her own right, and the couple established a successful commercial studio where forlorn or simply curious clients could have their portraits taken alongside the conjured dead.[10] A new visual language for depicting the communion with ghosts was applied to the carte de visite, a popular portrait format in the era. Mumler's technique became quite accomplished over the years, with spirits seemingly interacting with sitters, as in the case of the remarkable portrait of Herbert Wilson, whose late fiancée rests an arm upon his shoulder and holds an anchor purportedly bearing her name, "Nellie S." (fig. 82).[11]

Soon after establishing a studio in New York City in 1868, Mumler was brought up on charges of swindling the public, and his hearing became a cause célèbre sensationalized in the press, with the notorious hoaxer P. T. Barnum testifying to Mumler's humbuggery. The landmark case, covered in *Harper's Weekly* and many newspapers, was the first to interrogate the notion of photographic evidence, though conclusions were ambiguous (fig. 83).[12] According to photography expert witnesses, Mumler's images were obviously created by double-exposed negatives and other forms of manipulation, which

fig. 81 (*previous page*) The London Stereoscopic Company, *The Horrified Englishman*, 1860s, albumen silver prints on paper board, 3 ⅜ × 6 ⅞ in. (8.6 × 17.5 cm), Collection of Tony Oursler

(*above*) Keystone View Company, Meadville, Pennsylvania, *There's Death in the Cup*, 1898, gelatin silver prints on paper board, 3 ½ × 7 in. (8.9 × 17.8 cm), Collection of Tony Oursler

fig. 82 William H. Mumler (1832–1884), *Herbert Wilson of Boston with the spirit of a young lady to whom he had once been engaged*, about 1870, albumen silver print, 4 ½ × 2 ½ in. (11.4 × 6.4 cm), Collection of Tony Oursler

HARPER'S WEEKLY.

A JOURNAL OF CIVILIZATION

VOL. XIII.—No. 645.] NEW YORK, SATURDAY, MAY 8, 1869. [SINGLE COPIES, TEN CENTS.
[$4.00 PER YEAR IN ADVANCE.

SPIRITUAL PHOTOGRAPHY.

THE case of the people against WILLIAM H. MUMLER, of 630 Broadway, is one so remarkable and without precedent in the annals of criminal jurisprudence that we devote this page to illustrations bearing upon it. The charge against Mr. MUMLER is that, by means of what he terms spiritual photographs, he has swindled many credulous persons, leading them to believe it possible to photograph the immaterial forms of their departed friends.

The case has excited the profoundest interest, and, strange as it may seem, there are thousands of people who believe that its development will justify the claims made by the spiritual photographer. We shall not attempt to give an expression to our own opinions, but simply to follow the developments of the case through the testimony offered during the first few days of the trial.

It is through the instrumentality of Marshal JOSEPH H. TOOKER that the case has been brought before the courts. He deposes that he was ordered by Mayor HALL to investigate the case, which he did by assuming a false name, and by getting his photograph taken by Mr. MUMLER. After the taking of the picture the negative was shown him, with a dim, indistinct outline of a ghostly face staring out of one corner; and he was told that the picture represented the spirit of his father-in-law. He, however, failed to recognize the worthy old gentleman, and emphatically declared that the picture neither represented his father-in-law, nor any of his relations, nor yet any person whom he had ever seen or known. With this evidence the prosecution rested.

The counsel for the defense have brought forward a number of witnesses who testify to the genuineness of spiritual photographs taken for them by Mr. MUMLER. WILLIAM P. SNELL, a photographer, of Poughkeepsie, testifies that MUMLER succeeded in producing spiritual photographs at his gallery in Poughkeepsie, and he was unable to discover how it was done. Judge EDMONDS, one of the most distinguished advocates of Spiritualism, deposed that he had two photographs taken by MUMLER; the spirit form in one of them he thought he could recognize, but not the one in the other. He said: "I believe that the camera can take a photograph of a spirit, and I believe also that spirits have materiality

— not that gross materiality that mortals possess, but still they are material enough to be visible to the human eye, for I have seen them; only a few days since I was in a court in Brooklyn when a suit against a life assurance company for the amount claimed to be due on a certain policy was being heard. Looking toward that part of the court-room occupied by the jury, I saw the spirit of the man whose death was the basis of the suit. The spirit told me the circumstances connected with the death; said that the suit was groundless, that the claimant was not entitled to recover from the company, and said that he (the man whose spirit was speaking) had committed suicide under certain circumstances; I drew a diagram of the place at which his death occurred, and on showing it to the counsel, was told that it was exact in every particular."

A large number of witnesses deposed that they recognized the forms of departed friends (in some cases of those long dead) in the photographs taken for them by MUMLER. The most striking case was that of a gentleman of Wall Street, whose deceased wife's features both he and his friends distinctly recognized in a photograph taken for him in this way.

If there is a trick in Mr. MUMLER's process it has certainly not been detected as yet. To all appearances spiritual photography rests just where the rappings and table-turnings have rested for some years. Those who believe in it at all will respect no opposing arguments, and disbelievers will reject every favorable hypothesis or explanation. Mr. MUMLER has certainly been very fortunate. He has been believed in, in the first place, by a large number of people. He has obtained, again, a good price for his photographs; for who could expect spirits to be called "from the vasty deep" for less than ten dollars per head? And, finally, he has been prosecuted, and thus extensively advertised. Beyond this, the trial, like all legal prosecutions of this nature, will amount to nothing.

In addition to our illustrations of specimens of Mr. MUMLER's spirit photographs, we give also representations of similar photographs taken by Mr. ROCKWOOD of this city. The latter were taken by natural means, but not so as to escape detection as to the trick resorted to to secure the result. Mr. MUMLER has certainly the advantage of a longer experience in the business.

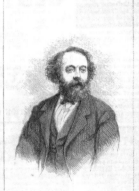

W. H. MUMLER.

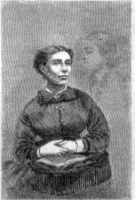

MRS. W. H. MUMLER.—BY MUMLER.

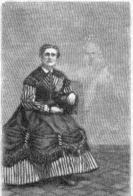

SPIRIT PHOTOGRAPH BY MUMLER.

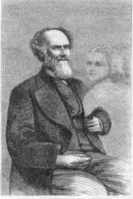

SPIRIT PHOTOGRAPH BY MUMLER.

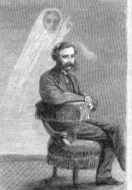

SPIRIT PHOTOGRAPH BY MUMLER.

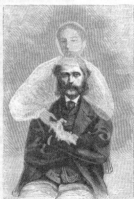

SPIRIT PHOTOGRAPH BY MUMLER.

SPIRIT PHOTOGRAPH BY MUMLER.

F. V. HICKEY.—BY ROCKWOOD.

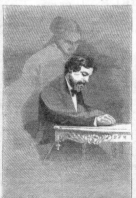

C. B. BOYLE.—BY ROCKWOOD.

SPIRITUAL PHOTOGRAPHY.—[SPECIMENS FURNISHED BY MUMLER AND ROCKWOOD.]

PHOTOGRAPH OF MRS. LINCOLN,
with spirit of Abraham Lincoln and Son.
BY MUMLER, BOSTON, U.S.A.

they listed for the record; for believers, the hazy apparitions were clear proof of visits from the afterlife.[13] In his verdict, Judge John Dowling noted that he was "morally convinced" that Mumler was a deceiver yet ultimately acquitted him, determining that the prosecution did not prove his modus operandi with certainty, nor was it disproved that spirits could appear through means that looked like fakery.[14]

Returning to Boston after the New York ordeal, Mumler continued in spirit photography until 1879. During this time, he produced perhaps his most heralded image, in which the spirit of President Lincoln was conjured to console his widow, still adorned in her mourning attire years after his assassination (fig. 84).[15] However we may view Mumler today, this photograph reads as an emblem of the nation's yearning, in the wake of the Civil War's ravages, for "balm to the aching breast" and "peace and comfort to the weary soul," as Mumler offered in one of his advertising pamphlets.[16]

Mumler's 1869 trial had been followed internationally. Even as it brought the tenets of Spiritualism under scrutiny, his acquittal was interpreted as a victory for those in the movement, and curiosity in spirit photography emerged in Europe. In 1872, the *British Journal of Photography*, aimed at serious and professional photographers, announced that "psychic force cartes," once thought confined to the other side of the Atlantic, had arrived in London as a new "sensation."[17] It seems the spirits themselves via séance had directed the medium Elizabeth Guppy and her husband, Samuel, to attend the photography studio of Frederick A. Hudson to obtain a spirit picture. There, Hudson captured a ghostly form behind Mr. Guppy in his portrait while Mrs. Guppy did her mediumistic work nearby. After this success, the Guppys quickly brought the medium

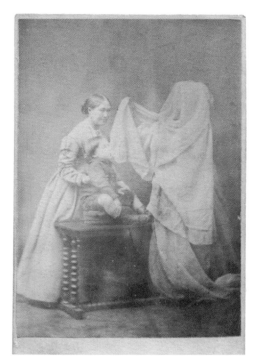

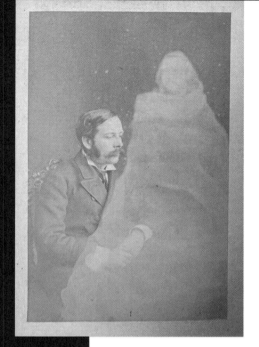

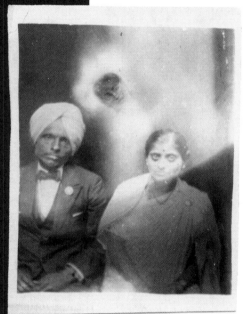

Georgiana Houghton, known for her psychic drawings, into their continuing photographic endeavors. Subsequently, Houghton participated in hundreds of sessions of spirit photography at Hudson's studio, often taking a central role in the images, such as propping up the Guppys' son during a visitation with his late grandmother (fig. 85). As in Mumler's images, spirits communed with the living in portraits, but Hudson's ghosts typically manifest with more density and look suspiciously like figures draped in sheets. Hudson's double exposures were debunked after only a few months, largely by skeptical Spiritualists with photographic knowledge. Nonetheless, true believer Houghton went on to publish the first serious work on the phenomenon, a lavishly illustrated tome reproducing fifty-four of Hudson's images.[18]

In France, reports of ghosts captured on collodion by Parisian photographer Édouard Isidore Buguet gave hope to leading Spiritualists such as Pierre Leymarie that photography could provide a means for spirits "to give irrefutable proof of their existence and their presence" among us.[19] Working from his Montmartre studio in the years following the violence of the Franco-Prussian War and the Paris Commune, Buguet began producing studio portraits with spirit extras to supplement his business in 1873.[20] His translucent apparitions were much like Mumler's but were often adorned in gauze drapery (fig. 86). More of a showman than Mumler or Hudson, Buguet reportedly worked while in a trance, reciting incantations to entice spirits to manifest and impress clients. However, when brought up on charges in 1875, Buguet confessed to being nothing more than a photographer with "skillful tricks" and a studio of props to create fake ghosts. He was fined and served a year in prison for his fraud, and Leymarie was convicted as an instigator.[21]

The respected British photographer and Spiritualist John Beattie was among those frustrated by Hudson's trickery. Theorizing it was folly to suppose that a literal portrait of an immaterial spirit could be photographed, Beattie, diverging from the commercial studio setting, set up his own experiment. In trial séances in 1872 and 1873, he used the camera as a recording apparatus to capture the kinds of forms that mediums and clairvoyants reported seeing. Prefiguring the photographic motion studies that Eadweard Muybridge and Étienne-Jules Marey would conduct in the

fig. 86 Édouard Isidore Buguet (1840–1901), Spirit photograph, about 1870, albumen silver print, 4 ⅛ × 2 ½ in. (10.5 × 6.4 cm), Collection of Tony Oursler

fig. 87 William Hope (1863–1933), Photograph of a couple with spirit of a deceased family member, early 20th century, gelatin silver print, 4 ¼ × 3 in. (10.8 × 7.6 cm), Collection of Tony Oursler

following years, Beattie's images unfold in series as spectral forms dramatically emerge and morph (fig. 88). Unlike the double-exposed portraits of the studio photographers, Beattie's photographs hinge on abstracted figural forms that represent, perhaps, his own stated idea of an underlying "universal substratum of spirit-substance" molded and shaped by invisible intelligent beings.[22] Regardless of the truth in Beattie's claims, his images expanded how the spirit world could be visualized.

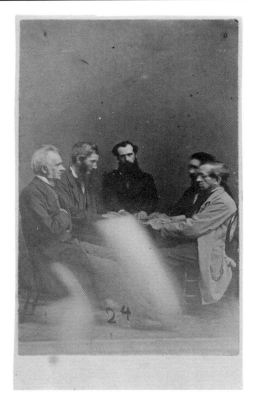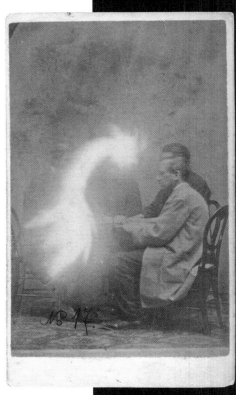

fig. 88 John Beattie (1820–1883), *Spirit Séance* (left) and *Abstract manifestations* (right), 1872, albumen silver prints, 4 × 2 7/16 in. (10.2 × 6.2 cm), 4 × 2 ½ in. (10.2 × 6.4 cm), Collection of Tony Oursler

Spirit photography had its most public resurgence after the violence brought by World War I, as an interest in Spiritualism redoubled among the grief-stricken hoping to reconnect with the war dead. Two of the most successful mediumistic photographers in England, the Crewe Circle photographers William Hope and Ada Deane, were at the center of public debates between Spiritualists and anti-Spiritualist skeptics. Both photographers were from humble, working-class backgrounds and claimed their mediumistic powers allowed spirits, in the form of disembodied heads shrouded in cotton or ectoplasm—depending on the viewer's interpretation—to appear in portrait photos (fig. 87).

One of the most indefatigable defenders of the Crewe Circle was the famed Sherlock Holmes author and avid Spiritualist Sir Arthur Conan Doyle, who sat for Hope in order to commune with his son Kingsley, killed in the war.[23] Doyle used images by these mediums as visual evidence in his lectures promoting Spiritualism. One example shows Deane and her daughter attended by their personal spirit guides, along with Fred Barlow at right, the investigator from the Society for the Study of Supernormal Pictures, who adds his imprimatur (fig. 89). Both photographers were publicly debunked—Hope was caught swapping preexposed negatives during a test visit, and Deane was exposed for using faces clipped from newspapers as her spirit extras.[24] The most notable of the anti-Spiritualists, celebrity illusionist Harry Houdini, broke with his friend Doyle and wrote an exposé on Spiritualism, claiming that tricks such as spirit photography were "evidence of how

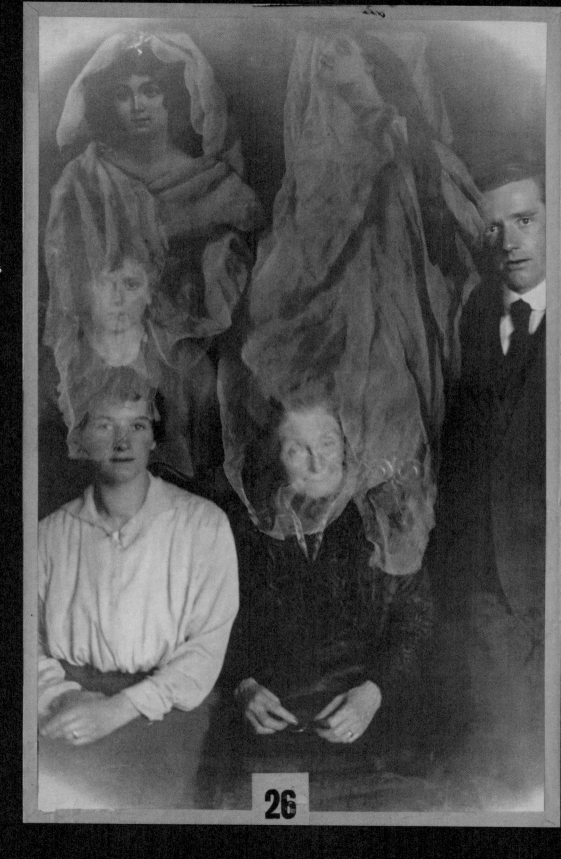

fig. 89 Fred Barlow (1888–1964) and Ada Deane (1864–1957), Photograph of Violet Deane and Ada Deane (*front*), Mrs. Barlow and Fred Barlow (*center*), and spirit guides "Stella" and "Bessie" (*above*), 1920 (enlarged reproduction printed later), gelatin silver print, 37 ¼ × 23 ¾ in. (94.6 × 60.3 cm), Arthur Conan Doyle Literary File Photography Collection, Harry Ransom Center, University of Texas at Austin, 957:0114:0346

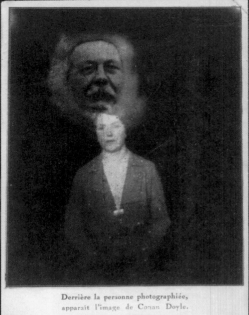

fig. 90 *Derriere la personne photographiee, apparait l'image de Conan Doyle* (Behind the photographed person, appears the image of Conan Doyle), 1930s, gelatin silver print, 5 × 3¾ in. (12.7 × 9.5 cm), Collection of Tony Oursler

Derrière la personne photographiée, apparaît l'image de Conan Doyle.

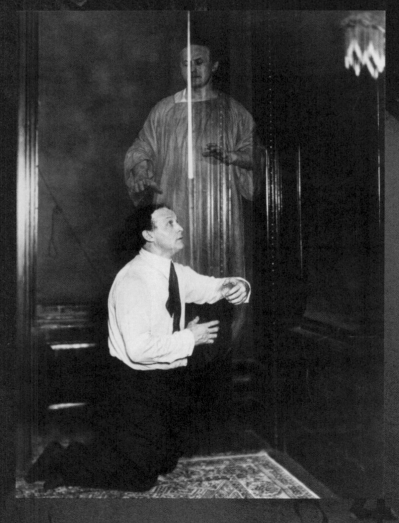

fig. 91 Harry Houdini (1874–1926), Spiritualist image of Houdini appearing to Houdini, about 1920, gelatin silver print, 9 × 7 in. (22.9 × 17.8 cm), Collection of Tony Oursler

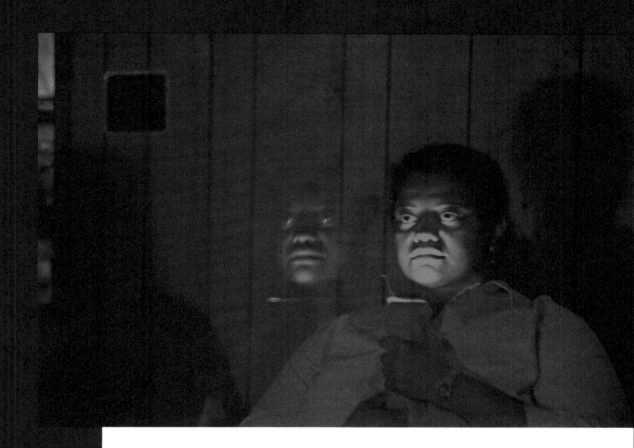

unscrupulous mediums become and how callous their consciences" for deluding and manipulating their victims' emotions.[25] To prove his point, he created humorous demonstration hoax photographs, such as one in which he appears both living and as a ghost (fig. 91). But in a world increasingly accustomed to darkroom tricks in commercial photography and the new special effects of the cinema, his images had little shock value. The apparitions of double exposure were more an article of faith than empirical evidence, as seen in the return of Spiritualism's patron saint Doyle's frequent appearances from beyond the veil in the photographs of believers (fig. 90).

Spirit photography proceeded to influence popular culture. The iconography of spirits and specters is commonplace in horror and fantasy, and it also appears in fine art and photography, from the Surrealists to the present. The photo-based artist Shannon Taggart takes up the legacy of spirit photography in a long-term project exploring the endurance of Spiritualist belief around the world. Neither proving nor debunking claims of the supernatural, her work evokes the vivid textures of séance rooms and psychic studios, embracing the drama and mystery as believers continue to pierce the boundaries between material and spiritual domains (fig. 92). Although these Spiritualist communities may be at the margins of mainstream belief, they represent a persistent human desire to connect with the ineffable beyond.

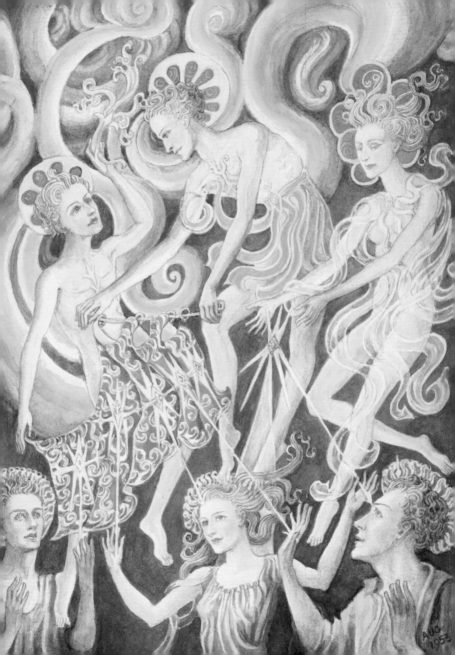

IMAGINING ETHEL LE ROSSIGNOL

May 24th, 1920.... Then came a picture of a figure draped in a garment.... "You have been very careful in drawing for me and have made a good picture of a spirit form. But you must understand I draw a figure with draperies, which are symbolical of speed and light, otherwise you would not see how we speed along in the sphere. Such movement is impossible for you to realise and when you draw you only see a wave of thought which reaches your mind. This idea is what I want you to seize, not the actuality. That is beyond your powers of expression in lines of drawing. You try when you draw to make every line visible but only the wave of thought is what I send, not a drawing of lines.... I am glad you are advancing in your drawing for me and you will find that the drawing will improve if you continue it constantly."

—J.P.F. / Ethel Le Rossignol[1]

IN THE SÉANCE ROOMS OF THE LATE NINETEENTH AND

early twentieth centuries, women found freedom from the patriarchy of traditional religions. The new mediumistic activities that allowed direct contact and communication with the spirit world were also used as a means for art production. Among these Spiritualist artists were Georgiana Houghton, a painting medium who was also a pioneer in the development of British spirit photography using her mediumistic skills to contact the spirits (fig. 95 and see p. 104, fig. 85); Madge Gill, a self-taught British artist who claimed that her spirit guide "Myrninerest" worked through her to create artworks (fig. 96); and the American Mina Crandon, known as Margery the Medium, who some may argue bested Harry Houdini with her physical mediumship (see p. 66, fig. 51). One of the most prolific and least known of these artists was Ethel Le Rossignol, whose life and work are emblematic of the rapid changes in the world across the religious, social, scientific, and artistic landscape.

Le Rossignol, born in Argentina to a British family in 1873, was nineteen when they returned to Kensington, England. It is not known when and how she became involved with art making, but she apparently received some formal art instruction in London. Her efforts before 1920 were quotidian and traditional, depicting landscapes in watercolor, most likely reproducing what she saw in nature. How could a woman who made such

by TONY OURSLER

111

unremarkable works suddenly be inspired to produce the luminous floating worlds of ethereal creatures surrounded by shimmering spectrums of colors that seem to prefigure the psychedelic era some fifty years in the future? Though Le Rossignol remains a mysterious figure, we have many clues that lead us toward a possible understanding of her startling works, which are just now being integrated into the canon of art history.[2]

Theosophy, cofounded in New York City in 1875 by Madame Blavatsky (Helena Petrovna Blavatsky), was a new religion that combined Western esoteric and occult movements with facets of Hinduism and Buddhism. Theosophy expanded to Europe, with its headquarters set up in London in September 1887. The syncretic religion attracted two extremely productive members, Annie Besant and Charles W. Leadbeater, who published a series of influential and richly illustrated books: *Man Visible and Invisible* (1903), *The Other Side of Death* (1903), and the New Age masterpiece *Thought-Forms* (1905) (fig. 94). Published around the same time that Albert Einstein articulated his theory of relativity and that long-distance radio transmissions began, these books and pamphlets visualized a mystical world of codified emotions, auras, visualized thoughts, and astral planes.

As quickly as the modern world disenchanted all that was spiritual, natural, and mythological, the Theosophical project made the case for re-enchantment. Within nine years, World War I would alter everything, including art. Cubism and Dada were visual reactions, contemplations on the changing human position within the rapidly evolving machine age. Technology—once a celebration of speed, power, and accuracy—now revealed a darker side of progress: during the war, the machine gun, at an unprecedented scale, and poison gas would be used on troops for the first time, with devastating effect. There were also positive strides forward in the sciences during the war and in the years after, such as the discovery of penicillin, which would save millions of lives. It is through these lenses that Le Rossignol would have seen the world, and for a visual artist the act of seeing was quickly changing.

Physics built upon Isaac Newton's use of a prism to discover the rainbow spectrum, adding powerful invisible energies, which suggested otherworldly possibilities to some. Was the afterlife scientifically provable? In an interesting nexus of religion and science, some Spiritualists were in fact atheists, proposing a godless afterlife. Visual perception was extended as the forces of nature were revealed and harnessed to allow us to see inside the body with X-rays and deeper into space with more powerful telescopes, and to

fig. 94 Plates 4 and 10 from *Thought-Forms*, by Annie Besant and Charles W. Leadbeater, 1905 Collection of Tony Oursler

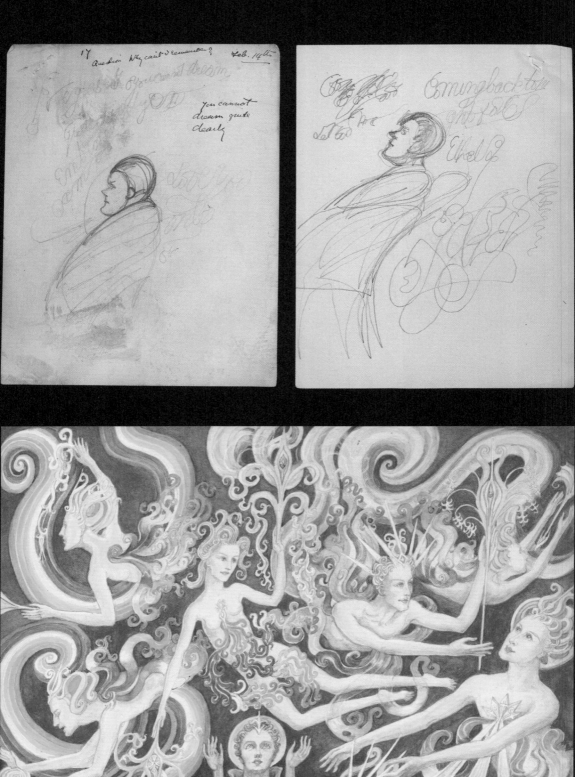

fig. 97 Ethel Le Rossignol (1873–1970), Automatic writing manuscripts, 1920s, pencil and ink on paper, each 8 ¾ × 7 in. (22.2 × 17.8 cm), Collection of Tony Oursler

fig. 98 Ethel Le Rossignol (1873–1970), *Master presences radiate power throughout the way…*, 1954, gouache on art board, 7 ½ × 11 in. (19.1 × 27.9 cm), Collection of Tony Oursler

observe quantum operations of light. Echoes of these discoveries appear in the oil-painted standing-wave schematics of early abstraction.

When war broke out in 1914, Le Rossignol was called upon to serve as a nurse in France. One can only imagine the horrors she would have witnessed and how they would inform her attraction to the mystical movements at the time. For many, various forms of Spiritualism and Theosophy offered an alternative balm for the traumatized public adrift by the end of the conflict. It was evident that traditional social structures and religions struggled to respond to the heavy casualties of a war they had failed to prevent. Le Rossignol would have been keenly interested in the fact that women could vote in the United Kingdom in 1918, followed by the United States in 1920. She would have been affected by the cultural conditions in Europe that led some to believe, as Jennifer Farrell notes, that "after what they viewed as a final and necessary conflict ended, oppressive political systems (often dynasties whose various rulers were related by blood or marriage) would disappear and a more peaceful, spiritual, and anti-materialist era would begin."[3]

An abrupt artistic change occurred in 1920 when Le Rossignol used her brushes and colors to carve an astounding window into the unknown, revealing a speculative utopia. As with many cultural producers, Le Rossignol found her way to artistic innovation through personal tragedy and mediumistic practices. In 1920, she began to communicate with the spirit of a deceased friend referred to only as J.P.F., who instructed her in her new art-making enterprise. Sigmund Freud called the interpretation of dreams the "royal road to the knowledge of the unconscious" and encouraged stream of consciousness, a technique that Le Rossignol practiced through automatic writing, jotting down communications from J.P.F. (fig. 97). This practice resonates with concurrent movements in art at the time, such as the Surrealists' method of automatism.

In addition, many artists were open to a mixture of cross-cultural influences, as already exemplified by the Cubists looking to African art. Le Rossignol was influenced by Eastern entities such as Shiva and Dakini, and her kaleidoscopic paintings show traces of her exposure to the syncretic thinking and graphics of Theosophy (figs. 93, 98). She took this imagery into an uncharted future, however, imbuing her works with qualities of science fiction. For women at the turn of the previous century, these tropes offered palpable alternatives to repressive societally entrenched stereotypes. The arts were no different from other pursuits for women in this regard.

The séance rooms offered a liberating if bittersweet bypass for women like Le Rossignol, Houghton, Gill, and Crandon, who were interested in cultural production; they could disavow authorship of their own works by claiming to have been mere conduits for male spirits. These women, as if by magic, are now slowly appearing in art history.

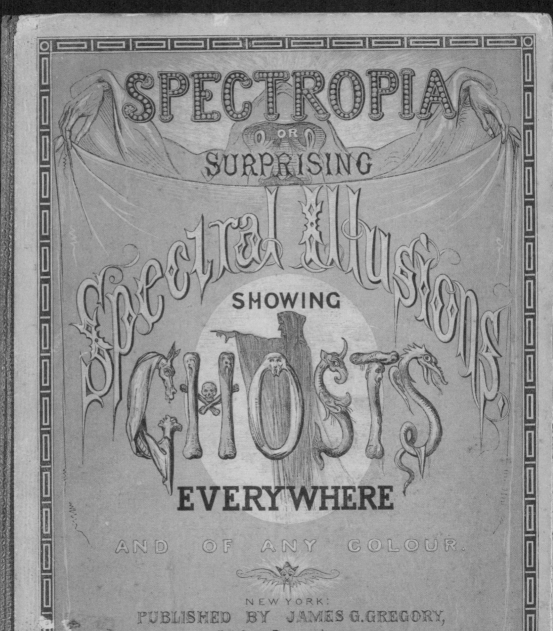

SPECTROPIA

OR

SURPRISING

Spectral Illusions

SHOWING

GHOSTS

EVERYWHERE

AND OF ANY COLOUR.

NEW YORK:
PUBLISHED BY JAMES G. GREGORY,
540 Broadway.

BELIEF IN THE BRAIN AND BODY

PEOPLE'S RESPONSES TO THE PHENOMENA OF SÉANCES and magic shows that emerged out of Spiritualism beautifully demonstrate how belief shapes identities, relationships, and society. The ubiquitous presence and prominence of belief are indisputable, yet some of the most fundamental questions about it remain elusive. Why do we believe what we do? How can different people develop opposing beliefs based on the same experience? Why do human beings believe at all, and what role does the human body play in determining and meeting that purpose?

The lens of neuroscience, the study of the nervous system, can clarify how we engage with and share the need for the *process of believing*, irrespective of *what it is* that we believe. The human nervous system includes the brain, spinal cord, and neurons throughout our body. It modulates our physiology and behavior to maintain holistic equilibrium within our bodies and allows our inner "self" to interface with the outside world. As such, one could argue that comprehending the somatic factors and processes that underlie human belief is fundamental to understanding oneself and others.

To understand "belief" as a human experience, we must first define it and what it means to believe. Colloquially, *to believe* is "to consider to be true or honest; to accept the word or evidence of."[1] From a neuroscience perspective, belief is a human ability, an aspect of normal mental functioning, with which people *make meaning* of their experiences. Beliefs, in turn, guide behavior. Accordingly, some neuroscientists consider the ability to believe to be one of the "building blocks of intelligent behaviour" characteristic of human beings as a species.[2]

According to some scientific models, belief involves three categories of neural processes: *perception*, *valuation*, and *action*.[3]

Perception is the process by which we gather information about our environment (sensory input) and in our own bodies (physiology) through our sensory systems. Using exteroceptive senses such as sight, sound, taste, touch, and smell, we can become aware of various characteristics of our environment and discern, for example, information about objects' shape, size, color, texture, sound, and distance from us. Using interoceptive senses, we

by TEDI E. ASHER

fig. 100 (below, right, and following pages) Illustrations from Spectropia

get signals about our own state of being, such as levels of stress hormones, heart rate, blood pressure, sweat production, and body temperature. But what this information *means* depends on who is making meaning of it.

Valuation is the process by which we attribute personal meaning to the information gathered via perception, how we understand (consciously or unconsciously) our experiences.[4] Valuation draws upon multiple systems in the brain, including those that mediate cognition, memory, and emotion. These systems integrate and process exteroceptive and interoceptive sensory information, allowing us to identify objects and people, associate them with danger or safety based on past experience, relate them to our own identity, and guide our behavior.

Action is how we engage with the environment and ourselves based on our subjective understanding of our experiences generated through the perception and valuation processes. Our actions, in turn, often give us access to more sensory information, allowing us to reassess and update our understanding and behavior.

A *belief*, then, is an understanding about one's own experience that results from the dynamic interplay among these three processes in the human brain and body.

A variety of factors modulate the dynamics of these belief-generating processes. Some relate to how sensory information is detected (contextual factors), while others relate to one's unique life experience (idiosyncratic factors). Contextual factors include the duration of a sensory experience, the clarity of the sensory information, the amount of sensory information someone encounters simultaneously, and repetition of the sensory experience. Idiosyncratic factors include one's expectations for a given experience, the focus of one's attention, associations developed based on past experience, and the emotional significance of experience elements.

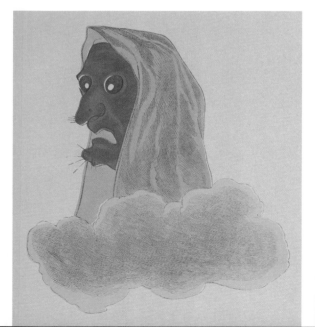

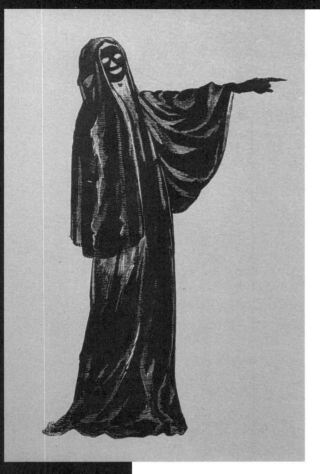

While we are often aware of the differences among people's beliefs, we tend to be less conscious of the origins of these differences. This is because most belief-generating neural processing occurs subconsciously. Even for the beliefs we hold most strongly, and upon which we act most passionately, we often are not cognizant of how or why they came to be, nor that their origins are fundamentally rooted in our bodies.

An awareness of the dynamics underlying human belief can be powerful. It can, in essence, serve as a strategic tool with which to shape the experiences and beliefs of others, to learn about others, and to access agency in one's own life. In the age of Spiritualism, magicians and mediums both used an implicit understanding of the mechanisms underlying human belief to recruit audiences to their performances and cultivate followings. Magicians candidly used techniques such as sleight of hand or optical illusions to persuade audiences of the apparent "magic" in their performances. Similarly, though perhaps with more dubious intentions, some mediums use the darkened séance room to their advantage when "conjuring" spirits.

The dynamics underlying human belief can also help to explain how people can develop such different beliefs from the same contextual experience. During the late nineteenth and early twentieth centuries, some people believed that mediums communed with the dead; some believed that magicians produced supernatural feats; and some believed neither. Many of the objects born out of the age of Spiritualism were meant to serve as evidence supporting or refuting supernatural phenomena, reflecting the perceived need—then and now—for tangible proof to validate an assertion.

This complex relationship among objects, people, and belief systems is exemplified by a slim volume published in 1864 by J. H. Brown (fig. 99). Titled *Spectropia*, the book was authored with the motivation to dispel the all-too-commonplace "superstitious belief that apparitions are actual spirits, by showing some of the many ways in which our senses may be deceived."[5] It was marketed, however, as a parlor entertainment that sensationalized the perception of spirits.[6] Indeed, for many, Brown's attempt to explain away visual apparitions using scientific evidence and physiologically based visual mechanisms was insufficient to sway those who believed in the ability of the living to access the dead.

Brown alludes to a common scenario in which "a person may, after looking steadily, and as often happens, unconsciously for a short time at

printed or painted figures, on paper, porcelain, etc., see, on turning the head in some other direction, a life-sized or colossal spectre."[7] Looking briefly at one of the sixteen images in the book (fig. 100) and then turning one's gaze away causes the viewer to perceive a negative version of the original image: a floating white translucent figure. Such visual effects result from the way environmental elements (here the black-on-white print) differentially stimulate areas of the retina (the light-sensitive tissue in our eyes). The visual impression may be understood as a ghost or as a physiologically generated visual aftereffect, depending on contextual and idiosyncratic factors that modulate a given individual's valuation of the visual information.

War and scientific advancement were two contextual factors during the late nineteenth and early twentieth centuries that significantly influenced how individuals engaged with Spiritualist beliefs. During the Civil War and World War I, many people lost loved ones in battle far from home, and they were thus unable to bury and mourn them in traditional ways. This made supernatural means of communing with the dead all the more enticing. Concurrently, science was generating new understandings about the human body. Newly revealed physiological mechanisms primed some with skepticism and lent scientific evidence with which to refute Spiritualist beliefs.

Against this backdrop, one can imagine two very different reactions to the same encounter with *Spectropia*. Consider the scenario of a grief-stricken widow whose late husband was killed in battle during the Civil War and her nephew, studying science at the university, who had never met his uncle. Seated side by side in a sitting room one evening, they both glance at a print in the book lying open on the side table between them. Their gaze is interrupted when their hostess hands them each a cup of tea. The nephew accepts his teacup, chuckling at the image in the book, which he recognizes from his university course on sensory physiology. He is startled, though, when his aunt gasps and turns pale as she looks up to accept her teacup.

Although the widow and her nephew may both have experienced a visual afterimage after looking at a print in *Spectropia*, they understood their experiences quite differently. The widow's belief that her perception of a ghostlike figure was the spirit of her dead husband is rooted in the way her cognitive systems focus her attention on her memories of him rather than on the exteroceptive information about the objects in front of her. For her, there is great significance in being able to connect with the dead, causing high emotional activation physiologically upon her visual perception and a strong drive to believe in the apparition. Conversely, the nephew has no memories of his late uncle or any real emotional turmoil over his death. He is able to notice the details of his surroundings and process them largely with logical cognitive systems rather than with reactive ones. He thus understands his visual perception as a physiologically generated afterimage, a concept with which he is already familiar from his studies.

How people understand their experiences often contributes to their sense of self, their *identity*. It is conceivable, then, how we can so often find

ourselves in polarized relationships among different systems of belief and associated identities. The way people make meaning of their experiences and form beliefs and identities dictates that objects and *objectivity* are inherently susceptible to the *subjectivity* that is inextricable from human nature. As individuals and as communities, we can strive to mitigate our own tendencies toward divisiveness by intentionally and thoughtfully traversing some of the boundaries separating "differences."

Today, we are overwhelmed with domestic and international conflicts rooted in the very same fundamental realities about the nature of "proof" and belief that characterized the age of Spiritualism. We can catalyze enhanced agency, and perhaps even unity, by being mindful that the significance of objects, events, information, and even the sensations we each feel within our own body is subject to the way that a given individual experiences and interprets them. In a sense, then, this essay proposes that choosing to learn why — and how — people believe what they do may help individuals find respect for one another, without the need for either agreement or deleterious conflict.

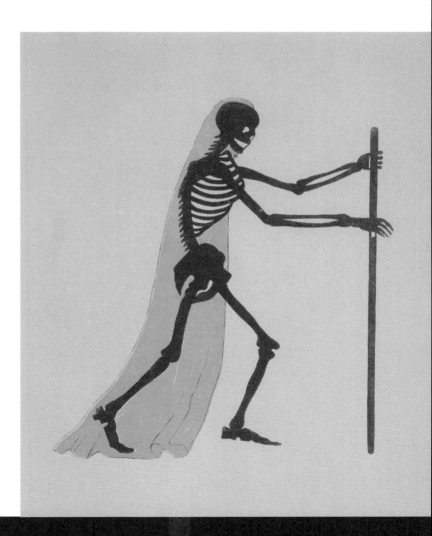

CODA

by GEORGE H. SCHWARTZ

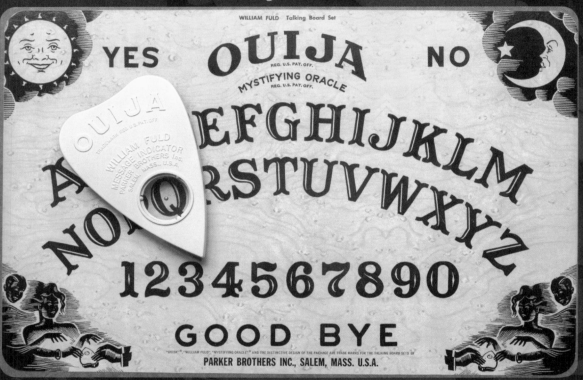

PUBLIC INTEREST IN SPIRITUALISM AND SÉANCES WANED

during the Great Depression and after World War II.[1] At the same time, the growing popularity of Hollywood films led to the collapse of the large, traveling magic shows on the vaudeville circuit, replaced by smaller performances in clubs that did not rely on big illusions.[2] The spook shows of the first half of the twentieth century, which combined live performance with horror and other B movies and were more entertainment than a quest for spirit communication, incorporated the remnants of large spirit act performances. Most popular in the 1940s and early 1950s, many spook shows were Spiritualist-themed and incorporated spirit illusions (figs. 102–104).[3]

While Spiritualist churches, camps, and other associations exist today, the number of adherents and disciples has diminished. The central tenets of Spiritualism, however, have stayed alive in popular culture. In the early days of motion pictures, short exposés, such as *Le portrait spirituel* (*A Spiritualistic Photographer*, 1903) and *L'armoire des frères Davenport* (*Cabinet Trick of the Davenport Brothers*, 1902) by the French illusionist and early cinema pioneer Georges Méliès, mocked or exposed the methods of fraudulent mediums. Hollywood films in the first half of the twentieth century, such as *The Spiritualist* from 1948, continued this anti-Spiritualist message (fig. 105).[4] After that point and to this day, feature films have depicted séances from different perspectives, while reality television series have shown psychics who purport to connect with the departed. Popular attractions such as the Haunted Mansion at Disney theme parks use the Pepper's Ghost illusion, which has also been employed in the entertainment industry to resurrect artists like the 1990s rap icon Tupac Shakur "back" onstage to perform with living artists. The 2022 smartphone app HereAfter AI lets the living communicate with a virtual form of the dead created using artificial intelligence.[5]

With regard to material culture connections, some contemporary mediums continue the tradition of spirit portraiture, and ghost-hunting devices are available for anyone to purchase online.[6] Magic companies such as Abbott's Magic Shop in Colon, Michigan (established 1934), sell talking skulls, spirit slates, and spirit painting sets derivative of early twentieth-century examples. The American artisan John Gaughan, who has spent more than fifty years inventing and designing illusions for celebrated magicians and theatrical entertainers, makes apparatuses in the classic nineteenth-century style, such as a spirit clock inspired by Jean-Eugène Robert-Houdin's creations (fig. 106). Premier among the objects born in the age of Spiritualism that remain popular today is the Ouija board. Developed in the late nineteenth century as the blending of planchettes and tabletop alphabet boards that were used in Ohio-based Spiritualist camps, the Ouija board is an object whose origins are shrouded in a bit of mystery mixed with outlandish tales. Purportedly, when Charles Kennard of Baltimore and the investors he pulled together to manufacture and market this new device in 1890 sat with a medium and asked the board what they should call it, the object, expressing agency as a *thing*, named itself.[7]

fig. 101 Parker Brothers, Salem, Massachusetts, *Ouija Mystifying Oracle*, 1967, Masonite, cardboard, and plastic, board: 11 ½ × 17 ⅝ × ⅛ in. (29.2 × 44.8 × 0.3 cm), planchette: 5 ⅞ × 3 ⅞ × ⅞ in. (14.9 × 9.8 × 2.2 cm), Peabody Essex Museum, gift of Shannon Planka, 1985, 136861.1-3

Long viewed as a means for spirit communication, the Ouija board was used by the St. Louis–based journalist Emily Grant Hutchings and medium Lola V. Hays to create *Jap Herron: A Novel Written from the Ouija Board* (1917). Hutchings and Hays claimed that the spirit of Mark Twain had dictated the book to them over a two-year period. It caused quite a stir with Twain's estate and his publisher, Harper & Brothers, who argued the novel violated intellectual property if the authors and their publisher, Mitchell Kennerley, asserted it was written by the deceased Twain. Hutchings eventually settled in 1918, before the case came before the U.S. Supreme Court. When the *New York Times* reviewed the book, it scoffed, "If this is the best that 'Mark Twain' can do by reaching across the barrier, the army of admirers that his works have won for him will all hope that he will hereafter respect that boundary."[8]

During World War I and the 1918 influenza pandemic, Ouija boards appealed to many people who tried to connect with lost loved ones. But they were also used by those with little or no interest in Spiritualism to entertain in the parlor or to play with on a date. The American artist Norman Rockwell whimsically captured this sentiment in his painting *The Ouija Board*, which featured on the cover of the *Saturday Evening Post* of May 1, 1920 (fig. 107). Manufactured by William Fuld and his children for most of the twentieth century as the "mystifying oracle," their Ouija board was purchased in 1966 by Parker Brothers of Salem, which sold two million copies the following year, making it more popular than Monopoly (fig. 101).[9] While some believe the planchette moves on the board through spirit activation, others attribute it to ideomotor response. The planchette, according to the American psychologist Terence Hines, is "guided by unconscious muscular exertions like those responsible for table movement," so the illusion that it is moving "under its own control is often extremely powerful and sufficient to convince many people that spirits are truly at work."[10]

The Ouija board was reviled by some organized religions as a tool of the devil. This was cemented in the public imagination in a film that forever changed how some people look at the device: William Friedkin's 1973 horror movie *The Exorcist*, where a Ouija

fig. 102 Skeleton prop for a spook show, 1940s–1950s, wood, paint, and metal, approx. 51 × 18 ½ in. (129.5 × 47 cm), Collection of Tony Oursler

fig. 103 Triangle Poster & Printing Company, Chicago, *Mel Roy on the Stage, Midnite Spook Party, Talking Skulls, Spirit Date Writing, Spirit Table Raising, Ghosts from the Dead,* 1935, lithograph, 28 3/8 × 22 in. (72.1 × 55.9 cm), Library of Congress, McManus-Young Collection

fig. 104 Central Show Printing Company Inc., Mason City, Iowa, *5 Big Happenings of Horror!… Do the Dead Return? Do You Believe in Ghosts? You Must See to Believe!,* 1960s, lithograph on cardboard, 22 × 14 in. (55.9 × 35.6 cm), Collection of Tony Oursler

fig. 105 Morgan Lithograph
Company, Cleveland,
The Spiritualist, 1948,
lithograph, 81 × 41 in.
(205.7 × 104.1 cm),
Collection of Tony Oursler

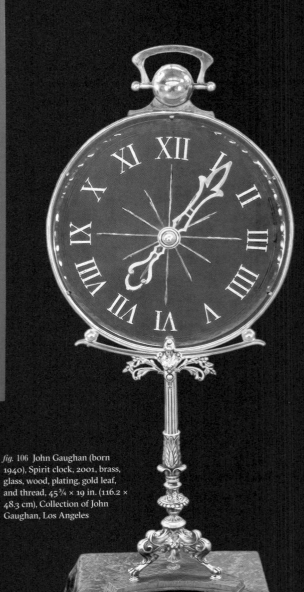

fig. 106 John Gaughan (born
1940), Spirit clock, 2001, brass,
glass, wood, plating, gold leaf,
and thread, 45¾ × 19 in. (116.2 ×
48.3 cm), Collection of John
Gaughan, Los Angeles

board served as the portal for Regan's possession by a demon. Whether viewed as a harmless game or as a mechanism for accessing the spirit world, the Ouija board has endured as a popular object across generations. It is the material legacy of our continued desire to believe we can communicate with the dead through art and objects, no matter if the spirits return or not.

fig. 107 Norman Rockwell (1894–1978), *The Ouija Board*, 1920, oil on canvas, 27 × 24 in. (68.6 × 61 cm), Private collection

EPIGRAPH, p. 5

Ricky Jay, 'Twixt Two Worlds: Selections from the Collection of Ricky Jay, exhibition broadside (Davis: Nelson Gallery at the University of California, Davis; New York: Christine Burgin, 2005).

FOREWORD, p. 14

1 Marina Warner, *Phantasmagoria: Spirit Visions, Metaphors, and Media into the Twenty-First Century* (New York: Oxford University Press, 2006), 309.
2 Ricky Jay, 'Twixt Two Worlds: Selections from the Collection of Ricky Jay, exhibition broadside (Davis: Nelson Gallery at the University of California, Davis; New York: Christine Burgin, 2005).
3 Nicholas R. Bell, *Wonder* (Washington, DC: Smithsonian American Art Museum in association with D. Giles Limited, London, 2015), 19.
4 John Rogers, *Groups of Statuary* (New York, 1889), 10.

INTRODUCTION, p. 20

1 These devilish creatures whispering in the ear of conjurers were first incorporated into poster design in 1894 for Thurston's predecessor Harry Kellar, who may have been the inspiration for L. Frank Baum's wizard in *The Wizard of Oz*.
2 Jim Steinmeyer, *The Last Greatest Magician in the World: Howard Thurston versus Houdini & the Battles of the American Wizards* (New York: Jeremy P. Tarcher/Penguin, 2011).
3 For more on the influence of early nineteenth-century Shaker spirit communication, including the connections between gift drawing and mediumistic spirit painting, see France Morin, *Heavenly Visions: Shaker Gift Drawings and Gift Songs* (New York: Drawing Center; Los Angeles: UCLA Hammer Museum; Minneapolis: University of Minnesota Press, 2001); and Jane F. Crosthwaite, "A Silver Light and a Golden Wheel: Shaker Gift Drawing and Sacred Text as a Communal Enterprise," *Communal Societies* 33, no. 2 (December 2013): 29–52.
4 At the start of the Civil War, about 240,000 people in New York State (6 percent of the total population) practiced Spiritualism. In the South, a good portion of the population were Spiritualists (for example, 20,000 people in Louisiana), even though the progressive and

abolitionist tenets of Spiritualism were at odds with Southern slavery. See Drew Gilpin Faust, *This Republic of Suffering: Death and the American Civil War* (New York: Alfred A. Knopf, 2008), 181, quoted in Jeremy Bohonos, "Spiritualism and Gender: Questions of Leadership & Masculine Identity" (MA thesis, Ball State University, 2012), 3–4.
5 For more on the impact of Spiritualism on British households in the mid-nineteenth century, see Aviva Briefel, "'Freaks of Furniture': The Useless Energy of Haunted Things," *Victorian Studies* 59, no. 2 (Winter 2017): 209–34.
6 The Fox sisters sheet music documents a tune that was purportedly communicated from the spirit world to the oldest Fox sister, Leah Fish, as recorded in Ann Leah (Fox Fish) Underhill, *The Missing Link in Modern Spiritualism* (New York: Thomas R. Knox & Co., 1885), 415–20. For more on the role of sound, music, and listening to Spiritualism, see Codee Ann Spinner, "Resonant Spirits: Spiritualism, Music, and Community in Lily Dale, NY (1848–1920)" (PhD diss., University of Pittsburgh, 2021). Music also was an important aspect of magic performances.
7 John Benedict Buescher, "Cornering the Market on Fraud: Stage Magicians versus Spirit Mediums," *Magic, Ritual, and Witchcraft* 9, no. 2 (Winter 2014): 210; Simone Natale, *Supernatural Entertainments: Victorian Spiritualism and the Rise of Modern Media Culture* (University Park, PA: Penn State University Press, 2016), 2.
8 This is best explained by John Cutter (played by Michael Caine) at the end of Christopher Nolan's 2006 film on rival magicians in Victorian London, *The Prestige*: "Every great magic trick consists of three parts or acts. The first part is called 'The Pledge.' The magician shows you something ordinary: a deck of cards, a bird or a man. He shows you this object. Perhaps he asks you to inspect it to see if it is indeed real, unaltered, normal. But of course . . . it probably isn't. The second act is called 'The Turn.' The magician takes the ordinary something and makes it do something extraordinary. Now you're looking for the secret . . . but you won't find it, because of course you're not really looking. You don't really want to know. You want to be fooled. But you wouldn't clap yet. Because making something disappear isn't enough; you have to bring it back. That's why every magic trick has a third act, the hardest part, the part we call 'The Prestige.'"
9 Jules David Prown, "Mind in Matter: An Introduction to Material Culture Theory and Method," *Winterthur Portfolio* 17, no. 1 (Spring 1982): 3.

10 Bill Brown, "Thing Theory," *Critical Inquiry* 28, no. 1 (Autumn 2001): 4. An interruption can also be metaphysical, such as when the holder of the glass realizes that it had been a cherished item belonging to a grandparent.

11 Joel S. Schwartz, *Darwin's Disciple: George John Romanes, a Life in Letters* (Philadelphia: American Philosophical Society, 2010), 136, 220–21, 470–86.

12 Bohonos, *Spiritualism and Gender*, 4. Bohonos also argues that men still dominated the Spiritualist press and countered some of the liberating aspects of the movement for women.

13 Born enslaved, Brown mailed himself from Richmond, Virginia, to Philadelphia in a crate measuring 3 by 2 ½ by 2 feet, with assistance from two other men. He wrote and lectured on his experience in the Northeast, and after the passage of the Fugitive Slave Act in 1850, he moved to the United Kingdom, where he learned magic and acted in semiautobiographical plays written specifically for him by the minor British playwright E. G. Burton. Brown went on to perform panoramas of his experience and stage shows involving magic, mesmerism (hypnosis), phrenology, and even dark séances in the United States, the United Kingdom, and Canada. For more on Brown's story, see Henry Box Brown, *Narrative of the Life of Henry Box Brown, Written by Himself* (Manchester, UK: Lee and Glynn, 1851); Kathleen Chater, *Henry Box Brown: From Slavery to Show Business* (Jefferson, NC: McFarland, 2020); and Martha J. Cutter, *The Many Resurrections of Henry Box Brown* (Philadelphia: University of Pennsylvania Press, 2022).

MEDIUMS, MAGICIANS, MAKERS, p. 33

1 Translated in R. Bruce Elder, *Harmony + Dissent: Film and Avant-garde Art Movements in the Early Twentieth Century* (Waterloo, Ont.: Wilfrid Laurier University Press, 2008), 104. Elder notes that Robertson would speak to the audience at the end of the show and "offer to conjure up the spirits of their loved ones who had departed the earthly realm" (104).

2 Pepper's book also featured a new illusionary effect, the Metempsychosis, where a performer appears to transform one object into another.

3 J. H. Brown, *Spectropia; or, Surprising Spectral Illusions. Showing Ghosts Everywhere, and of Any Colour* (New York: James G. Gregory, 1864); *Boston Evening Transcript*, September 15, 1864, and March 10, 1866. The *Salem Register* remarked, "The tribe of scientific ghost-seers will be likely to multiply greatly" from this book; quoted in the *Portsmouth Journal*, September 3, 1864.

4 John Gaughan, as told to Dustin Stinett, "Balsamo: The Living Skull," *Genii: The Conjurors' Magazine* 74, no. 10 (October 2011): 26; David P. Abbott, *The Marvelous Creations of Joseffy* (Chicago: Open Court, 1908), 7–9. Most talking skulls were made out of papier-mâché or wood.

5 Robert J. Albo, *Still Further Classic Magic with Apparatus*, vol. 5 (Jostens Printing and Publishing, 1985), 244; Ken Klosterman, with Gabe Fajuri, *Salon de Magie* (Loveland, OH: Kenneth Klosterman, 2006), 207. Charles F. Fillebrown of Salem, Massachusetts, considered the oldest professor of magic in the United States near the end of the nineteenth century, owned a talking skull made by "Mr. Chase, of Boston, celebrated maker of conjuring apparatus." Fillebrown's wife received it "neatly packed in a large pail" and, believing it was a package of butter, "at once proceeded to open the package." H. J. Burlingame, *Leaves from Conjurers' Scrap Books or, Modern Magicians and Their Works* (Chicago: Donohue, Henneberry & Co., 1891), 21.

6 Up to this point, most spirit communication focused on noises such as table rapping or the movement of objects such as table tipping. Mediums who channeled the dead in this manner condemned materialization "as an impudent impersonation" and viewed trance mediums as "either audacious pretenders or victims of their own delusions." "Table Tipping Spirits: A Superstition Which Has Never Been Exploded," *New York Times*, May 3, 1885, 4.

7 Psychologist Richard Wiseman and magician and historian Mike Caveney argue that magic posters should also be seen as "an integral part of the show itself" if viewed through a psychological and advertising lens, changing "customers' perceptions, experiences, and memories," swaying "spectators' memory for magic," and leading "people to develop false memories." Richard Wiseman and Mike Caveney, "Magic Posters and the Manipulation of Memory," *Genii: The Conjurors' Magazine* 84, no. 8 (August 2021): 17–19.

8 On the history of the spirit cabinet, see the essay by Mark Schwartz in the present volume.

9 Massimo Polidoro, "William S. Marriott's *Gambols with the Ghosts*," *Skeptical Inquirer* (March/April 2003): 34. While *Mahatma* focused mostly on magicians, it did incorporate announcements and advertising pertaining to Spiritualists, as noted by the editor: "All of our readers are requested to co-operate with the editor to make this journal a concensus of news interesting to Magicians, Mesmerists, Jugglers and Spiritualists." George H. Little, "To *Mahatma*'s Readers," *Mahatma* 1, no. 2 (April 1895): 2.

10 "Spirits Artists," *Spiritual Telegraph*, April 22, 1854, 202. This article focuses on the work of Josiah Wolcott, who was originally a skeptic of Spiritualism before attending a séance in 1853. While the article characterizes Wolcott as an untrained artist, he actually studied under well-respected landscape painter Thomas Doughty in the late 1830s. See Justin T. Clark, *City of Second Sight: Nineteenth-Century Boston and the Making of American Visual Culture* (Chapel Hill: University of North Carolina Press, 2018), 134–36.

11 "Secure the shadow e're the substance fade," advertising broadside printed in New London, Connecticut, November 16, 1848, American Antiquarian Society, American Broadsides and Ephemera, Series 1, no. 7103.

12 Andrew V. Rapoza, *Promising Cures: The Pursuit of Health in a 19th Century New England Community: Lynn, Massachusetts*, vol. 2, *Mid-Century Choices* (Oak Ridge North, TX: Andrew V. Rapoza, 2022), 396. A year earlier, Fenton created a portrait of a boy named Natty, who had died in 1815, for a group led by the former Unitarian minister turned Spiritualist author Allen Putnam and Boston mediums. They purportedly communicated with the spirit of the boy, who asked them to find Fenton to paint his portrait. The story is recounted in greater detail in Allen Putnam, *Natty, a Spirit: His Portrait and His Life* (Boston: Bela Marsh; New York: Partridge and Brittan, 1856).

13 On the advice of local mediums and clairvoyants, Marble purchased the land from the noted Spiritualist Jesse Hutchinson Jr., a member of the popular American singing troupe the Hutchinson Family, which supported progressive causes such as abolition.

14 Rapoza, *Promising Cures*, 398. "Passed to spirit life" appears on Marble's headstone.

15 B.P.S., "A Late Visit to Dungeon Rock," *Boston Saturday Evening Gazette*, September 25, 1858; "Treasure Digging and Spiritualism in Massachusetts," *Holmes County Republican* (Millersburg, OH), from the *Salem Observer*, October 15, 1857; "The Hermit Suicide . . . Portraits Executed in Oil and Crayon under Spirit Guidance," *Boston Globe*, March 14, 1886. The *Salem Observer*'s account, reprinted in many newspapers across the United States, notes, "Mr. Marble has been engaged at the place for six years past in what he considers to be a spiritual mission, and in what most other people consider to be a wild and absurd undertaking. . . . Mr. Marble says his object is not money or treasure, but to investigate 'spiritualism' and establish its truth."

16 "Dungeon Rock: A Curious Mixture of Avarice and Superstition, from the *New York Evening Post*," *Daily Missouri Republican*, September 1, 1867. Arabella appears wearing a string of pearls that, according to local mediums, the spirits said would be found in the cave.

17 Kevin Young, *Bunk: The Rise of Hoaxes, Humbug, Plagiarists, Phonies, Post-Facts, and Fake News* (Minneapolis: Graywolf Press, 2017), 53.

18 Molly McGarry, *Ghosts of Futures Past: Spiritualism and the Cultural Politics of Nineteenth-Century America* (Berkeley: University of California Press, 2008), 15. See also Kathryn Troy, *The Specter of the Indian: Race, Gender, and Ghosts in American Séances, 1848–1890* (Albany: State University of New York Press, 2017), 151–52.

19 "An Adroit Humbug Exposed," *Norwich Aurora*, November 5, 1873.

20 *Religio-Philosophical Journal* 41, no. 16 (December 11, 1886): 4; *Religio-Philosophical Journal* 22, no. 19 (July 21, 1877): 5.

21 "An Astounding Novelty, and Wonder of the Age," *Morning Chronicle*, August 11, 1868. I would like to thank Brandon Hodge for sharing this advertisement. Most planchettes in the United Kingdom were teardrop-shaped.

22 See William D. Moore, "'To Hold Communion with Nature and the Spirit-World': New England's Spiritualist Camp Meetings, 1865–1910," in *Perspectives in Vernacular Architecture*, vol. 7, *Exploring Everyday Landscapes*, ed. Annmarie Adams and Sally McMurry (Knoxville: University of Tennessee Press, 1997), 230–48.

23 "The Little Wonder, 'Planchette,'" *Montreal Daily Witness*, April 18, 1868. I would like to thank Brandon Hodge for sharing this advertisement. Jennings's patent for his asymmetrical shield-like design also contained a four-inch-tall turned-wood spindle with a six-inch propeller-like indicator (missing from the example shown here) placed in the center hole, according to "Planchette," *Springfield Republican*, July 20, 1868. Brandon Hodge, email to the author, February 16, 2023.

24 "Planchette," *Hawaiian Gazette*, September 2, 1868, 3.

25 Dan Piepenbring, "The Photographer Who Claimed to Capture Abraham Lincoln's Ghost," *New Yorker*, October 27, 2017, accessed July 21, 2023, https://www.newyorker.com/culture/photo-booth/photographer-who-claimed-to-capture-abraham-lincoln-ghost.

26 For a full discussion of spirit photography, see the essay by Christopher Jones in the present volume.

27 See, for example, the discussion of Ethel Le Rossignol by Tony Oursler in the present volume.

28 Erika White Dyson, "Spiritualism and Crime: Negotiating Prophecy and Police Power at the Turn of the Twentieth Century" (PhD diss., Columbia University, 2010), 58; "A Female Cagliostro," *Frank Leslie's Illustrated Newspaper*, April 21, 1888, 155; "Diss Debar-Marsh," *Courier-News* (Bridgewater, NJ), April 6, 1888, 3. Marsh agreed to sell his Madison Avenue town house to Debar for a nominal sum.

29 Some investigators believed the Bangs sisters used spray airbrush equipment. Many of their portraits survive today in the museums of the two most prominent Spiritualist camps in the United States: Lily Dale, New York, and Camp Chesterfield, Indiana. Both camps continue to be summer gathering spots for believers and mediums, with daily Spiritualist activity ranging from lectures to séances to private readings and other common resort activities.

30 David P. Abbott, *The Spirit Portrait Mystery: Its Final Solution* (Chicago: Open Court, 1913), 11.

31 Magic collector Ken Klosterman notes that William Marriott of London had stolen the idea from Abbott and licensed it to English magician P. T. Selbit for the right to perform this illusion before Abbott published his book. Klosterman, *Salon de Magie*, 277.

32 Gardner Bradford, "Imagine Buying 'Voices from *beyond* the Grave!,'" *Los Angeles Times Sunday Magazine*, July 9, 1933, 12–13. Bradford concludes, "Thus does a dealer in mysteries acknowledge a Greater Magician and a greater mystery—a ghost maker who believes in ghosts."

33 David Charvet, *Alexander, The Man Who Knows: Mindreader, Charlatan, Extortionist, Bootlegger, Bigamist, Murderer, Magician*, 2nd ed. (Pasadena, CA: Mike Caveney's Magic Words, 2007), 25–26.

34 Charvet, *Alexander*, 71. According to the rival mentalist C. A. George Newmann, "Alexander undoubtedly had the finest, most varied and expensive line of special lithographic posters ever used by any magician." Quoted in Charvet, 71. Alexander claimed in *Alexander's Book of Mystery* (Los Angeles: C. Alexander Publishing Company, 1923), 70–71, that Jones was the originator of aura portraits and used crystal balls to produce them.

35 "Secrets Are Revealed at Pantages," *Los Angeles Times*, March 22, 1922.

36 "'Man Who Knows' Here This Week," *Los Angeles Times*, June 3, 1923.

37 David Copperfield, Richard Wiseman, and David Britland, *David Copperfield's History of Magic* (New York: Simon & Schuster, 2021), 44; Albo, *Still Further Classic Magic with Apparatus*, 213, 253, 363.

38 Purportedly, Samri Baldwin was associated with a Spiritualist church at the end of his life. John Benedict Buescher, "Cornering the Market on Fraud: Stage Magicians versus Spirit Mediums," *Magic, Ritual, and Witchcraft* 9, no. 2 (Winter 2014): 216.

39 "Amusements," *Portsmouth Star* (Portsmouth, VA), February 28, 1896, 3.

40 Mount was part of early New York City Spiritualist séance circles and claimed to have communicated with the spirit of the Dutch artist Rembrandt van Rijn. Deborah J. Johnson, "William Sidney Mount: Painter of American Life," in *William Sidney Mount: Painter of American Life*, ed. Deborah J. Johnson (New York: American Federation of Arts, 1998), 81, 105; Alfred Frankenstein, *William Sidney Mount* (New York: Harry N. Abrams, 1975), 11, 285.

41 "Great Psychic Medium," *Washington Reporter* (Washington, PA), July 28, 1914; "Ava Muntell—The World's Greatest Mind Reader," *Daily Courier* (Connellsville, PA), June 2, 1919; "Vaudeville's Greatest Sensation—Ava Muntell," *The Tribune* (Coshocton, OH), May 8, 1914, 5.

42 "Amusements," *News-Journal* (Mansfield, OH), May 12, 1914, 5.

43 "Personal," *Pittsburgh Press*, June 15, 1919, 57.

44 "Carter at Columbia Is Thrilling," *San Francisco Examiner*, September 10, 1918, 9.

45 Mike Caveney, *The Conference Illusions: Research, Rethink, Rebuild, and Restage Classic Illusions from Magic's Golden Age* (Pasadena, CA: Mike Caveney's Magic Words, 2013), 174.

46 *Houston Post*, April 11, 1915, 30. Thayer continued to develop his rapping hand, creating the version seen here, which was nearly identical to Carter's prop. It was part of a special Dr. Q line of products, named after a fictional mystic that Alexander and Thayer created in 1916 to augment the sale of spirit-themed apparatuses. This model included a wooden board that allowed a magician to perform the illusion for a small group up close. In the 1930s, Thayer was working on a rapping hand that "may be examined and passed about with impunity and will tap its answer on the very knees of its questioner." Bradford, "Imagine Buying 'Voices from *beyond* the Grave!,'" 12.

47 "Carter Tonight," *Honolulu Advertiser*, October 11, 1909, 10.

48 John Gerrard Keulemans attended four séances with Slade, and during two he thought that "Slade often resorts to cheating in order to induce the 'power' to manifest itself in a more regular way." "Curiosities of Henry Slade's Mediumship," *Religio-Philosophical Journal* 40, no. 15 (June 5, 1886): 4. Eglinton's methods

were exposed in articles published in the *Journal of the Society for Psychical Research* in 1886 and 1887. Janet Oppenheim, *The Other World: Spiritualism and Psychical Research in England, 1850–1914* (Cambridge: Cambridge University Press, 1988), 139–40.

49 John Gerrard Keulemans, "Phenomena Called 'Spiritual' Illustrated by Chromo-Lithography," *Light: A Journal of Psychical, Occult, and Mystical Research* 5, no. 218 (March 7, 1885): 114.

50 "'Twixt Two Worlds," *The Medium and Daybreak* 17, no. 825 (January 22, 1886): 57.

51 *Light: A Journal of Psychical, Occult, and Mystical Research* 5, no. 220 (March 21, 1885): 139. Keulemans declared in 1891, after further observations of mediums at séances, that "nearly all the so-called materialisations of the full 'form' are no independent beings at all, but always the medium himself in a state of transfiguration or transformation . . . acting under the influence of both extraneous spirits and self-suggestion." John Gerrard Keulemans, "Letters to the Editor: What Do Phenomena Mean?," *Light: A Journal of Psychical, Occult, and Mystical Research* 40, no. 529 (February 21, 1891): 94–95.

52 Melissa E. Buron, "'Twixt Two Worlds: The Visions of James Tissot" (PhD diss., Birkbeck College, University of London, 2021), 49; "The London Spiritualist Alliance," *Light: A Journal of Psychical, Occult, and Mystical Research* 6, no. 264 (January 23, 1886): 43. Tissot also gave copies of the mezzotint to acquaintances, including Newton's niece. Melissa E. Buron, "The Visions of Tissot," in *James Tissot*, ed. Melissa E. Buron with Krystyna Matyjaszkiewicz (San Francisco: De Young, Legion of Honor, Fine Arts Museums of San Francisco; Munich: Delmonico Books/Prestel, 2019), 325n24.

53 The advent of infrared photography in the early twentieth century allowed photography of séances in the dark. Some mediums were caught in the act of deception, such as speaking directly into trumpets.

54 Jeremy Bohonos, "Spiritualism and Gender: Questions of Leadership & Masculine Identity" (MA thesis, Ball State University, 2012), 39–40. In the banner image, Earth is surrounded by dark clouds and light shines down only on the eastern portion of the United States, to highlight it as both the main center of Spiritualism and the primary market for the periodical.

55 Brandon Hodge, "Dr. Robert Hare," Mysterious Planchette: A Survey of Curious Devices for Speaking to the Dead, accessed July 22, 2023, http://www.mysteriousplanchette.com/Manu_Portal/roberthare.html; Lisa Hix,

"Ghosts in the Machines: The Devices and Daring Mediums That Spoke for the Dead," *Collectors Weekly*, October 29, 2014, https://www.collectorsweekly.com/articles/ghosts-in-the-machines-the-devices-and-defiant-mediums-that-spoke-for-the-spirits/. The dial was based on the "Spirit Telegraph Dial" made by the nineteenth-century American clockmaker Isaac Pease.

56 "Spirito: Thayer's Latest Sensation!," advertisement, *Magical Bulletin* 12, no. 1 (November 1924).

57 John Gaughan, as told to Dustin Stinett, "Spirito," *Genii: The Conjurors' Magazine* 78, no. 4 (April 2015): 20–21.

58 Joel S. Schwartz, *Victorian Science and Spiritualism: Alfred Russel Wallace and Sir Arthur Conan Doyle* (Cambridge, MA: Briony Lodge Press, 1983), 8.

59 William Hodson Brock, *William Crookes (1832–1919) and the Commercialization of Science* (Aldershot, UK: Ashgate, 2008), 199.

60 Since the turn of the twentieth century, the newly established societies for psychical research in England and America focused on studying, testing, and proving mental capabilities drawn from unseen forces such as extrasensory perception (ESP) and telekinesis, the ability to move or alter physical objects. In the second half of the nineteenth century, mediums claimed intangible contact with the spirit world often aided by objects, but by the mid- to late twentieth century and onward, contact was through intangible psychic means. Matthew L. Tompkins, *The Spectacle of Illusion: Deception, Magic and the Paranormal* (New York: Distributed Art Publishers, 2019), 15.

61 Charles G. Page, *Psychomancy: Spirit-Rappings and Table-Tippings Exposed* (New York: D. Appleton and Company, 1853).

62 Page was superintendent of the East India Marine Society Museum, the founding institution for the Peabody Essex Museum, from 1835 to 1837. He is best known for his work and inventions related to electricity, specifically his induction coil and circuit breaker patents and attempts at electromagnetic locomotion. "Art. 1—Charles Grafton Page," *American Journal of Science and Arts*, 2nd ser., 48, no. 142 (July 1869): 1–17; Robert C. Post, *Physics, Patents, and Politics: A Biography of Charles Grafton Page* (New York: Science History, 1976).

63 Purportedly, upset mediums destroyed the majority of the copies, the electrotypes, and the image plates upon publication. Harry Houdini reviewed the reprint of this volume on August 20, 1922, for the *New York Times*.

64 Buescher, "Cornering the Market on Fraud," 210–11.

65 Jim Steinmeyer, "What We Hide: The Master Magician Who Disappeared," *Jim Steinmeyer | JHS Productions Incorporated Blog*, May 11, 2022, https://jimsteinmeyer.com/2022/05/11/what-we-hide-the-master-magician-who-disappeared/. By age twenty-six, Tobin had invented popular and successful stage illusions. After his magic performances, his career took a twist as a friend from Louisville, Colonel Young, recommended him to chair the Department of Chemistry at the Central University of Kentucky at Richmond.

66 "Tobin and Spiritualism," *Salem Register*, August 16, 1875. A couple of weeks earlier, the *Boston Daily Advertiser* remarked that Tobin "did not propose to discuss the abstract question of Spiritualism, which he regarded with a certain degree of reverence, but only to deal with its physical manifestations. . . . He was careful . . . not to state that the results which he produced by scientific apparatus might not possibly be produced by honest mediums through the aid of spirits, but he maintained strongly that he doubted if they could . . . indeed, some Spiritualists who were among the audience could not make themselves believe that there was not a supernatural agency at work, and asked among themselves: 'If it is not Spiritualism, what is it?'" "Science vs. Spiritualism," *Boston Daily Advertiser*, August 2, 1875.

67 Reuben Briggs Davenport, *The Death Blow to Spiritualism: Being the True Story of the Fox Sisters* (New York: G. W. Dillingham Co., 1888). Maggie was also driven by anger toward her older sister, Leah, who she thought had exploited Maggie and Kate.

68 Cited in Buescher, "Cornering the Market on Fraud," 211.

69 Meryem Ersoz, "American Magic, American Technology: Visual Culture and Popular Science in the Machine Age" (PhD diss., University of Oregon, 1997), 57.

70 On the Cassadaga Propaganda, see the essay by Mark Schwartz in the present volume.

71 Katherine Harmon Courage, "Science vs. the Supernatural," *Scientific American* 323, no. 3 (September 2020): 57, https://www.scientificamerican.com/article/scientific-american-vs-the-supernatural/.

72 Harry Houdini, "Mediums and Magicians," *New York Times*, August 20, 1922.

73 In the April 1895 edition of *Mahatma*, Dr. Albert Merlin notes, "Prof. Houdini and his assistant, Mme. Ola, are busy practicing a new theosophic wonder, invented by Prof. Houdini, and entitled 'The Temple of Buddha,' a clever idea and a new departure in illusionary effects. A small cabinet thirty inches deep by twenty-four high, represents a Buddhist temple, in which the usual spirit manifestations and a number of new ones are presented." "Letter from Our Chicago Correspondent," *Mahatma* 1, no. 2 (April 1895): 8.

74 In 1904, *Mahatma* magazine reported, "Some extraordinary suggestions have been put forward as to Houdini's power to free himself from locks and bars, but the strangest of all is the theory of one of the serious faddist papers called *Light*, which suggests that the feats of the Handcuff King are to be attributed to spiritualism. . . . Of course that proves nothing; but it is a suggestion. . . . We have strong reasons for believing that he has been well acquainted with spiritualism for many years." *Mahatma* 7, no. 11 (May 1904): 124.

75 Houdini biographer Kenneth Silverman notes, "Anti-Semitism always roused Houdini's indignation. 'I never was ashamed to acknowledge that I was a Jew, and never will be,' he wrote to a friend in 1902. . . . During Houdini's anti-Spiritualist campaign, his Jewish origin came in for praise or attack. As the *New York Herald Tribune* put it, 'Jew and Gentile in their churches have for centuries been figuring this battle that Houdini, the son of a rabbi, now wages in his shrewd, dogged manner.' . . . By contrast, the *National Spiritualist* informed its readers that Houdini's real name was 'Harry Weiss' and that he was 'racially a Jew'; his attacks were 'racial bombast.'" Kenneth Silverman, "Houdini, the Rabbi's Son," in Brooke Kamin Rapaport, *Houdini: Art and Magic*, with contributions by Alan Brinkley, Gabriel de Guzman, Hasia R. Diner, and Kenneth Silverman (New York: Jewish Museum, under the auspices of the Jewish Theological Seminary of America; New Haven, CT: Yale University Press), 77, 84. Within a scrapbook containing newspaper clippings related to Spiritualism, a hand-drawn antisemitic caricature of Houdini contains the words "Houdini the Jew. Faker. Fraud. Bum. Biggest Money Getter under False Pretenses Alive. Does Not Believe in Himself." Tony Oursler, ed., *Imponderable: The Archives of Tony Oursler* (Zurich: LUMA Foundation, 2015), 253.

76 "Margery Genuine, Says Conan Doyle; He Scorns Houdini," *Boston Herald*, January 26, 1925. Doyle first met Margery and her husband, Dr. Le Roi Goddard Crandon, when Margery conducted a séance at Doyle's flat in London in 1923. For more on Mina Crandon's life,

see Thomas R. Tietze, *Margery* (New York: Harper & Row, 1973).

77 "Is Spirit Photography a Trick?," *Current Opinion*, June 1, 1923, 724.

78 Sir Arthur Conan Doyle, "Our American Adventure: In Which Sir Arthur Continues His Account of the Remarkable Séance at the Home of Ada Besinnet at Toledo," *Los Angeles Times*, October 28, 1922, I4.

I SEE THEE STILL, p. 71

1 Charles Sprague, "I See Thee Still," in *The Poetical and Prose Writings of Charles Sprague* (Boston: Ticknor, Reed, and Fields, 1850), 71.

2 Steven C. Bullock, "'Often concerned in funerals': Ritual, Material Culture, and the Large Funeral in the Age of Samuel Sewall," in *New Views of New England: Studies in Material and Visual Culture, 1680–1830*, ed. Martha J. McNamara and Georgia B. Barnhill (Boston: Colonial Society of Massachusetts, 2012), 183.

3 William Bentley, *The Diary of William Bentley, D.D., Pastor of the East Church, Salem, Massachusetts*, 4 vols. (Gloucester, MA: P. Smith, 1962), 2:253, https://babel.hathitrust.org/cgi/pt?id=inu.30000102994351&seq=281&q1=ring.

4 "William Pickman," Findagrave.com, accessed September 11, 2023, https://www.findagrave.com/memorial/54921084/william-pickman.

5 A second, accompanying portrait also by Cornè, titled *Portrait of William* (about 1807), of a living boy, may depict a second child (also named William) born to the family, or it may show the present William in a risen state. Peabody Essex Museum, 125895.A.

6 Graham Boettcher, "The Artist's Queen: John Trumbull's *Sarah Trumbull on Her Deathbed*," *Yale University Art Gallery Bulletin* (2015): 42, https://www.jstor.org/stable/43870906.

7 Matthew Adams Stickney to an unknown recipient, September 1, 1847, Peabody Essex Museum, Phillips Library, MSS 436, box 11, folder 5.

8 Advertisement for "Miss Prosch's Old Established Gallery," *Newark Daily Advertiser*, January 2, 1850, 1; Nancy M. West, "Camera Fiends: Early Photography, Death, and the Supernatural," *Centennial Review* 40, no. 1 (Winter 1996): 172, https://www.jstor.org/stable/23740730.

9 "Mascher's Stereoscope," *Scientific American* 8, no. 37 (May 28, 1853): 292, http://www.jstor.org/stable/24938337.

10 Jacquelyn Oak, "Artist and Visionary: William Matthew Prior Revealed," in *Artist and Visionary: William Matthew Prior Revealed*, ed. Jacquelyn Oak and Gwendolyn DuBois Shaw (Cooperstown, NY: Fenimore Art Museum, 2012), 27, 57; Stacy C. Hollander, *American Perspectives: Stories from the American Folk Art Museum* (booklet published in association with the exhibition *American Perspectives: Stories from the American Folk Art Museum Collection*, presented February 11, 2020–January 3, 2021, at the American Folk Art Museum, New York, 2020), 73.

11 The depiction of the dead as floating, ethereal beings emerging from cloud formations is a recurrent visual theme in posthumous portraiture across religious beliefs. Nineteenth-century American literature is rife with rhetoric meant to soothe grieving parents with the idea that their deceased children had "gone home" to a heaven rejoicing their arrival. For a popular and widely quoted example, see William Simonds, *Our Little Ones in Heaven* (Boston: Gould & Lincoln, 1858).

SPECTACLES OF SCIENCE, p. 81

1 Koen Vermeir, "The Magic of the Magic Lantern (1660–1700): On Analogical Demonstration and the Visualization of the Invisible," *British Journal for the History of Science* 38, no. 2 (June 2005): 127–59, http://www.jstor.org/stable/4028694.

2 Vermeir, "The Magic of the Magic Lantern," 136.

3 X. Theodore Barber, "Phantasmagorical Wonders: The Magic Lantern Ghost Show in Nineteenth-Century America," *Film History* 3, no. 2 (1989): 73–86, http://www.jstor.org/stable/3814933. Robertson's Phantasmagoria initially opened at the Pavillon de l'Echiquier and then moved to the Couvent des Capucines, where it was presented for six years.

4 Tom Gunning, "'Animated Pictures': Tales of the Cinema's Forgotten Future, after 100 Years of Film," in *The Nineteenth-Century Visual Culture Reader*, ed. Vanessa R. Schwartz and Jeannene M. Przyblyski (New York: Routledge, 2004), 100–113.

5 Barber, "Phantasmagorical Wonders," 74–75.

6 James P. Stanley, "How Spiritualism Spread," *Public Books*, July 15, 2016, https://www.public-books.org/how-spiritualism-spread/.

7 Brenda Weeden, "The Impact of John Henry Pepper," in *The Education of the Eye* (London: University of Westminster Press, 2008), 51–64, https://doi.org/10.2307/j.ctv6zd979.14; Brenda Weeden, "Pepper's Ghost," in *The Education of the Eye*, 71–86, https://doi.org/10.2307/j.ctv6zd979.16.

BOXING UP THE MEDIUM, p. 87

1 Lisa Morton, *Calling the Spirits: A History of Seances* (London: Reaktion Books, 2022), 12.

2 Anonymous, *Confessions of a Medium: With Five Illustrations* (London: Griffith & Farran,

1882), 106; Sciens, *How to Speak with the Dead: A Practical Handbook* (New York: E. P. Dutton, 1918), 100.

3 Mary Luckhurst and Emilie Morin, eds., *Theatre and Ghosts: Materiality, Performance and Modernity* (Basingstoke, UK: Palgrave Macmillan, 2014), 103. Spook shows, the campy 1950s descendants of these demonstrations, used the same principle in their "blackouts," during which an audience would be plunged into total darkness.

4 Anonymous, *Confessions of a Medium*, 106.

5 Jim Steinmeyer, *Hiding the Elephant: How Magicians Invented the Impossible and Learned to Disappear* (New York: Carroll & Graf, 2003), 57.

6 Elizabeth Lowry, "Gendered Haunts: The Rhetorical and Material Culture of the Late Nineteenth-Century Spirit Cabinet," *Aries: Journal for the Study of Western Esotericism* 12, no. 2 (2012): 221; Barry Wiley, "The Indescribable Phenomenon: The Early Years of Spiritualism and Anna Eva Fay," *Genii: The Conjurors' Magazine* 68, no. 4 (April 2005): 64–89.

7 P. T. (Phineas Taylor) Barnum, *The Humbugs of the World: An Account of Humbugs, Delusions, Impositions, Quackeries, Deceits and Deceivers Generally, in All Ages* (New York: Carleton, 1866), 77.

8 Henry Ridgely Evans, *The Spirit World Unmasked: Illustrated Investigations into the Phenomena of Spiritualism and Theosophy* (Chicago: Laird & Lee, 1897), 140.

9 Evans, *The Spirit World Unmasked*, 141.

10 Sidney W. Clarke, *The Annals of Conjuring* (Seattle: Miracle Factory, 2001), 302.

11 Evans, *The Spirit World Unmasked*, 145.

12 Maskelyne would go on to have a long and distinguished career in stage magic, creating famous illusions such as the levitation, inspired by the stories of mediums levitating in séance rooms.

13 Evans, *The Spirit World Unmasked*, 135; William V. Rauscher, *Religion, Magic, and the Supernatural* (Woodbury, NJ: Mystic Light Press, 2006), 461.

14 Charles Stépanoff, "Shamanic Ritual and Ancient Circumpolar Migrations: The Spread of the Dark Tent Tradition through North Asia and North America," *Current Anthropology* 62, no. 2 (April 2021): 239–46.

15 Åke Hultkrantz, *Belief and Worship in Native North America* (Syracuse, NY: Syracuse University Press, 2018), 70.

16 D. L. Smith-Christopher, "Shaking Tent Ceremony," in *American Indian Culture*, ed. Carole A. Barrett and Harvey Markowitz, 3 vols. (Pasadena, CA: Salem Press, 2004), 2:649–50.

17 Kenneth Silverman, *Houdini!!! The Career of Ehrich Weiss: American Self-Liberator, Europe's Eclipsing Sensation, World's Handcuff King & Prison Breaker—Nothing on Earth Can Hold Houdini a Prisoner!!!* (New York: HarperCollins, 1996), 42.

18 Mike Caveney and William P. Meisel, *Kellar's Wonders* (Pasadena, CA: Mike Caveney's Magic Words, 2003), 39.

19 Caveney and Meisel, *Kellar's Wonders*, 53.

20 Caveney and Meisel, *Kellar's Wonders*, 208, 224. In 1897, one of Kellar's assistants, William Robinson, would reveal the secret of the Cassadaga Propaganda to *Scientific American*. William Benjamin, "Cassadaga Propaganda," *Scientific American* 75, no. 19 (November 7, 1896): 351.

21 Caveney and Meisel, *Kellar's Wonders*, 269.

22 Stuart Cramer, *Germain the Wizard*, ed. Todd Karr in association with Ken Klosterman (Seattle: Miracle Factory, 2002), 41–44.

23 Max Holden, *Programmes of Famous Magicians* (New York: Published by Max Holden, 1937), 6.

24 Cramer, *Germain the Wizard*, 457–62.

25 John A. McKinven, "The Best Show . . . I Ever Saw: Howard Thurston," *Magic: An Independent Magazine for Magicians* 10, no. 8 (April 2001): 60; Rauscher, *Religion, Magic, and the Supernatural*, 473.

26 Arnold Furst, *Famous Magicians of the World: Reviewed by Arnold Furst* (Oakland, CA: Magic Limited, Lloyd E. Jones, 1957), 51.

27 "30th Anniversary Something Magical," *Index Journal* (Greenwood, SC), May 24, 2009; "Ammars to Debut Famed Spirit Cabinet," *Index Journal* (Greenwood, SC), June 4, 2009. Remarkably, Hannah Ammar is the fourth generation of Willard women to perform as a medium in the spirit cabinet routine, and she did so with her magician husband, Michael Ammar, as recently as 2009.

28 "David Copperfield: Part 1—Richard Young," *Magic Circular* 114, no. 1249 (August 2020): 236–38, 272.

29 "Magic," *The Dispatch* (Moline, IL), October 29, 1995, 74.

PHANTOM EVIDENCE, p. 97

1 Susan Sontag, *On Photography* (New York: Dell, 1978), 15.

2 Talbot quoted in Geoffrey Batchen, *Each Wild Idea: Writing, Photography, History* (Cambridge, MA: MIT Press, 2001), 132.

3 Edgar Allan Poe, "The Daguerreotype," in *Classic Essays on Photography*, ed. Alan Trachtenberg (New Haven, CT: Leete's Island Books, 1980), 38.

4 Nadar, "My Life as a Photographer," in *Photography in Print*, ed. Vicki Goldberg (Albuquerque: University of New Mexico Press, 1981), 127–28.

5 Cathy N. Davidson, "Photographs of the Dead: Sherman, Daguerre, Hawthorne," *South Atlantic Quarterly* 89, no. 4 (Fall 1990): 667–701.

6 These were in response to a suggestion by David Brewster, one of the stereoscope's inventors, that a photographer could easily produce such an "amusement" by having a certain figure move about or exit the camera's view before an exposure was completed, creating "an aerial personage." See David Brewster, *The Stereoscope: Its History, Theory, and Construction with Its Application to the Fine and Useful Arts and to Education* (London: John Murray, 1856), 205–6.

7 The French scientist and politician François Arago made an emphatic claim for photography as a scientific instrument, among many other utilitarian functions, when he first introduced the invention of the daguerreotype to a stunned French Chamber of Deputies on July 3, 1839. See Dominique François Arago, "Report," in Trachtenberg, *Classic Essays on Photography*, 15–18.

8 Jennifer L. Mnookin, "The Image of Truth: Photographic Evidence and the Power of Analogy," *Yale Journal of Law & the Humanities* 10, no. 1 (1998): 9–12.

9 Louis Kaplan, *The Strange Case of William Mumler, Spirit Photographer* (Minneapolis: University of Minnesota Press, 2008), 35.

10 For a significant consideration of the overlooked importance of Hannah Mumler in establishing the studio and teaching her husband photography, see Felicity Tsering Chödron Hamer, "Helen F. Stuart and Hannah Frances Green: The Original Spirit Photographer," *History of Photography* 42, no. 2 (2018): 146–67.

11 Kaplan, *The Strange Case of William Mumler*, 114.

12 In *Harper's Weekly*'s front-page column, the publication astutely points out that "to all appearances spiritual photography rests just where the rappings and table-turnings have rested for some years. Those who believe in it at all will respect no opposing arguments, and disbelievers will reject every favorable hypothesis or explanation." "Spiritual Photography," *Harper's Weekly*, May 8, 1869, 303.

13 Mnookin, "The Image of Truth," 30.

14 Kaplan, *The Strange Case of William Mumler*, 206.

15 Mumler commented in a letter published in the *Boston Herald*, "Who the 'ghost-like image' looks like I leave you to judge and draw your own inferences. Suffice it to say, the lady fully recognized the picture." "Mrs. Abraham Lincoln Sits for a Spirit Picture," republished in *The Shelby County Democrat* (Sidney, OH), March 15, 1872, 2.

16 Kaplan, *The Strange Case of William Mumler*, 155. Mumler's spirit photography career was a footnote, or not mentioned at all, in published obituaries. Rather, his advances in the photo-electrotype plate process, which made photographs easier to print in publications (the Mumler process), were forefronted.

17 *British Journal of Photography* 19, no. 621 (March 28, 1872): 143. Whereas the *Journal* had lampooned Mumler when it reported on him in 1863, the publication, under the editorship of John Traill Taylor, was much more even-handed in its coverage when the phenomenon appeared in the United Kingdom. For the *Journal*'s earlier discussion of Mumler, see "About Some Photographic Ghost Stories," *British Journal of Photography* 10, no. 181 (January 1, 1872): 15.

18 Georgiana Houghton, *Chronicles of the Photographs of Spiritual Beings and Phenomena Invisible to the Material Eye: Interblended with Personal Narrative* (London: E. W. Allen, 1882).

19 Clément Chéroux, "Ghost Dialectics: Spirit Photography in Entertainment and Belief," in *The Perfect Medium: Photography and the Occult*, ed. Jean-Loup Champion and Clément Chéroux (New Haven, CT: Yale University Press, 2005), 48.

20 Chéroux, "Ghost Dialectics," 46.

21 Harry Houdini, *A Magician among the Spirits* (New York: Harper & Brothers, 1924), 120.

22 John Beattie, "The Philosophy of Spirit-Photography," *Spiritual Magazine* 8, no. 1 (January 1873): 25.

23 Arthur Conan Doyle, *The Case for Spirit Photography* (New York: George H. Doran Company, 1923), 23.

24 On the debunking of William Hope by Harry Price and other accounts of spirit photography, see Harry Price, *Confessions of a Ghost-Hunter* (London: Putnam, 1936), 168–208. On Ada Deane's rise and fall as a spirit photographer, see Martyn Jolly, *Faces of the Living Dead: The Spirit Photography of Mrs. Ada Deane* (Canberra: Canberra Contemporary Art Space, 2001).

25 Houdini, *A Magician among the Spirits*, 136.

IMAGINING ETHEL LE ROSSIGNOL, p. 111

1 Ethel Le Rossignol, *A Goodly Company* (London: printed for the author by the Chiswick Press, 1933).

2 "Our Collection of Ethel Le Rossignol's paintings," The College of Psychic Studies, https://www.collegeofpsychicstudies.co.uk/enlighten/our-collection-of-ethel-le-rossignol-paintings.

3 Jennifer Farrell, "Art as Influence and Response: A First Look at World War I and the Visual Arts," Metropolitan Museum

of Art (blog), October 16, 2017, https://www.metmuseum.org/blogs/now-at-the-met/2017/world-war-i-and-the-visual-arts-introduction.

BELIEF IN THE BRAIN AND BODY, p. 117

1 *Merriam-Webster*, s.v. "believe," accessed September 22, 2023, https://www.merriam-webster.com/dictionary/believe.

2 Rüdiger J. Seitz, Raymond F. Paloutzian, and Hans-Ferdinand Angel, "Processes of Believing: Where Do They Come From? What Are They Good For?," *F1000 Research* 5:2573 (January 2017), https://doi.org/10.12688/f1000research.9773.2.

3 Rüdiger J. Seitz, Matthias Franz, and Nina P. Azari, "Value Judgments and Self-Control of Action: The Role of the Medial Frontal Cortex," *Brain Research Reviews* 60, no. 2 (May 2009): 368–78, https://doi.org/10.1016/j.brainresrev.2009.02.003.

4 Seitz, Paloutzian, and Angel, "Processes of Believing."

5 J. H. Brown, *Spectropia; or, Surprising Spectral Illusions Showing Ghosts Everywhere, and of Any Colour* (New York: James G. Gregory, 1864), 7, https://archive.org/details/39002002968692.med.yale.edu.

6 For further discussion of Brown's book, see the essay by George H. Schwartz in the present volume.

7 Brown, *Spectropia*, 11.

CODA, p. 122

1 The culture and communication professor Peter Otto notes that "the years immediately following World War II . . . prepared the ground for the New Age movement . . . for those fascinated by occultism, neo-paganism, witchcraft, astrology, shamanism, meditation, reincarnation, psychic experience, crystal gazing, channelling and so forth." Peter Otto, *Entertaining the Supernatural: Animal Magnetism, Spiritualism, Secular Magic and Psychical Science*, Adam Matthew Publications: Primary Sources for Teaching and Research–Digital content, 2015, 2.

2 Gardner Bradford, "Imagine Buying 'Voices from *beyond* the Grave!,'" *Los Angeles Times Sunday Magazine*, July 9, 1933, 20.

3 Beth A. Kattelman, "Magic, Monsters, and Movies: America's Midnight Ghost Shows," *Theatre Journal* 62, no. 1 (March 2010): 23.

4 Bill McIlhany, "The Medium Is the Message: Hollywood's Anti-Spiritualist Crusade," *Magic* 5, no. 7 (March 1996): 42. McIlhany notes that Howard Thurston plays a Spiritualist who murders his best friend, a Hindu philosopher, in the 1920 film *Twisted Souls*, and Dante performed as himself in the 1950 film *Bunco Squad*, in which he teaches detectives the methods of phony psychics.

5 Charlotte Jee, "Technology That Lets Us 'Speak' to Our Dead Relatives Has Arrived. Are We Ready?," *MIT Technology Review*, October 18, 2022, https://www.technologyreview.com/2022/10/18/1061320/digital-clones-of-dead-people/amp/. The app uses images, recordings, and footage of a person to create the "spirit" version. I would like to thank Dana Gee for sharing this article.

6 The "ghost box" created by Frank Sumption in 2002 is somewhat akin to Thayer's Spirito: a modified AM/FM radio for spirit communication that sweeps over different radio signals, "forming" messages from audio fragments.

7 Linda Rodriguez McRobbie, "The Strange and Mysterious History of the Ouija Board," *Smithsonian Magazine*, October 27, 2013, https://www.smithsonianmag.com/history/the-strange-and-mysterious-history-of-the-ouija-board-5860627/. See also Bill Brown, "Thing Theory," *Critical Inquiry* 28, no. 1 (Autumn 2001): 1–22.

8 "Latest Works of Fiction: Jap Herron," *New York Times*, September 9, 1917, 336. Hutchings agreed to destroy the remaining copies and cease publication.

9 McRobbie, "The Strange and Mysterious History of the Ouija Board."

10 Terence Hines, *Pseudoscience and the Paranormal*, 2nd ed. (Amherst, NY: Prometheus Books, 2003), 47.

Abbott's Magic Company. *Target: Midnight: The Incredible Story of the Midnight Magic Spook Shows & Séances!* Colon, MI: Abbott's Magic Company, 2022.

Bechtel, Stefan, and Laurence Roy Stains. *Through a Glass, Darkly: Sir Arthur Conan Doyle and the Quest to Solve the Greatest Mystery of All.* New York: St. Martin's Press, 2017.

Brandon, Ruth. *The Spiritualists: The Passion for the Occult in the Nineteenth and Twentieth Centuries.* New York: Knopf, 1983.

Braude, Ann. *Radical Spirits: Spiritualism and Women's Rights in Nineteenth-Century America.* Boston: Beacon Press, 1993.

Brown, Gary R. "Henry Slade and His Slates: From Europe to the Fourth Dimension." *Gibecière* 12, no. 1 (Winter 2017): 9–112.

Buescher, John Benedict. "Cornering the Market on Fraud: Stage Magicians versus Spirit Mediums." *Magic, Ritual, and Witchcraft* 9, no. 2 (Winter 2014): 210–23.

Burger, Eugene. *Spirit Theater: Reflections on the History and Performance of Seances.* Washington, DC: Kaufman and Greenberg, 1986.

Caveney, Mike. *Carter the Great.* Pasadena, CA: Mike Caveney's Magic Words, 1995.

Caveney, Mike, and Bill Miesel. *Kellar's Wonders.* Pasadena, CA: Mike Caveney's Magic Words, 2003.

Charvet, David. *Alexander, The Man Who Knows: Mindreader, Charlatan, Extortionist, Bootlegger, Bigamist, Murderer, Magician,* 2nd ed. Los Angeles: Mike Caveney's Magic Words, 2007.

Chéroux, Clément, Andreas Fischer, Pierre Apraxine, Denis Canguilhem, and Sophie Schmit. *The Perfect Medium: Photography and the Occult.* New Haven, CT: Yale University Press, 2005.

Colbert, Charles. *Haunted Visions: Spiritualism and American Art.* Philadelphia: University of Pennsylvania Press, 2011.

Conlin, Claude Alexander. *The Life and Mysteries of the Celebrated Dr. "Q."* Los Angeles: Alexander Publishing, 1921.

Cook, James W. *The Arts of Deception: Playing with Fraud in the Age of Barnum.* Cambridge, MA: Harvard University Press, 2001.

Copperfield, David, Richard Wiseman, and David Britland. *David Copperfield's History of Magic.* New York: Simon and Schuster, 2021.

Cozzolino, Robert, ed. *Supernatural America: The Paranormal in American Art.* Minneapolis: Minneapolis Institute of Art in association with the University of Chicago Press, 2022.

Daniel, Noel, ed. *Magic: 1400s–1950s.* Cologne: Taschen, 2013.

Dunninger, Joseph. *Houdini's Spirit Exposés from Houdini's Own Manuscripts, Records and Photographs, and Dunninger's Psychical Investigations.* Edited by Joseph H. Kraus. New York: Experimenter, 1928.

During, Simon. *Modern Enchantments: The Cultural Power of Secular Magic.* Cambridge, MA: Harvard University Press, 2002.

Fast, Francis R. *The Houdini Messages: The Facts Concerning the Messages Received through the Mediumship of Arthur Ford.* New York, 1929.

Ferris, Alison. *The Disembodied Spirit.* With contributions by Tom Gunning and Pamela Thurschwell. Brunswick, ME: Bowdoin Museum of Art, 2003.

Frank, Robin Jaffee. *Love and Loss: American Portrait and Mourning Miniatures.* New Haven, CT: Yale University Art Gallery and Yale University Press, 2000.

Grant, Simon, Susan L. Aberth, and Lars Bang Larsen. *Not without My Ghosts: The Artist as Medium.* London: Hayward Gallery, 2020.

Hansen, George P. *The Trickster and the Paranormal.* Philadelphia: Xlibris, 2001.

Hatfield, Sharon. *Enchanted Ground: The Spirit Room of Jonathan Koons.* Athens, OH: Swallow Press, 2018.

Heagerty, N. Riley. *Portraits from Beyond: The Mediumship of the Bangs Sisters.* Hove, UK: White Crow Books, 2016.

Hollander, Stacy C. *Securing the Shadow: Posthumous Portraiture in America.* With an essay by Gary Laderman. New York: American Folk Art Museum, 2016.

Houdini, Harry. *A Magician among the Spirits.* New York: Harper & Brothers, 1924.

Jaher, David. *The Witch of Lime Street: Séance, Seduction, and Houdini in the Spirit World.* New York: Crown, 2015.

Jolly, Martyn. *Faces of the Living Dead: The Spirit Photography of Mrs. Ada Deane.* Canberra: Canberra Contemporary Art Space, 2001.

Kaplan, Louis. *The Strange Case of William Mumler, Spirit Photographer.* Minneapolis: University of Minnesota Press, 2008.

Keene, M. Lamar, as told to Allen Spraggett. *The Psychic Mafia.* New York: St. Martin's Press, 1976.

Klosterman, Ken, with Gabe Fajuri. *Salon de Magie.* Loveland, OH: Kenneth Klosterman, 2006.

Kucich, John J. *Ghostly Communion: Cross-Cultural Spiritualism in Nineteenth-Century American Literature.* Hanover, NH: Dartmouth College Press, 2004.

Lande, R. Gregory. *Spiritualism in the American Civil War*. Jefferson, NC: McFarland & Company, 2020.

Leeder, Murray. *The Modern Supernatural and the Beginnings of Cinema*. London: Palgrave Macmillan, 2017.

Luckhurst, Mary, and Emilie Morin, eds. *Theatre and Ghosts: Materiality, Performance and Modernity*. Basingstoke, UK: Palgrave Macmillan, 2014.

Macknik, Stephen, and Susana Martinez-Conde, with Sandra Blakeslee. *Sleights of Mind: What the Neuroscience of Magic Reveals about Our Brains*. London: Profile Books, 2011.

Mangan, Michael. *Performing Dark Arts: A Cultural History of Conjuring*. Bristol, UK: Intellect, 2007.

Manseau, Peter. *The Apparitionists: A Tale of Phantoms, Fraud, Photography, and the Man Who Captured Lincoln's Ghost*. New York: Houghton Mifflin Harcourt, 2017.

Mays, Sas, and Neil Matheson, eds. *The Machine and the Ghost: Technology and Spiritualism in Nineteenth- to Twenty-First-Century Art and Culture*. Manchester, UK: Manchester University Press, 2013.

McGarry, Molly. *Ghosts of Futures Past: Spiritualism and the Cultural Politics of Nineteenth-Century America*. Berkeley: University of California Press, 2008.

Midorikawa, Emily. *Out of the Shadows: Six Visionary Victorian Women in Search of a Public Voice*. Berkeley, CA: Counterpoint, 2021.

Morris, Dee. *Boston in the Golden Age of Spiritualism: Séances, Mediums & Immortality*. Charleston, SC: History Press, 2014.

Morton, Lisa. *Calling the Spirits: A History of Seances*. London: Reaktion Books, 2022.

Moses, Arthur. *Houdini Speaks Out: "I Am Houdini! And You Are a Fraud!"* Philadelphia: Xlibris, 2007.

Nadis, Fred. *Wonder Shows: Performing Science, Magic, and Religion in America*. New Brunswick, NJ: Rutgers University Press, 2005.

Natale, Simone. *Supernatural Entertainments: Victorian Spiritualism and the Rise of Modern Media Culture*. University Park: University of Pennsylvania Press, 2016.

Nehama, Sarah. *In Death Lamented: The Tradition of Anglo-American Mourning Jewelry*. Boston: Massachusetts Historical Society, 2012.

Nickell, Joe. *The Science of Ghosts: Searching for Spirits of the Dead*. Amherst, NY: Prometheus Books, 2012.

Nickle, Piet, comp. *The Chesterfield Exposé*. Agawam, MA: Modern American Spiritualism, 2019.

Ottaviani, Jim, and Janine Johnston. *Levitation: Physics and Psychology in the Service of Deception*. Ann Arbor, MI: G.T. Labs, 2007.

Pearsall, Ronald. *The Table-Rappers: The Victorians and the Occult*. Stroud, UK: Sutton Publishing, 2004.

Price, Harry. *Confessions of a Ghost-Hunter*. London: Putnam, 1936.

——. *Leaves from a Psychist's Case-Book*. London: Victor Gollancz, 1933.

Putnam, Allen. *Natty, a Spirit: His Portrait and His Life*. Boston: Bela Marsh; New York: Partridge and Brittan, 1856.

Randi, James. *Flim-Flam! The Truth about Unicorns, Parapsychology and Other Delusions*. New York: Lippincott & Crowell, 1980.

Rapaport, Brooke Kamin, ed. *Houdini: Art and Magic*. With contributions by Alan Brinkley, Gabriel de Guzman, Hasia R. Diner, and Kenneth Silverman. New York: Jewish Museum, under the auspices of the Jewish Theological Seminary of America; New Haven, CT: Yale University Press, 2010.

Rapoza, Andrew. "Touched by the 'Invisibles': Communicating with the Dead in Nineteenth Century Lynn." In *No Race of Imitators: Lynn and Her People, an Anthology*, ed. Elizabeth Hope Cushing, 51–80. Lynn, MA: Lynn Historical Society, 1992.

Rauscher, William V. *The Houdini Code Mystery: A Spirit Secret Solved*. Pasadena, CA: Mike Caveney's Magic Words, 2000.

——. *Pleasant Nightmares: Dr. Neff and His Madhouse of Mystery*. Neptune, NJ: S. S. Adams, 2008.

——. *Religion, Magic, and the Supernatural: The Autobiography, Reflections, and Essays of an Episcopal Priest*. Woodbury, NJ: Mystic Light Press, 2006.

Sandford, Christopher. *Masters of Mystery: The Strange Friendship of Arthur Conan Doyle and Harry Houdini*. New York: Palgrave Macmillan, 2011.

Sauvage, Suzanne, Christian Vachon, and Marc H. Choko, eds. *Illusions: The Art of Magic*. Montreal: McCord Museum; Milan: 5 Continents, 2017.

Seeman, Erik R. *Speaking with the Dead in Early America*. Philadelphia: University of Pennsylvania Press, 2022.

Silverman, Kenneth. *Houdini!!! The Career of Ehrich Weiss: American Self-Liberator, Europe's Eclipsing Sensation, World's Handcuff King & Prison Breaker—Nothing on Earth Can Hold Houdini a Prisoner!!!* New York: HarperCollins, 1996.

Smith-Dalton, Maggi. *A History of Spiritualism and the Occult in Salem: The Rise of Witch City*. Charleston, SC: History Press, 2012.

Steinmeyer, Jim. *The Glorious Deception: The Double Life of William Robinson, aka Chung Ling Soo, the "Marvelous Chinese Conjurer."* New York: Carroll & Graf, 2005.

———. *Hiding the Elephant: How Magicians Invented the Impossible and Learned to Disappear*. New York: Carroll & Graf, 2003.

———. *The Last Greatest Magician in the World: Howard Thurston versus Houdini & the Battles of the American Wizards*. New York: Jeremy P. Tarcher/Penguin, 2011.

Taggart, Shannon. *Séance*. Somerset, UK: Fulgur Press, 2019.

Tietze, Thomas R. *Margery*. New York: Harper & Row, 1973.

Tompkins, Matthew L. *The Spectacle of Illusion: Deception, Magic, and the Paranormal*. New York: Distributed Art Publishers, 2019.

Troy, Kathryn. *The Specter of the Indian: Race, Gender, and Ghosts in American Séances, 1848–1890*. Albany: State University of New York Press, 2017.

Walker, Mark. *Ghostmasters*. Rev. ed. Boca Raton, FL: Cool Hand Communications, 1994.

Warner, Marina. *Phantasmagoria: Spirit Visions, Metaphors, and Media into the Twenty-First Century*. New York: Oxford University Press, 2006.

Weinstock, Jeffrey Andrew, ed. *Spectral America: Phantoms and the National Imagination*. Madison: Popular Press, an imprint of University of Wisconsin Press, 2004.

Weisberg, Barbara. *Talking to the Dead: Kate and Maggie Fox and the Rise of Spiritualism*. San Francisco: Harper San Francisco, 2004.

Wiseman, Richard. *Paranormality: Why We See What Isn't There*. London: Spin Solutions, 2010.

Young, Kevin. *Bunk: The Rise of Hoaxes, Humbugs, Plagiarists, Phonies, Post-Facts, and Fake News*. Minneapolis: Graywolf Press, 2017.

CONTRIBUTORS

Tedi E. Asher is Neuroscience Researcher at the Peabody Essex Museum, where she explores ways to combine understandings of the human nervous system with caring curiosity to connect across differences and build new understandings of individuals, communities, and the human experience.

Christopher Jones is Stanton B. and Nancy W. Kaplan Curator of Photography and Media Art at The John and Mable Ringling Museum of Art, where he has curated numerous photography and contemporary art exhibitions. He has also taught courses on the history of art and the history of photography at Eckerd College, St. Petersburg, Florida, and at New College of Florida, Sarasota.

Lan Morgan is assistant curator at the Peabody Essex Museum and a specialist in American art and material culture. Her research and curated exhibitions span topics across the decorative arts, design, and cross-cultural exchange, and she has a particular interest in early American mourning traditions.

Tony Oursler is an artist whose work, research, and collecting interests relate to belief systems, technology, stage magic, spirit photography, pseudoscience, telekinesis, and pop cultural manifestations of magical thinking.

Jennifer Lemmer Posey is Tibbals Curator of Circus at The John and Mable Ringling Museum of Art, where she oversees and interprets the museum's collection of objects and ephemera related to the history of the circus, with a focus on the relationship of the circus arts, mass media, and popular culture.

George H. Schwartz is curator-at-large at the Peabody Essex Museum, where he curates exhibitions and specializes in maritime art, material culture, early collecting and museum history, and how global objects were used to shape an emerging national identity in the early United States. He also teaches material culture at Tufts University in the museum studies program.

Mark Schwartz is a professor of anthropology and archaeology at Grand Valley State University in Allendale, Michigan, who has had a lifelong interest in the history of stage magic that has included the occasional escape from a straitjacket or jail cell.

INDEX

PHOTO CREDITS